The STEAMPUNK
Adventurer's Guide

About the Author (Wanted for Questioning)

With an education in physics, history, and art, it was perhaps inevitable that **Thomas Willeford** (aka Lord Archibald "Feathers" Featherstone) would become a Steampunk enthusiast. His work blurs the precarious line between art and engineering. If, upon viewing a piece, one does not ask, "Does that actually work?" he considers the piece a failure.

Photo by Thomas Willeford

Thomas has been creating unique and beautiful corsets and all manner of striking Steampunk gadgetry for more than 20 years. Thomas is also the author of the critically acclaimed Steampunk how-to book *Steampunk Gear, Gadgets, and Gizmos* (McGraw-Hill Professional). He and his products have been widely featured on television (MTV, BBC, *Castle*, and *Oddities*), online (Wired, Forbes, and Popular Mechanics), and in print (*The Art of Steampunk*, *The Steampunk Bible*, and *Steampunk: An Illustrated History*). Satisfied customers include musician Rick Springfield, director David Silverman (*The Simpsons Movie*), and actresses Patricia Tallman (*Babylon 5*) and Virginia Hey (*Farscape*). Thomas also contributed to the design of Alchemy Gothic's "Empire Collection," a line of Steampunk jewelry and accessories.

Thomas's artwork has also been featured in numerous museum exhibitions worldwide, including Penn State's "STEAMpunk!," Dr. Grymm's "Steampunk Bizarre," the Charles River Museum of Industry and Innovation's "Steampunk: Form and Function," and the Ashmolean Museum of the History of Science at Oxford's "Steampunk," "20,000 Leagues" at Patriot Place, and "Mobilis in Mobili" at The Wooster Street Social Club (home of The Learning Channel's *NY Ink*). His clockwork spider "Arachnae Mechanica" is currently housed in the Cosmopolitan Hotel in Las Vegas, Nevada. He is currently a consultant and prop master of the upcoming Steampunk television series, Bruce Boxleitner's *Lantern City*.

Thomas currently resides in Harrisburg, Pennsylvania, with his six spoiled cats.

About the Artist (Have You Seen This Man?)

Phil Foglio is the coauthor, with Kaja Foglio, of the Hugo Award–winning *Girl Genius* graphic novel series and the novels *Agatha H and the Airship City* and *Agatha H and the Clockwork Princess*. Phil has been writing and drawing comics since the 1980s, with work that includes Buck Godot, the adaptation of *MythAdventures*, and work for DC and Marvel Comics.

Photo by Loren Sebastian DeLaOsa

The
STEAMPUNK
Adventurer's Guide

Contraptions, Creations, and Curiosities Anyone Can Make

Thomas Willeford

**Mc
Graw
Hill
Education**

New York Chicago San Francisco
Athens London Madrid Mexico City
Milan New Delhi Singapore Sydney Toronto

Cataloging-in-Publication Data is on file with the Library of Congress

McGraw-Hill Education books are available at special quantity discounts to use as premiums and sales promotions, or for use in corporate training programs. To contact a representative, please visit the Contact Us pages at www.mhprofessional.com.

The Steampunk Adventurer's Guide: Contraptions, Creations, and Curiosities *Anyone* Can Make

1 2 3 4 5 6 7 8 9 0 DOW DOW 1 0 9 8 7 6 5 4 3

ISBN 978-0-07-182780-5
MHID 0-07-182780-3

Sponsoring Editor	**Copy Editor**	**Composition**
Roger Stewart	Valerie Cooper	TypeWriting
Editorial Supervisor	**Proofreader**	**Art Director, Cover**
Janet Walden	Paul Tyler	Jeff Weeks
Project Manager	**Indexer**	**Cover Designer**
Patricia Wallenburg	Jack Lewis	Jeff Weeks
Acquisitions Coordinator	**Production Supervisor**	**Cover Illustration**
Amy Stonebraker	Jean Bodeaux	Phil Foglio

This book is dedicated to Louise R. Howard,
for being a better friend than I deserve,
and Alexander "Marty" Gear,
for not letting me be just "good enough" at what I do.

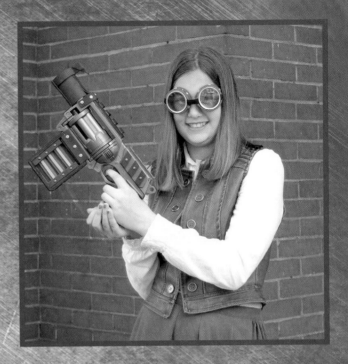

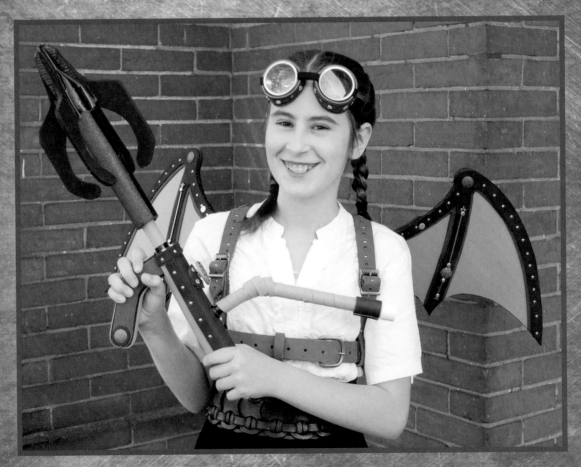

Contents at a Glance

Part the Third
Hastily Scribbled Laboratory Notes

Contents

Part the First
Before We Begin

Chapter 1

Chapter 2

Chapter 3

Part the Second
The Adventure

Chapter 8

Airship Harness

Chapter 9

Glider Wings

Chapter 10

Rivet Gun (Modded Nerf Blaster)

Chapter 11

Power Armor and Magnetic Amplification Gauntlet

Chapter 12

Rocket Pack

Chapter 13

Epilogue

Part the Third
Hastily Scribbled Laboratory Notes

A Foreword of Sorts—All Sorts

It wasn't always called Steampunk. It may have been referred to as "Victorian Fantasies" or "Jules Verne Technologies" or "HG Wells Horsing Around" (ok, I made that last one up). The point is, that at about the time the expression was coined, Thomas Willeford had already been in the Steampunk business. He had been designing and building great stuff, in the Steampunk style.

It's a style of designing a science fiction future with late 19th-century technology. I've always been a fan of the earliest science fiction, or "scientific romances" as they were called back then. The works of Jules Verne and H. G. Wells, these were the great pioneers of imagination. Wells particularly fascinates me—he invented so many themes of science fiction, and most of them within a six-year period. That's a lot of genius!

Growing up as a boy cartoonist in the 1960s, I was enthralled with the George Pal film version of *The Time Machine*, the Ray Harryhausen fx-driven *First Men in the Moon*, and the TV show *The Wild Wild West*. They all had something in common: Steampunk design. Of course, my pals and I didn't call it that; the expression was years away. But we all loved it.

Then, many years later, I am strolling around the 2011 San Diego Comic Convention. And I stumble onto Brute Force Studios. "What th— ?!" says I. "Here's a mad scientist from those pages and shows I loved as a kid, selling stuff!" Well, I had to buy a few items, as I needed them for Burning Man (which has some incredible Steampunk creations as well). Thomas and I got to chatting and have been pals ever since.

So now Thomas has done something unusual. Here's a Steampunk tale with an invitation to build Steampunk props. An interactive notion; an imaginative adventure, and a way to further stimulate your own imagination. It's a nifty idea. I think even I can build these, thanks to Thomas's clear guides, and I'm a lousy carpenter.

Sit back in your favorite chair, with your favorite tools. Time to get reading and building. At the same time! Go for it, you can—ah—what's that? Oh—oh—yes I see.

I apologize, I've been asked not to encourage reading and building at the same time.

It started as scientific romances, became science fiction, and now has come to be known as Steampunk. Call it what you like, it is the stuff of dreams. And I like it all. Because I'm a dreamer—but aren't we all?

—David Silverman
Adventurer, Animator, Tuba Aficionado
Director and producer of
The Simpsons Movie and
co-director of *Monsters, Inc.*

Agents and Accomplices

With thanks to the lovely Sarah, for again putting up with me as I became downright demented (even worse than the first time) while writing another book.

To Phil Foglio, for taking on the illustrations when he could have been doing more important things.

To Ray Witte (writing assistance) and Brian Thomas (photographic assistance), for coming to my rescue when my hard drive got hungry and ate about 20,000 words with a side order of 50 photographs.

To Dene Woodman for his inspirational work on "foam armor."

To Roger Stewart and the rest of the team at McGraw-Hill Professional, for giving me the chance to prove I had more than one book in me.

And to all of my other friends, family, and colleagues, who have been so supportive and encouraging through the process of writing this book.

Meanwhile, in an Underground Lair

All of the so-called, conventional scientists called me mad! Mad, I tell you! But I scoff at their pedestrian ideas and boring theories! They wish to keep all the true science for themselves! Not I! I present it to you all to free you from the oppressive yoke of the technocrats!

—Dr. Charles Claremont, Scientist, Quite Mad

You are cordially invited on an adventure. After all, isn't that what Steampunk is really all about? Adventure? If there were no adventure, this would just be another book you wish you did not have to pretend to like after receiving it as a gift from a kind but woefully misguided friend or relative. But you are lucky, and this is not just any old book you have here. This is *The Steampunk Adventurer's Guide*. You get to do much more than just read a story about someone else's adventures. You get to make the equipment for your own adventures.

It might seem like the best way for you to enjoy this book would be to read the story until it tells you to make the bit of required Mad Science, then make the project, and then go on and read a bit more of the story, then repeat this process until you have finished the book or you cannot take the strain any longer. Are you going to do that? Yeah, I wouldn't either.

You go ahead and read the whole story. It's not very long, and I thought it was a lot of fun, with loads of airships, automatons (by the way, that is a fancy, Steampunk way of saying "robots"), and even a few Mad Scientists. Then, pick your favorite projects and get to work. You can't exactly fight off a Type II Combat Automaton with a toothbrush, now, can you? You are going to need to equip yourself with devices available to those willing to apply only the maddest of scientific advances.

When I first thought I would write this book, I was thinking it would be fun and easy to write a "kid's book." I would come up with really simple projects. After just one look online at other craft project books, I was horrified to see all the same stuff I was embarrassed to make from way back when I was a kid. I thought, "I can't do this to those poor people." So I thought I would give them really cool projects to work on, something anyone would be proud to have and make the others jealous.

I came up with all these grand ideas, and about halfway through each one, I had to stop. How many people own a 7-inch metal-cutting mini-lathe? Or a 9-inch band saw? I had to stop myself and clutch my head like a stunned monkey and yell over to a friend, "Hey, do you think having a kid ask their parents for a 50-pound anvil for an early birthday present is a bit too much?" Their answer was, "Not if you are writing this thing for a coyote who happens to be chasing a swift but flightless bird. . . ." It is hard to imagine not using a tool you use all the time. Who doesn't have a couple of drill presses sitting about? It's like writing a school paper with a pencil when the computer is sitting right there.

So I started from scratch and I thought long and hard about it. I came up with a list of important questions.

- What would I want to make?

- What if I didn't have all these tools?

- What tools would even the most tool-impaired house have within?

- And why does this have to be a book just for kids?

Yeah? Why does it? Well, it doesn't. When I started talking about the projects and how I was going to make them really special, but requiring minimal tools and no glue or special skills, loads of my adult friends were eagerly asking me, "When will this book be out, and why can't it be sooner?" I keep forgetting that using tools is becoming a bit of a dying art. I ask people about making things and they will tell me all about the incredible model airship they made. When I ask them to show it to me, they pull out their computer and I think they are going to show me a picture of it flying around in their backyard. This is when they show me the computer-generated image of an airship they have made using Photoshop, and I try not to cry.

Computer art can be incredible, but I like to think you want something you can touch. That is when I realized this book was for everyone who always wanted to make incredible things but thought, "I don't have the tools or the space to make that." If you have this book—and considering you are reading these words, that is a reasonable assumption—now you are going to need to come up with a brand new set of excuses.

There is another thing I would like you to think about as you are crafting away on these projects.

I don't expect you simply to follow what I have laid out here as if it were just a set of blueprints; that's what minions do. You are made of much more adventurous stuff. You are going to make the basic pieces and then go wild combining other found objects and your own creations with the basic structures I show you here. Please expand the scope of what you find here. Add coils, switches, and old model parts. Make each piece your own invention.

This is not a book that should sit pristine on your desk or bookshelf. It should have greasy fingerprints all over it, many dog-eared pages, loads of notes scribbled in the margins, tears around the edges, and maybe even a few pages missing. When you are done with this battered tome, and you hear the stomping of your nemesis's Combat Automatons coming toward you, you should have a veritable arsenal of Infernal Devices at your fingertips as you don your Magnetically Hyper-Bonded Power Armor and shout across the deck of their renegade Aerial Cruiser, "You have messed with the wrong Mad Scientist!"

—*Thomas Willeford*, Gentleman Genius

Part the First

 Before We Begin

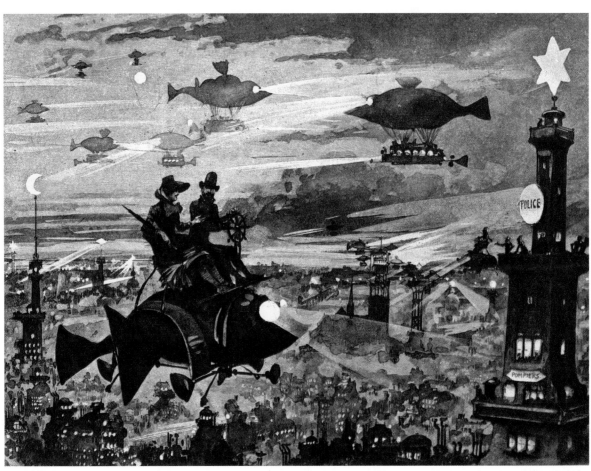

Albert Robidas

Chapter 1

What Is Steampunk?

People ask me all the time, "What is Steampunk?" Well, according the *Oxford English Dictionary*, Steampunk is defined as "a genre of science fiction that typically features steam-powered machinery, rather than advanced technology." That is the answer you would write on a test in school, but I don't think it really covers it.

What is Steampunk? Well, my goggle-curious friends, it's the answer to the question, "What if…." What if what we think of as our history is completely wrong? What if Ben Franklin spent more time in the laboratory and less time goofing off in Paris? What if H. G. Wells was a reporter instead of a science fiction writer? What if the library of Alexandria had not been destroyed and science had a bit more of a head start? In a world like that, almost anything would be possible.

According to subcultural folklore, the term "Steampunk" was first coined by author K. W. Jeter back in the early 1980s. Steampunk authors such as Tim Powers, William Gibson, James Blaylock, and Bruce Sterling were looking back at an interrupted past, with technologies emerging out of sync with our original timeline, and people of the world were all just coming along for the ride.

Although many people consider Jules Verne, H. G. Wells, and George Chetwynd Griffith (by the way, these are some of my favorite authors in the entire universe) to be Steampunk authors, it might

be better to consider them science fiction writers of their own time. Almost every Steampunk author I have ever spoken to thinks these classic authors are some of the most incredible inspirations to us all, and they wrote amazing things about their own time or about a speculative future. You should hunt their works down and read them (you will find a list of their titles in Appendix A). They will make you want to make everything in this book and more. But to me, Steampunk is usually about an alternative past instead of a glimpse into their futures.

I am going to push the boat out here and risk taking a shot across the bow from the DARC (the Department of Advancement, Regulation, and Control). The first piece of media to come about that I would classify as truly Steampunk is the '60s television show, *The Wild Wild West* (pilot episode, 1965). There, I said it. I looked as far as I could and nothing else really fit the bill. Yes, *20,000 Leagues Under the Sea* came out in 1954, but it was a movie based on a novel published in 1869. *The Wild Wild West* had all my prerequisites for good, honest Steampunk, without any stretching of the definition whatsoever. It had the gadgets, the alternative history, the mad scientists, and dashing heroes. Others might wish to stretch the definition, even if just to try and prove me wrong, but there is no question about whether *The Wild Wild West* was Steampunk or not—it just was.

Yes, the *Oxford English Dictionary* definition might be correct to a certain degree, but I find it to be inadequate. Steampunk has graduated from a simple science fiction genre into a growing subculture. Its style is based on the clash of history and anachronism and infused with the demands and constraints of antiquated technology. People are developing entire wardrobes and lifestyles based on where they park their airship. This is not simple Victorian re-enactment; Steampunk is much more than that. Its literary roots make it a more character-driven world. One might dress Victorian, but I seldom see people dressing generically Steampunk; instead, they put on their Lady Machinanna's best hunting outfit, holster their Dr. Visbaun's High Voltage Electro-Static Hand Cannon, and head off on a dinosaur hunt to deepest, far-flung Neptune. I hear it's Victoriasaurus season on the Baron's estate. (I also hear they have lost only two hunting parties this season, but don't worry; there are still two months to go.)

Of course, this is just my own take on Steampunk. I tend to stick with the alternative past, but there are worlds upon worlds out there. You get to decide when your imaginary world exists, but just to make it easy, I'm going to suggest two different types of Steampunk worlds here: the alternative history, and retro-futurism/modernism.

Alternative History

It is the past but not quite the same as we remember it. Some shift has made science take an extra step. Usually a few technologies or groups of technologies have made an advancement, while leaving other things behind. Maybe we can fly faster sooner, but Marconi's radio is nowhere in sight. People often create highly developed *dramatis personae* to fit into these "brave new worlds." Here's an example: It's 1879, and with the advent of Professor Grimmelore's Patented Helium Expander, mankind has taken to the skies like never before. Expanded helium has six times the lift of standard hydrogen and is so much safer. The sky is buzzing with airships kept from colliding only by the constant vigilance of the tireless operators of Her Majesty's Light Tower Semaphore Corps.

This is the type of world *The Wild Wild West* is set in. My favorite flavor of alternative history is Victorian/Western, but it can be almost any time up to now where things went a bit…different. Imagine if the internal combustion engine was never developed and we had steam cars in the '40s and steam planes fighting WWII.

Retro-Futurism/Modernism

History, until the time of the story, tends to be the same as you read about in the history books. Then a group or culture has decided to pull its style from the past. Everything might have already changed, and now we are in the present day or the future, dealing with the consequences of what has already happened, or perhaps all of our modern technology has stopped working and we need to look back to the age of steam to keep things going.

My favorite literary example of this type of Steampunk is Neal Stephenson's *The Diamond Age*. It's the late twenty-first century and England has a new Queen Victoria. People are wearing full Victorian dress constructed of nearly indestructible and self-cleaning nanofabrics. This is one of the few books I've read more than once. Another good example of this is the 2006 movie *Perfect Creature*. It featured an alternative history but brought it up to a present or near-present place and time, with vampires, and no, they do not sparkle, even a little bit.

The Steampunk aesthetic is not only about books, movies, and television, however. Fashion, music, and decor are all rapidly being integrated into this subculture. In mid-2006, with its album *Lost Horizons*, the band Abney Park became the first all-Steampunk band (as opposed to a band that occasionally plays goggle-friendly music). The band helped define the soundtrack of air piracy, and for a while, they were the only airship pirates. Other musicians soon followed—The Men That Will Not Be Blamed for Nothing, The Extraordinary Contraptions, Unextraordinary Gentlemen, Vernian Process, Dr. Steel, Professor Elemental, and Ghostfire—to name a few. A DJ could play all night at a party and not leave the Steampunk soundtrack.

What Steampunk Is Not ("Cog on a Stick")

No one likes to say, "These are the Steampunk rules that you must now follow," but there is a tendency within Steampunk art and fashion toward what I like to call "cog on a stick." Don't do it! The best way to avoid the "cog on a stick" effect is for things to at least look like they function. You are allowed to do anything you like, but put in the effort. Take your time, and don't just glue a gear on it. In fact, I don't really like glue that much, so I am not going to show you how to glue a gear on a box and call it a "Steampunk Time Capsule," which would be fine if you just want to make something to bury it in your backyard and forget about it, but I presume you want to show this stuff off at least a little bit. I am going to show you how to make some Steampunk contraptions you will be proud to own. This is the real stuff.

Steampunk is just too much fun. You can imagine if the events in this book had really happened, or maybe they did and the history books are wrong. Who is to say they weren't? Ask around; loads of people think the first car was invented by Ford, or Benz, yet if you look, you will find steam carriages appearing long before these guys even got a wheel turning. A bunch of submarines were made in the 1800s—some even earlier—and do you really think the Wright brothers were the first people to fly? Not even close. Who knows what adventures were happening with all these magnificent devices kicking around? After all, it is all about the adventure. Maybe that is the true meaning of Steampunk—an adventure in historic science fiction.

Chapter 2

Tools of the Modern Mad Scientist . . . and Materials, Too

I have tried to make these projects as easy and tool-free as possible while keeping them absolutely awesome, but let's face the cold, hard reality. Unless you plan on chewing the ends off each piece of craft foam and such, you are going to have to use at least some really basic, bare-bones tools. Remember, the ability to use tools and at least a moderate nod to personal grooming is what separates us from bears with furniture.

Note

In the "Availability" part of each description, I have left out the words "the Internet" because it's too obvious; of course you can find these things on the Internet. You can find nearly anything on the Internet.

Tools

I won't cover every single tool you might possibly use, but I want to show you some of the more likely culprits to help avoid any confusion. Here are some of the tools you will need to get started on your quest toward becoming a true Mad Scientist.

Measure Twice

These are the various measuring devices you will find quite handy.

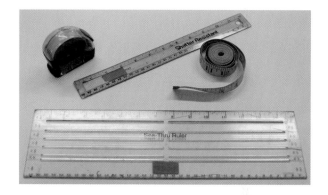

Items: Retractable tape measure, 12-inch ruler, fabric tape measure, wide see-thru ruler

Availability: Craft/hobby stores, sewing supply stores, hardware stores, office supply stores

Notes: The bare minimums you will need are the fabric tape measure and the 12-inch ruler. The wide see-thru ruler is the best straightedge for use with the craft knives, as it keeps your fingers far away from the blade. The retractable tape measure is convenient for flat parts, and once opened, it can be used one-handed.

Cut Once

Occasionally you are going to have to cut things, and these should do the trick.

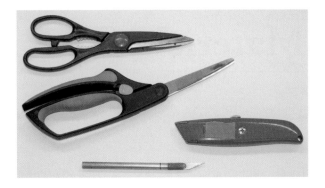

Items: Two kinds of scissors, a large craft knife, and a small craft knife

Availability: Craft/hobby stores, sewing supply stores, hardware stores, office supply stores

Notes: The large craft knife is also called a construction, or carpenter's, knife. The small one is often called an X-Acto® knife, which is a name brand that makes such knives. In both, the blades are easily replaceable and should be replaced often as in my experience, a dull blade is more of a hazard than a sharp one. The scissors are common enough and should require no explanation. Do not run with them. Use *extreme* caution when using any of these items.

Pointy, Pokey Things

You will need to poke holes in order to put all of those rivety-looking things on your projects. This selection of implements should do nicely.

Items: Meat thermometer, Japanese chopstick, pencil, scratch awl, kitchen skewers, nails

Availability: Kitchen supply section in the groceries stores, office supply stores, hardware stores

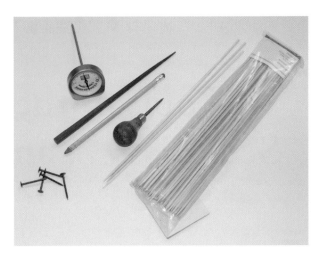

Notes: The scratch awl—or just awl—is the best of the lot. Surprisingly, the meat thermometer is the next best choice. The pencil is the least favorite, but is good for widening a hole. The skewers are dirt-cheap and come a zillion to a bag. Nails are the best, cheap choice as they cost pennies and will go through every material this book requires.

On Your Mark, Get Set

Measuring is not much good without a way to mark the spot. For coloring things, markers are much less messy than paint and a brush.

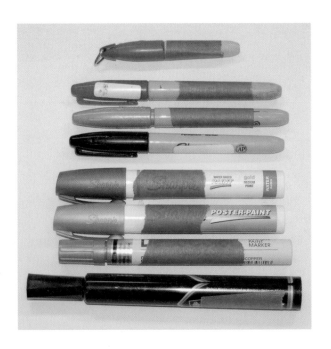

Items: Wide black marker, metallic copper paint marker (oil based), water-based metallic non-toxic markers

Availability: Office supply stores, craft/hobby stores

Notes: Quick and relatively unmessy, markers provide such an easy way to add detail. Do not draw on anyone, including yourself.

A Cut Above

Cutting boards will save your table or work surface, and quite possibly your life. If you decide not to use one, and tear up the dining room table, do not say I did not warn you.

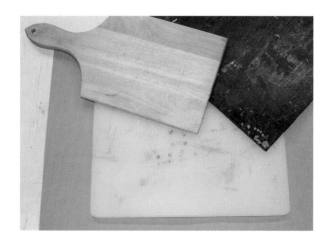

Items: Wooden kitchen cutting board; heavy, black rubber cutting mat; white plastic cutting board

Availability: Thrift store, leather-working supply store, kitchen supply store

Notes: The wooden board is the cheapest, and you can often find one at thrift stores for as little as $1. The rubber mat's length makes it good for long straight cuts, but it gets damaged after a bit of use. The white plastic board is easy to find and should last forever.

One of Your New Best Friends

If you want to make a nice, round hole instead of just stabbing your project, this is what you want.

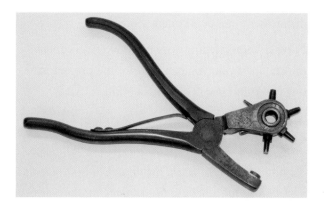

Items: Rotary punch

Availability: Craft/hobby stores, hardware stores, leather supply stores, sewing supply stores

Notes: Once you have one of these, you will wonder how you lived without it. They come in a range of qualities. The lighter, "economy grade" punches are usually available at your local craft store. The one in this picture is a heavy-duty, dinosaurs-will-again-rule-Earth-before-this-thing-breaks quality piece from a leather worker's supply store. The economy punch will work fine on everything in this book.

The Jail-Break Special

This is quite possibly the safest type of saw one can use. With its really tiny teeth, you would have to try really hard to hurt yourself. It is used for

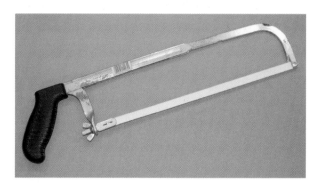

only one project in this book, but you will be glad to have one around.

Items: Hacksaw

Availability: Any hardware store or tool department in a department store

Notes: Very safe and very effective. You can use the cheapest one you can find for the project in this book and it will still be overkill.

Get It All on Tape

Tape is both a tool and a material. You will use the variety you have here to hold things in place and as decoration.

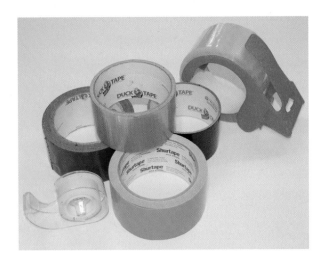

Items: Brown, gold, and black duct tape, clear packing tape, cellophane tape, double-sided duct tape (that's the blue stuff)

Availability: Office supply stores, craft/hobby stores, hardware stores

Notes: In the past few years, we have seen the advent of "fashion" duct tape, so now it is available in loads of colors. I suggest you take full advantage of this. The double-sided duct tape is a miracle of modern science, and the moment I first saw it I thought, "Why didn't they have this when I was a kid?"

Materials

When selecting the materials for this book, it took me a while to step backwards from what I am used to using. I have access to some pretty exotic materials. It was actually a lot of fun and a bit of a challenge coming up with projects that look good but use more easily accessible materials. You should have little trouble finding all the stuff listed here.

Craft Foam

This is a wonder material, and once you start using it, you will go way beyond what you find in this book.

Items: 9 × 12-inch sheets of craft foam

Availability: Craft/hobby stores

Notes: Craft foam comes in a great many colors and a few different sizes; the ones I suggest in the projects are just that, suggestions. Go wild.

Foam Board

This is a lightweight, rigid foam between two layers of heavy paper.

Items: 20 × 30-inch sheet of black foam board

Availability: Craft/hobby stores, office supply stores

Notes: I've heard some places call this stuff "foam core." It is best to cut foam board with a craft knife, because scissors tend to crush the edge. As always, be careful.

Tins

When you pick these up for your projects, think about getting extras, as they are great for sorting

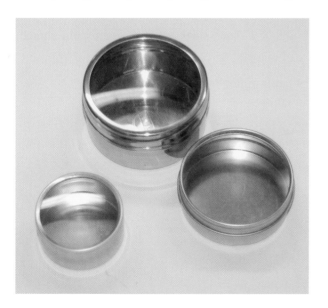

all of your split brads and other small bits of hardware.

Items: 3-inch tin, 2 1/2-inch tin, 2-inch tin

Availability: Craft/hobby stores, especially in the bridal section

Notes: When I first saw these tins, I immediately thought, "I need to find a way to make goggles out of those." Don't stop there; once you see how easy these are to work with, you will be going mad with the power of science!

Fasteners and Split Brads

These are great for holding your projects together without having to sew or use glue.

Items: "Screw-head" split brads, box of assorted split brads, 3/4-inch paper fasteners

Availability: Craft/hobby stores, office supply stores

Notes: I love these things! They are insanely easy to use. Punch a small hole, push the pointed bits through, and spread them out. Attachomatic! If you put a bit of duct tape on the back, it will make them even more secure and less scratchy.

A Material to Make: Fleather—the Latest Thing in Mad Science!

Are you tired of that heavy feeling leather has? Are you unhappy with how expensive leather is? Do you wish they made nice, square cows? Well, your wishes have been granted! Now you can make incredible equipment for any adventure at a fraction of the effort and cost. Introducing Professor Grimmelore's latest invention: Light as a feather, strong like leather, it's Fleather, the new secret to your success!

When I was younger, I always wanted to make cool belts and holsters and costumes and stuff, but I did not know where to get the stuff to make the stuff. It was unlikely they sold leather at my local department stores and, although it was summer and equally unlikely he would need them, my dad was not too happy with the idea of me cutting up his leather coats. When I decided to write this book, I remembered that frustration, and thought there must be some way to make this easier.

I searched all over the craft stores. I had seen and used craft foam before. I knew you could make pretty cool things with it, but they never seemed to last very long. It was just not strong enough to handle the rigors of the abuse to which I was going to subject it. This was really raining on my parade. I did not want to show you how to make just average stuff. I wanted to show you how to make incredible wonders of Mad Science!

Then, an idea came to me: Perhaps you could back the foam with duct tape and make it stronger. So off to the hardware store I went. I ran in and grabbed two rolls of brown duct tape. I turned around to leave and dropped one of the rolls on the floor. When I went to pick it up, I noticed, there on the bottom shelf, something I had never heard of before: *double-sided duct tape*.

How in the world had I not seen this before? Regular double-sided tape was easy to rip. With its fabric core, this double-sided duct tape would be amazing. All the possibilities ran about in my head. This was inspiration on a roll! I grabbed three rolls of this magical stuff and bought it, then ran back to the craft store and bought far too much craft foam. On that day, Fleather was born.

How to Make Fleather

Here is everything you need to make your first piece of Fleather.

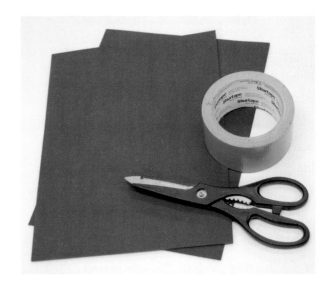

Materials:

- 2 9 × 12-inch sheets of craft foam (your choice of color)
- 1 roll of double-sided duct tape

Tools:

- Scissors

Alternative Tools:

- Cutting board
- Craft knife
- Wax paper

Step 1 Place your first piece of craft foam on a flat surface with the longer edge laying left to right. Clear off any dust or dirt. Make sure this is a surface you (or someone else) will not mind you getting tape on. If the surface is delicate, I recommend you put down some wax paper to protect it.

Step 2 Roll out and cut off a piece of double-sided duct tape slightly longer than the edge of the craft foam, then place this along the long edge of the craft foam with the sticky side down. Press it down firmly all along its length. Cut and place another piece right next to the first. Note: Do not overlap the tape. If you do, you will not be able to peel off the backing.

Repeat this until the whole piece of craft foam is covered in double-sided duct tape, and it looks like this.

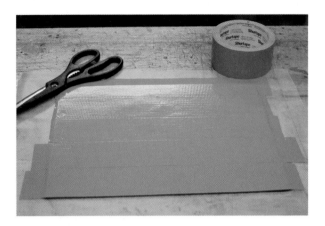

Do not trim off the excess tape just yet. Peel off the protective blue film (this may be a different

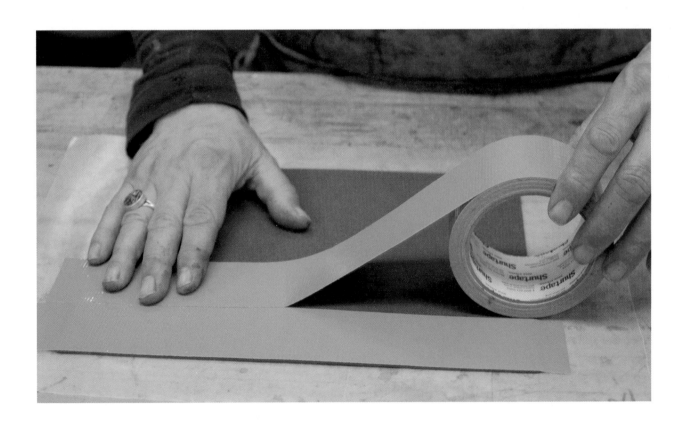

color than shown in the illustration, depending on what brand of tape you are using) and expose the second sticky side of the tape.

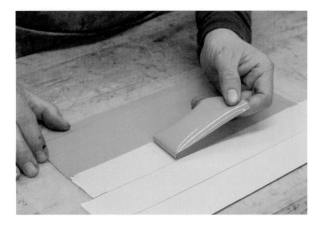

Step 3 Make sure the second piece of foam is clean, and carefully place it on top of the tape and directly over the first piece of foam. Make sure you do this nice and flat, pressing from the center out toward the edges to avoid making any bubbles in the foam, and then smooth it all out.

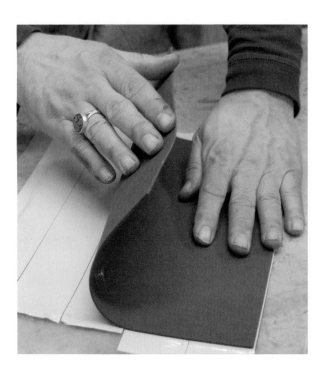

Step 4 Now trim off the edge of the foam and any tape that is sticking out, making your cut about

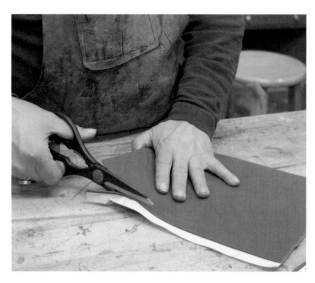

an eighth of an inch in from the edge of the foam. This ensures the whole piece has a strong grip on the tape. Smooth it all flat again.

You have now made your first piece of Fleather!

But Wait! There Is More!

There will be three varieties of Fleather used in this book: Fleather, reinforced Fleather, and Fleather tape.

You have already seen the wonder that is Fleather. To make reinforced Fleather, you will make your Fleather, then simply add a layer of colored duct tape to one side. For the best results, apply the tape before you cut it into strips. You see it here with a backing of black duct tape.

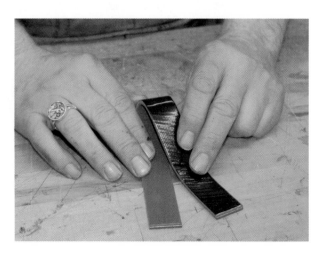

To make Fleather tape, follow Steps 1 and 2 of how to make Fleather, but do not peel off the protective film. Again, for the best results, apply the tape before you cut it into strips. Peel the film right before you use the Fleather tape.

You can, of course, make Fleather in any size in which you can find craft foam sizes. I generally get craft foam in two sizes, 9 × 12 inches and 12 × 18 inches. Thus, half of a 12 × 18-inch piece can make a 6 × 18-inch piece, or a 9 × 12-inch piece, and so on.

Now you know the secret to making the newest wonder material Mad Science has to offer! Amaze your friends! Scorn your foes.

Note

Double-sided duct tape is pretty cool, but occasionally it will peel up on its own, especially when used on wrap-around pieces. Just push it back down every once in a while, and add a little more tape, if needed. If a piece falls off, the good news is, these things are pretty cheap and easy to make so repairs are a breeze.

Embellishments

Instead of dictating to you how each piece must look and having you do it only the way I would, I wish to give you the tools to go forth and create on your own. Here are a few pieces you can pick up at the average craft store to enhance your projects' look and give them your own special style.

Split Brads and Paper Fasteners

They come in various sizes, shapes, and colors. I've already mentioned how useful they are for holding things together; use the longer ones for

belts and straps. But they are also great for creating that riveted look. Just push them through a hole and spread the bits on the back, like the clasps on manila envelopes. I really like the ones with screw heads. They are generally available in the scrapbooking section of the craft store.

GEARS!!

Steampunk has caught on enough that craft stores are starting to carry small packages of gears for you to use on your projects. You can use the split brads to attach them to your projects. Clocks are no longer afraid to show their faces in public.

Lettering

Do you want a button on your device? "E" for explosive? "D" for danger? "A" for adventure? Most of these have sticky backs and can be stuck to large-headed split brads.

Rubber Stamps

This is an easy and quick way to give your projects a tooled leather or filigree look. Besides just black ink, you can find metallic gold, silver, copper, bronze, and more, including sepia ink for a very Victorian look.

Stuff?

This is just stuff I found roaming about the craft store, in the jewelry section, the dollhouse section, even the wedding section. Keep your eyes open and never stop looking. You will be amazed at what you will find.

Embellishments to Make

I don't want to bore you by telling you how to do the same stuff over and over later; here are a few embellishments you can make yourself and then put on almost any piece. These are like mini-projects you can use again and again. Make a few and then try putting them on your project. Let yourself be creative.

The Patch

This is designed to look like a patch riveted on a device. It will give your pieces that rough, used look, and add a bit of detail. A patch can be round, or rectangular, and almost any size. I'll show you how to make a 2 × 3-inch rectangle patch.

Materials:

- 1 sheet of Fleather of the desired color

- 6 split brads

- 3 inches of double-sided duct tape

Tools:

- Scissors

- Nail, hole punch, or awl

Cut a 2 × 3-inch piece of Fleather, then round the corners a little bit. Use a poking tool to make six holes about 1/4 inch in from the edge, and then insert and secure the split brads. Apply a piece of double-sided duct tape to the back of the patch and do not peel the protective tape backing until just before you want to use it. Just peel and stick it where you need it.

Mount Patch

So, you have found this really neat little valve handle with a little screw to hold it on, or a key or some other trinket. How are you going to get it to stay on your project? Try this. I'm going to make one for a valve handle.

Materials:

- 1 sheet of Fleather of the desired color

- 4 split brads

- 1 small piece of double-sided duct tape

- I trinket, such as a handle, to put in the middle

Tools:

- Jar lid

- Scissors

- Nail, hole punch, or awl

The size of the patch should allow room for the split brads and the trinket you want to attach to your project. Finding something like a small jar lid the size of the patch you want to make, and press it into the piece of Fleather. It will leave a round impression in the foam. Cut this piece out. Using your hole-making tool, put four holes around the edge just in enough to keep the split brads from going over the patch's edge. Insert your four split brads. Put a hole in the middle of the patch to accommodate the screw for the trinket.

Screw the trinket on. Back the patch with double-sided duct tape and cut away the excess tape. Peel the tape when you need to stick the patch to the side of your next really cool project.

Copper Pipe Connector

This one is a little harder, but it looks so good that it is worth the effort. It is a great detail and perfect for connecting two tanks together, or adding a bit of plumbing to your Mad Science.

Materials:

- 1 sheet of Fleather of the desired color

- 8 split brads

- 2 pieces of double-sided duct tape

- 2 bendy straws

- Two round mount patches (see previous project)

Tools:

- Scissors
- Nail, hole punch, or awl
- Copper paint pen

This is going to look like a pipe connecting two mount patches. Bend the shorter part of each straw to a 90-degree angle to the long part. Figure out how far apart the bends in the pipe will need to be, then place the straws together as seen in the illustration. Mark the longer parts of the pipes at the center of their intersection. Make a mark one inch beyond the intersection on each pipe. Cut the pipes at these second marks. This will give them two inches of overlap.

You know how you would take a bunch of straws and stick one into the next to make one really long straw? Good, do that—fold the edge of one straw in a bit and slide it into the opening of the other. Slide it in until the mark an inch from the end just disappears. Poke a hole in the center of the two mounting patches. Widen this hole with a cooking skewer, chopstick, an awl, or whatever works, until it will allow the straw to barely pass through. Mark the shorter part of the straws one inch down from the top of the bend. Make another mark 1/2 inch down from that. Do that to both pipes. Cut both pipes on the second marks, 1 1/2 inches from the bend.

This part is hard to explain, but the picture helps it make sense. Make two cuts at right angles from each from the end of the pipe to the one-inch

marks on the short ends. Use a copper paint marker to color the entire pipe. You may have to let it dry and then flip it and paint the other side to get it all the right color.

The good news is it should only take about 15 minutes to dry. While you are waiting, put the split brads in the mounting patches. When the pipes are all dry, slide the slit ends of one end of the pipe through the hole in the center of one of the patches. Splay the split end out, as shown in the illustration, and back the patch with double-sided duct tape. Attach the other end of the pipe in the same manner to the second mounting patch.

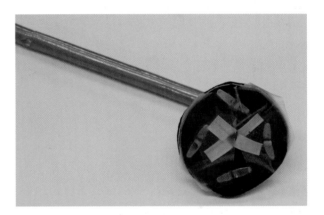

Trim off the excess tape and, as always, peel and apply this piece when you are ready to use it.

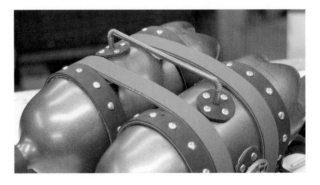

Rivet Tape

This is great for making a line of detail! I'm going to show you how to make a 1 × 12-inch piece, with one "rivet" every inch. You can change the width, length, color, spacing of the rivet, etc., to suit your project's needs.

Materials:

- 1 9 × 12-inch sheet of black craft foam
- 11 split brads
- Double-sided duct tape

Tools:

- Scissors
- Nail, hole punch, or awl

This is almost too easy to explain. Cut a 1 × 12-inch strip of craft foam. Make marks down the center of the strip, one inch apart. Push a brad though the foam at every mark. This stuff is thin,

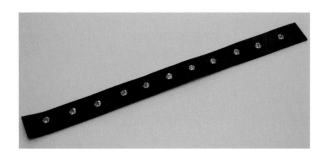

so you will probably be able to just push the split brads through with no problem. Back it with double-sided duct tape, and trim off the excess tape. When you need it, cut it to length, and then peel the back and stick it onto your project.

Use these wisely to enhance your devices and make them more powerful! All those valves, gears, and pipes will make your archenemies tremble in fear, even if they have no idea why those things are even on there!

One Last Note

The materials I use may differ in size from what you can get. If a 3/4-inch paper fastener is not enough to hold something together, use a bigger one. If you cannot find 12 × 18-inch craft foam, figure out a way to put two smaller pieces together. You are an aspiring Mad Scientist; do not let the instructions and available materials limit you!

Resizing Any Pattern with Your Mad Scientist Math Skills

"But the pieces I found are a different size than the ones you've listed!" I know this may seem like a project-stopping disaster. Well, do not worry! There is a trick to making the patterns fit a piece that is a different size than what I've shown. Let's use the tins for the goggles from Chapter 6 as an example.

My tins are 2 inches across the top. But let's say you found a clear-top tin that is 2 3/4 inches. First, get a calculator: 2 3/4 is 2.75 (3 divided by 4 is .75). So, take 2.75 and divide it by 2 (the measurement of my tin) and you get 1.375. Take 1.375 and move the dot two places to the right to get the percentage at which you need to photocopy your original, 137.5%.

"But I found tins that are only 1 1/2 inches across. How does that work?" No problem, back to your calculator: 1 1/2 is 1.5 (1 divided by 2 is .5). Take 1.5 and divide it by 2 and you get .75. Take .75 and move the dot two places to the right to get the percentage at which you need to photocopy your original, 75%.

This works for any pattern! If you know a measurement of the original, and the new size of that same measurement, you can get the percentage. When you print the pattern at this new size, it should fit. Trust me; it's easier than it sounds.

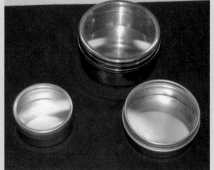

Chapter 3

You'll Shoot
Your Eye Out!

Parents, guardians, grandparents, teachers, governesses, and strict nannies, please take note:

For the sake of all that is scientific, be safe!

You may have noticed that I have not put any age indicators on the projects in this book. You know what I mean? Those little things saying, "This project is recommended for ages 7 and up," stuff like that. That's because I am probably not part of your family, or one of your closer friends, and for all I know you may have an eight-year-old who operates power tools all the time or a seventeen-year-old you still don't trust with a pair of blunted craft scissors, or paste. I suggest you read through the instructions and decide for yourself what would be appropriate for your little Mad Scientist. (Or yourself—you are not too old for this adventure!) Please consider everything that goes into making each project and try to keep everyone safe.

I have tried to keep the danger to a minimum. No power tools are needed for any of the projects in this book. Only two of the projects require spray paint, and I have managed to avoid glue altogether. This was in part to keep the mess down, and part of it was because I am notorious in my dislike of hot glue guns. Someone dared me to write this whole book and not make even a single project

that required one. I personally have never worked with one without at least burning a finger.

Here are some of the dangers you may face on your adventures.

Sharp Things

Scissors

Scissors are sharp, which is why they work at cutting things. The pointy ones are also sometimes used for poking holes in things, but not as good as an awl or a hole punch, so avoid using scissors for this if you can. It may sound wrong, but sharp scissors are better to use than dull ones. Dull scissors slip and require more pressure to cut. If you are working on tan craft foam, and the project is coming out red, call for help.

Craft Knives

These are the most dangerous tools used in this book. They have an exposed blade just sticking out there. Always try to use a straightedge and a cutting board when using a knife. A wide straightedge—maybe about 4 to 6 inches wide—is best, and keeps your hands away from the blade of destruction! Never pull the knife directly toward yourself. This is one of the few times I will say it: "use strictly under adult supervision."

Awls, Nails, and Skewers

These pointy things are used for making small, tight holes in fleather and stuff. If you are not careful, they will quite gladly make a hole in you. Do not point them at yourself, or anyone else. When you are using them to poke a hole in something, check and make sure you are not harming anything on the other side of your work.

Other Dangers

Rotary Punch

Not only does a rotary punch do a lovely job of making holes in things, in a variety of sizes, it will also pinch your fingers with impunity. Mine makes this little noise every time it pinches my fingers, like it's giggling about something. Very disturbing that. Before you use one, take a good look at it. Close and open the handles to observe where it might pinch. Also, the punches are on a wheel that turns in only one direction. Make sure the wheel is locked in place before you try to punch a hole. If not, it may shift under pressure and then you are on the road to Fingerpinch City, population, you.

Double-Sided Duct Tape

You are probably thinking, "What is he on about? How is a piece of tape dangerous?" This stuff is incredibly sticky. It seems to be even stickier than regular duct tape, and because it's sticky on both sides, there is no escaping the stuff. If you have sensitive skin, it can leave a nasty rash or mark. If you decide it is fun to press a big strip of it on your arm and pull it off, all the hair will come with it and people down the street will hear your screams. If you ball it up and it gets in your hair, or worse, someone else's hair, it's an absolute mess. To remove it, use a little cooking oil around the edges and peel it up slowly. Before you ask, most dish soaps will dissolve the cooking oil.

Spray Paint and Paint Markers

Always make sure there's plenty of ventilation when using these and never put paint on your skin, or anyone else's skin. Paint things outside; it's less of a mess and you can't really get much better ventilation. Read all the instructions on the can. The people who wrote them went to school for this kind of thing, so listen to them.

Mess

This may be the most important warning in this book. Clean up your mess. Clean up as much as you can at the end of each day. If you do not clean up after yourself, there is always somebody who is not going to like it, and when you want to make the next project, they are going to remember how you behaved with the first one. It's not just for them, either. It can be aggravating to spend half your time looking for your tools, or that last split brad you had sitting on the table. When everything is put away, you will know where to find it.

Remember: Be safe and make incredible things.

Part the Second

The Adventure

Chapter 4

Decoder Armguard
Wherein our heroes get the message

Lakehurst Aeroport, autumn 1891:

Thirteen-year-old Isaac and eleven-year-old Amelia Griffith stared eastward into a drizzly, cloudy sky, eagerly awaiting the arrival of their Uncle Adrian aboard the Airship HMS *Bristol*. Their parents both nervously checked the time. Anna Griffith was using her watch and Alexander Griffith was using their automaton Heathcliff Ebenezer Chadwick (everyone just called him HEC). Professor Adrian Grimmelore had been off on one of his mysterious expeditions for quite some time. The *Bristol* was due at 10:35 and it was already 13:23.

The Griffiths worked for DARC, the Department of Advancement, Regulation, and Control. The children knew it was very important work but Mum and Dad did not talk about it much. As the *Bristol* finally emerged from a cloudbank, HEC yet again announced the time. Isaac rummaged through his rucksack for his binoculars; he always kept a bag of such things around, since one never knew when they would be useful, and held them up to his eyes for a look. He saw smoke trailing from one of the engines, and the airship tilted slightly to one side.

"Dad, what's wrong with that ship?"

Alexander Griffith grabbed a pair of binoculars from one of the nearby airmen, looked toward the wounded airship, and said, "It appears to be heavily damaged."

Anna Griffith's voice boomed with authority as she yelled orders to those around her: "Somebody telegraph DARC headquarters! Tell them Adrian's ship's been damaged! You, the tall one, tell the observation tower to track every move that ship makes and get the base commander here, NOW!"

Mr. Griffith lowered his binoculars and pointed at a random airman. "You! Send up every interceptor you people have! Escort that ship down."

While the grownups were barking orders, Isaac kept watching the airship and saw it turn back toward the cloudbank. As it did, he noticed a flashing light coming from it.

"Mum," he said, "I think they are sending a signal."

Mr. Griffith jerked his binoculars back to his face just as the flashing ceased and said, "I don't see anything but they do seem to be turning away. I think they are making a run for it."

"Where are those interceptors?!" Mrs. Griffith yelled.

"I can see them lifting off!" Amelia said. Three small airships jumped skyward, their helium expanders glowing from the effort.

"Mum, it could have been a message!" Isaac insisted.

Mrs. Griffith answered, "Are you sure it wasn't just a fire? The starboard engine seems to be emitting a lot of smoke."

Before he could protest, Air Admiral Pike abruptly appeared and demanded, "Can anyone tell me the status of Professor Grimmelore?"

Mrs. Griffith turned to HEC and said, "Please take the children back to the waiting room, inside the aeroport. Quickly!"

"Certainly, madam," HEC responded. While the Griffiths briefed the air admiral and his aides on what little they knew of the situation, HEC ushered the children away.

Mrs. Griffith appeared about 15 minutes later in the lounge with the air admiral's aide, Ensign Willoughby, the airman whose binoculars were appropriated by Mr. Griffith, and various others. They all seemed to be awaiting her orders.

She told the kids, "Children, we are very concerned for your uncle Adrian. Three interceptors went out, but only one returned. It appears that your uncle has been captured by air pirates and is in great danger. I pray they don't know who he is and that he is still safe."

Isaac piped up, "Mum, what about the signal?"

"Yes, yes, I know," Mrs. Griffith said. "We've already had the base's top signalmen try to decipher the message and they could make nothing of it. It appears to have just been some random flashing, probably from the burning engine."

Isaac began to open his mouth in protest, but Amelia placed her hand gently on his arm to quietly tell him he was never going to get anywhere with Mum about this. Isaac fell silent. Mrs. Griffith again checked the time on her pocket watch. She turned to the children, then to HEC. "Mummy and Daddy have to get back to work, now. HEC, please make sure they get some luncheon." She kissed both children on the head and left.

Isaac and Amelia both started talking at once.

"We have to decode that message!" said Isaac.

"It's going to take those signalmen ages to figure it out!" said Amelia. Isaac started writing the dots and dashes.

"It's not Morse code," he muttered. "It's something else."

"It's definitely a pattern," said Amelia, "But it doesn't make any sense. What does it mean?"

HEC studied the dots and dashes that Isaac was now scribbling furiously in his notebook, which he'd procured from a pocket in his rucksack. "It looks similar to the pattern I have seen on the punch cards that Professor Grimmelore uses to program me."

"If we had one of your punch cards we might be able to figure it out," said Isaac. "Let's see if we can decode the message."

HEC said, "I am sure I can spare one," as he opened his chest and produced a very small punch card with tiny little holes in it.

"The pattern on this card is very similar to the one in the signal. Now we just need to make some kind of decoder to decipher what the message says."

Build the Decoder Armguard

This is a simple but fun piece you can use to send secret messages to your friends. It is also really fun to use with the signaling periscope (see Chapter 5). But don't stop there. Once you figure out how to make this mechanism, you can adapt it to make control dials for loads of your own projects!

Materials

- 2 9 × 12-inch sheets of brown craft foam
- 1 sheet of full-page sticker paper or shipping label
- 1 9 × 12-inch sheet of black craft foam
- 1 9 × 12-inch sheet of thick black craft foam
- 1 roll of double-sided duct tape
- 1 roll of black duct tape
- 1 roll of wide, clear packing tape
- 1 50-count box of 3/4-inch paper fasteners
- 1 2-inch diameter, clear-top favor tin
- 1 yard of 1/2-inch wide braided elastic

Tools

- Copier or computer with printer
- Black permanent marker
- Scissors
- Awl, skewer, or nail
- Rotary punch
- Roll of wax paper
- Cutting board

Step 1: The Armguard Base

This is a convenient place to put your decoder. Grab two 9 × 12-inch sheets of brown craft foam and make them into one 9 × 12-inch sheet of Fleather. If you do not know what I am talking about, you may want to read "A Material to Make: Fleather—the Latest Thing in Mad Science!" in Chapter 2. It will tell you all about this wonder substance you will be using for many of the projects in this book.

Figure 4-1 shows the pattern for the decoder armguard base.

The files for all the patterns used for the projects in this book are provided online and to scale. You can download them from www.mhprofessional.com/steampunkadventurer.

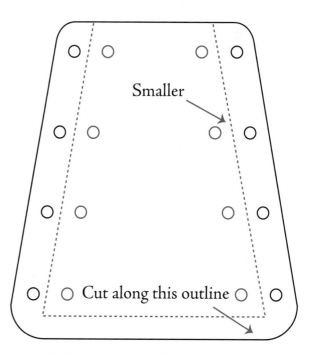

Smaller

Cut along this outline

FIGURE 4-1 Pattern for the decoder armguard base

Get the pattern named "Decoder Armguard Base" and cut it out along the outline labeled "Cut along this outline." Wrap the pattern around your arm, and if the sides meet, it's probably too big for you. In that case, cut along the dotted line labeled "Smaller." Don't forget to punch the holes, indicated by the little circles.

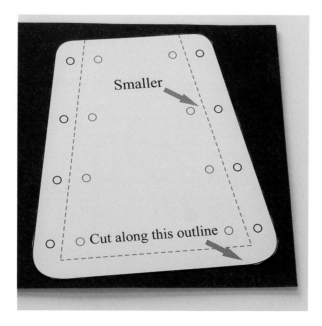

You can use a standard paper punch or your awl to punch the holes in your pattern, but you can also use a rotary punch. It's usually not easy to use this to punch holes in paper as it is too thin and might rip, but, if you take a scrap piece of craft foam and place it on the underside of the paper as you punch the holes, it will go right through with no problem.

Trace the pattern outline and holes onto the piece of 9 × 12-inch brown Fleather you made earlier. Cut along the outline. Punch your holes, with the rotary punch set on the largest setting.

When tracing this or any pattern, place the pattern as far to one side as possible, leaving behind the largest single piece you can so you will have more resources left over for other projects.

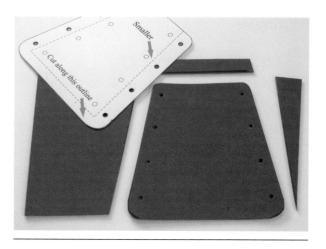

Step 2: Bits and Pieces

Figure 4-2 shows the patterns for the code base, code frame, decoder mount, and some other pieces.

If at all possible, print this on a full-page sticker. You can get these in a pack at the local office supply store or order them online. The decoder faces, Morse code plate, and the code wheel work best as stickers and sticky patterns don't slide about. Check to make sure you can peel off the patterns before applying them. If you can't get the full-sheet sticker stuff, some heavy card stock is the next best thing.

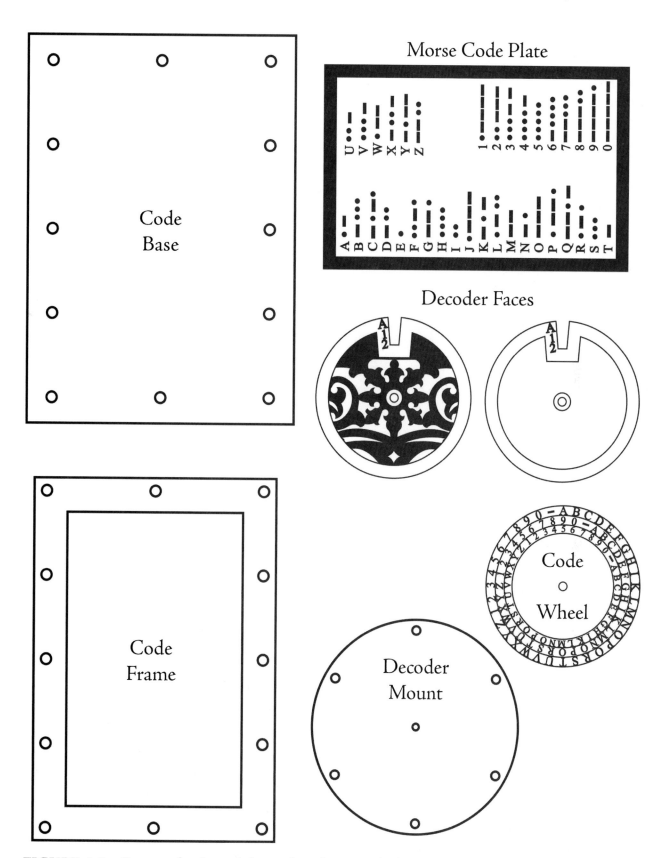

FIGURE 4-2 Patterns for the code base, plate, frame, and wheel, and the decoder mount and faces

Get the pattern shown in Figure 4-2 and cut out the pieces for the code base, code frame, and the decoder mount. If you use the rotary punch to punch the holes, set it on the smallest setting.

Cut a 9 × 12-inch sheet of black craft foam in half the short way, giving you two pieces measuring 6 × 9 inches. Cover one side of one piece with double-sided duct tape, thus making it into a sheet of black Fleather tape. Do not peel the backing yet. Trace the pattern for the decoder mount and the code frame onto the piece of Fleather tape.

Hint

You can use silver or white non-toxic paint marker to mark out pattern pieces on black craft foam, but they leave a light mark on the piece. Surprisingly, you can use a black marker and it will still show up, just barely, but if you are careful you can do it, and there is no light mark.

Carefully cut along the outlines of these pieces and punch the small holes. When cutting out the center of the code frame, it will be easier if you punch a medium-size hole in each corner, and use your scissors to connect the holes.

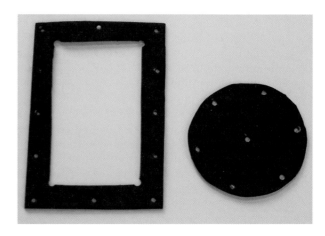

Cut a 9 × 12-inch sheet of tan craft foam in half the short way, giving you two pieces measuring 6 × 9 inches. Cover one side of one piece with double-sided duct tape, thus making it into a sheet of tan Fleather tape. Do not peel the backing yet. Trace the pattern for the code base onto the piece of Fleather tape and cut along the outlines of this piece and punch the small holes. You can now add this to your collection of parts.

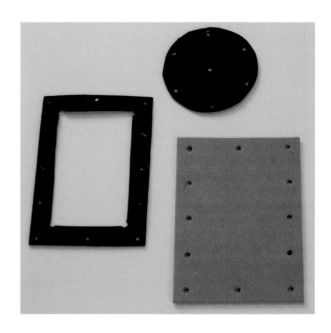

Step 3: The Code

It is almost time to cut out the graphics. Those are the pieces labeled "Morse Code Plate," "Decoder Faces," and "Code Wheel." Keep them all together on the piece of paper. Trim the piece so there is about 1/4 inch remaining around the sheet of graphics. Lay down a square piece of wax paper a bit larger than your sheet of graphics, to protect your work surface from the sticky stuff on the tape you are about to use.

You will notice there are two pieces labeled "Decoder Faces." One has a fancy piece of art on it and the other is mostly blank. The blank one is there for you to fill in with your own drawing if you want. If not, you can use the one that is ready to go. This is where you make that choice and fill in the face if you want.

Cover the front of the sheet of graphics with the wide, clear packing tape. Try to lay the pieces of tape down smoothly and with only a little overlap. I know you can't really see it, but the clear tape is on there in this picture.

Why are you covering the graphics with clear tape? That is quite a reasonable question. When you brush your fingers over the print on the graphics, they will eventually fade. The tape is there to protect the graphics and make them last longer. It's a quick and easy way to laminate them.

If you managed to get these printed on the full-sheet sticker or label paper, you are ready to just cut the outline of the Morse code plate. If you have them on card stock, turn the sheet over and back the whole piece with double-sided duct tape (you are going to either love or hate this stuff by the time you are done with this book). Now it's time to carefully cut out the graphic.

Peel the backing off the Morse code plate and place it centered on the code base; that's the tan piece. It should rather conveniently fit right between all those holes.

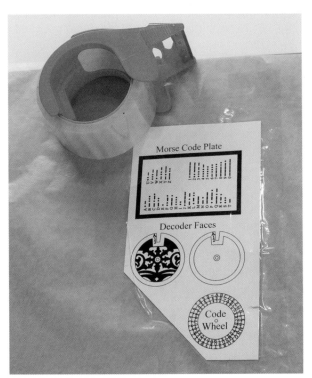

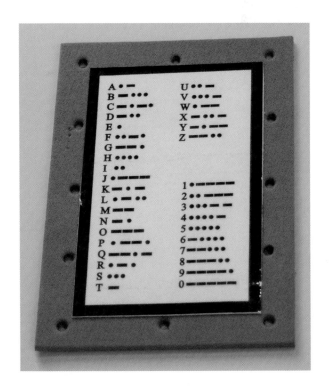

Peel the backing off the code frame and place it over the edge of the code plate around the code base. Be really careful! Use the holes to line the frame up where it goes. Take your time and do this right. This is the code assembly.

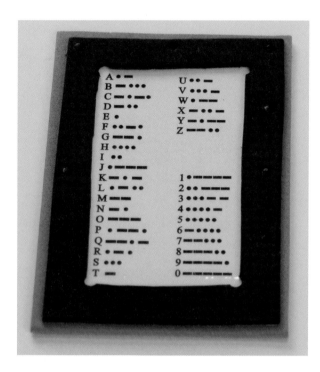

Peel the backing from the back of the code assembly and place it with the top of the code centered on the wrist end—that is the narrower

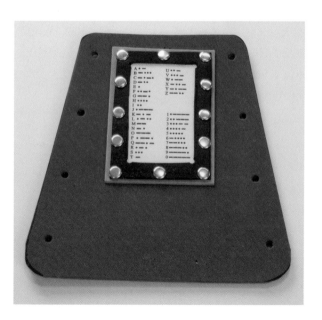

end—of the armguard base 1/2 inch from the edge. Use your awl or other pointy object to push the holes from the frame all the way through the back of the armguard base. Fill each of these holes with a 3/4-inch paper fastener.

Step 4: The Decoder Mechanism

Peel the backing from the decoder mount and place it centered on the base, but directly behind the code assembly, with one of the holes toward the widest end of the base. Use your awl to push the holes through the decoder mount and the back of the armguard base. Fill each of these holes with a 3/4-inch paper fastener.

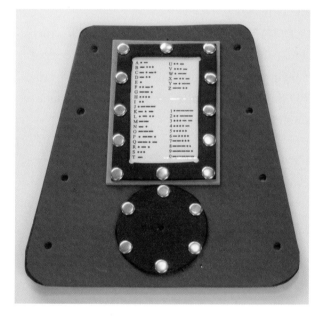

Put the armguard aside and grab your tin and a piece of 9 × 12-inch thick black craft foam. Place your foam on the table. Remove the top from the tin and place the tin, bottom up, on top of the foam, near one of the corners. Press the tin down on the foam; it will leave an impression from the rim of the tin. Cut this circle of foam out, and then make two more just like it.

Cover one side of each foam circle with double-sided duct tape and trim away any excess tape. You still have some black Fleather tape there somewhere: Use the tin to make an impression and cut out a disk of that, too.

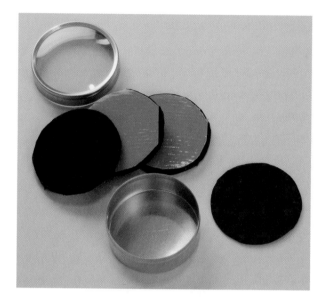

Cover the bottom of the tin with double-sided duct tape, and trim off any excess tape, but do not remove the backing. Place it on top of a piece of thick black craft foam. Place both of these on top of a cutting board. Remove the lid from the tin and set it aside. You are going to poke two holes, about 1 inch apart in the bottom of the tin. Use an awl or a nail for this, for I'm afraid a wooden skewer just

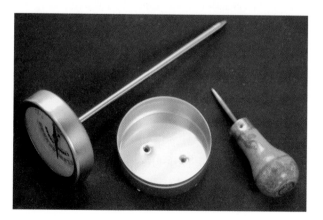

won't do it. I actually used a meat thermometer, yes, I really did. I put the point on the spot where I wanted a hole and tapped it gently with the palm of my hand.

Peel the backing from the bottom of the tin. Center the tin on the decoder mount and press firmly in the center of the tin to allow the tape to stick. Use your awl, skewer, or nail to drive the holes from the bottom of the tin through the mount and the base. Insert 3/4-inch paper fasteners through the holes, and spread them flat. You may have to use your pointy thing to widen the holes by moving it back and forth to accommodate your fasteners.

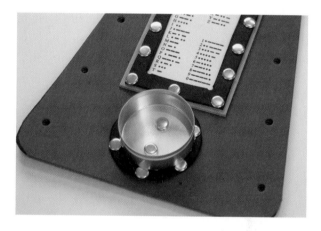

Peel the backing of one of the thick foam disks, and place the disk in the bottom of the tin. Peel the next disk and place it on top of the first. Peel and place the last on top of the second one. This should almost fill the tin. If it doesn't, make an extra disk or two from the Fleather tape and add them until they fill the tin.

Cut out the graphic labeled "Code Wheel" from the sheet. Peel the backing of the code wheel and place it centered on the disk of Fleather tape you recently cut. Punch the hole in the center with your rotary punch set at the smallest setting.

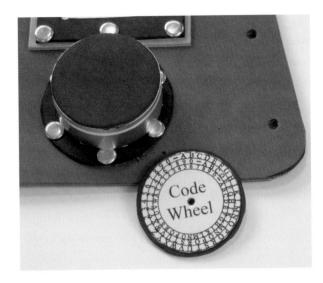

Cut out the graphic you selected from the ones labeled "Decoder Faces" and punch the tiny hole in the center. Don't forget to cut out the little notch at the top. That's the important bit!

Retrieve the lid from wherever you tossed it. Peel the back of the face and place it in the exact center of the lid.

Now do exactly as I ask, please: Punch a hole in the center of the lid, from the inside, with your rotary punch on the third smallest setting. If you are using a bigger tin, use your awl to make the hole if the rotary punch won't reach.

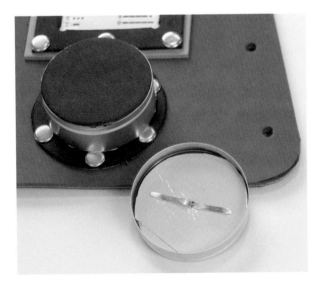

Place a 3/4-inch paper fastener through the front of the face, but do not separate the fastener parts on the back just yet.

Peel the back of the code wheel. Now run the fastener though the front of the code wheel, and now you can separate those parts of the fastener and stick them to the tape.

This is a very important part! So pay attention. Are you listening? Good. Place the lid on the tin, and push down; the lid should turn easily but not come off.

That's it. The mechanism is finished!

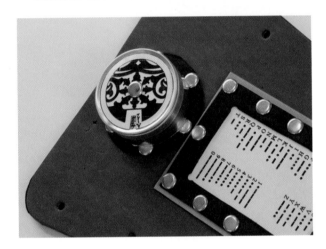

Step 5: Odds and Ends

There are so many backs of the fasteners on the underside that it probably looks like a torture device, so for safety and comfort, cover them with a layer of black duct tape. Then, take your braided elastic and lace the armguard like a shoe, from the wrist end to the other end. If you run into any difficulty pushing the elastic through the holes, use your awl or even a pen to push it through.

Embellishments. This is your first project, so I'm thinking: Keep it simple. I found some peel-and-stick fake half-pearls and placed them on the face of the device as buttons. You can add these all over, and some split brads to give it that riveted look that I like far too much.

I'm guessing this might be a good time to tell you how to use it. When you send or receive a message, the first thing you will send is a number, either 1 or 2. See the numbers 1 and 2 on the face? Those are the two different codes. Sending 1 means "Use code 1." I'm sure you get that. The top part of the little window on the face has the letter "A" next to it. This is for "Alphabet." If you receive a dot and two dashes, that is a "W" on the code. Turn the face of the decoder until a "W" is in the window next to the "A." If you are using code 1, that would mean that "W" stands for "T." For code 2, "W" stands for a "P". The "–" on the wheel is an extra-long space, meaning a new message.

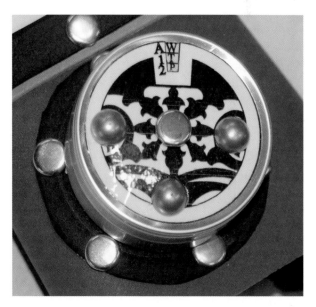

Our heroes now have their decoder, and what will the message say? Is it from the pirates or from Uncle Adrian?

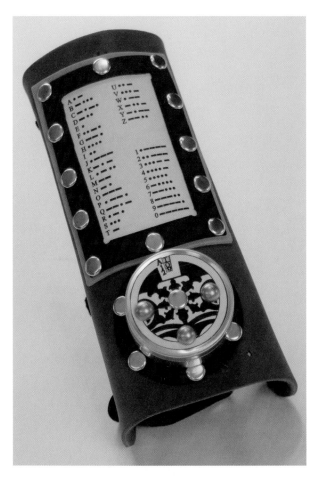

Chapter 5

Signaling Periscope
Wherein our heroes pass the message along

Isaac read out the decoded message. "Ship taken; not pirates; after the device; spy in department; from top north signal tower 287 deg at 15:00 send HEC Code 1889AG." When Isaac read out the code, HEC stiffened, emitted a tone, and his eyes started flashing brightly.

"Another code!" Isaac exclaimed, and started recording the new set of dots and dashes.

Once his eyes stopped flashing, HEC turned to the children and said, "My apologies. I seem to have a gap in my timer. What just happened?" The children told him about the new code. HEC sensibly suggested, "We should turn this information over to your parents."

Amelia said, "We can't do that."

Both HEC and Isaac turned their heads toward her.

Isaac said, "What? Are you crazy? Of course we are going to tell them!"

Amelia said, "No, we can't. Mum and Dad are constantly surrounded by people. Any one of them could be the spy. There is no way we will ever get either of them alone while they are trying to figure out what happened. If the spy finds out we know the attack was not the work of air pirates, we will probably lose any chance of ever seeing Uncle Adrian again. We have to send this message ourselves. Don't worry; there is no way this could end badly." She grabbed his hand and dragged him toward the door, "Come along, HEC."

Isaac's mouth still hung open in disbelief as the door closed behind them.

The hallway was empty, and the door at one end led out toward the north side of the airfield. Outside the door, the coast seemed to be clear, and they could see the tower just about one hundred yards away.

"I bet everyone is so busy looking up at the sky that they will never even notice us crossing the field to the signal tower," said Amelia.

Isaac disagreed. "More than likely, we will be caught and Mum and Dad will ship us off to a boarding school in Prussia."

"Don't be silly," Amelia said, "Prussian schools are not that bad. You are obviously confusing them with the Russian ones. I've read that those are actually quite miserable."

Isaac said, "Oh, joy."

Fortunately, Amelia was right and they reached the tower with no problem, except that the door was locked and it looked as if it had been locked awhile.

Isaac said, "See; now we must go back and find a way to tell Mum and Dad. I'm sure we…"

"HEC, can you open that door?" said Amelia.

"Yes, miss," stated HEC.

"Would you kindly do so?"

"Of course." HEC proceeded to twist the old lock off the door, and then punched it open. Other than a bit of dust and debris, the stairs were in good condition. The tower appeared to have only been decommissioned within the past year or so. They quickly ran up the stairs to the top. All the way, Isaac kept hoping that the signal gear was still at least roughly intact. Things never seem to work out that way though.

Isaac stared at the mount where the signaling device was once connected. "Now what are we going to do?"

"Can we just use a mirror or light to flash the signal?"

"I can't reach high enough over this wall to aim a mirror properly and a flashing light would attract too much attention."

"Can we put a mirror in HEC's hand and signal that way?"

"That won't work, either. He can reach high enough, but he still won't be able to see where he is aiming and we are still probably going to get caught. We need a directional signal that goes over the wall."

"You're supposed to be so clever; can't you come up with something?"

Isaac looked around at the abandoned remains of the original signal device and noticed bits of broken mirror and old water piping among them. "We need to make a signaling periscope."

Build the Signaling Periscope

This is a pretty simple project but I give you a word of caution: Scissors are a fairly safe way to cut things, but they do not work well on foam board. Foam board is the main construction material for this project. You are going to be using a craft knife with a very sharp edge to cut this stuff. If you do not feel comfortable doing this, get help from someone who is. I recommend you use a cutting board. They sell them at craft stores or even at thrift stores. You can even use a kitchen cutting board, but make sure it is one you never want to use for food.

Materials

- 1 20 × 30-inch sheet of black foam board
- 1 roll of black duct tape
- 1 roll of gold duct tape
- 2 3 × 3-inch mirrors
- Auto accessory lights
- Small compass

Tools

- Cutting board
- Craft knife
- Straightedge
- Black permanent marker
- Tape measure
- 1 box of ball-headed straight pins

Step 1: Cut Out Your Pieces

Place your 20 × 30-inch piece of black foam board on your cutting board, with the 30-inch edge going left and right. Measure and mark 2 3/4 inches in from the 20-inch edge at both the top and bottom of the piece. Place your straightedge at the marks and draw a line between them.

Hint

When cutting foam board with a craft knife in this manner, always mark the line on the foam board with a marker and a straightedge, then lay your straightedge over your mark and cut. This way you will know if the straightedge is moving and be able to ensure a straight cut.

Keep your straightedge in place and use your craft knife to cut along that line. You will need to cut two pieces this width, and two more pieces 3 1/2 inches wide. *Be very careful.* I can't say this enough. When you use your craft knife to cut these pieces, the wider the straightedge the better, and new, sharp blades are actually safer than dull ones.

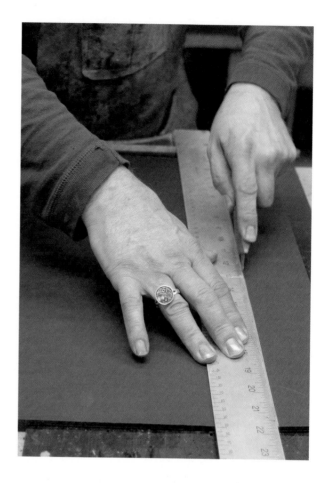

Cut both of the 2 3/4-inch wide pieces to 17 3/4 inches in length and the 3 1/2-inch wide pieces down to 18 inches.

Everything I've just explained is laid out very nicely for you to see in Figure 5-1. And to save you from having to do all kinds of confusing measurements to get the angle just as shown in the 17 3/4-inch piece, I've provided a pattern for the angled end (see Figure 5-2). You can download the file for that, and for Figure 5-1, from www.mhprofessional.com/steampunkadventurer.

Now that you have four long pieces of foam board, let's make a periscope!

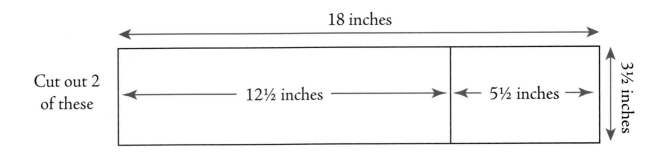

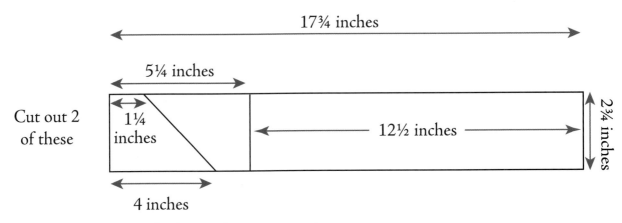

FIGURE 5-1 Layout for the signaling periscope pieces

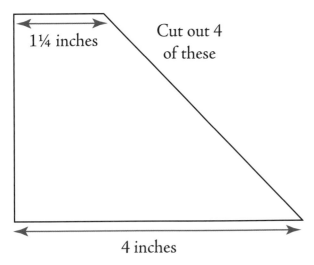

FIGURE 5-2 Pattern for the signaling periscope

Lay the pattern for the signaling end of the periscope on the end of one of the 2 3/4-inch wide pieces—even with the edges, like you see here—and mark the angled edge.

Then, turn the pattern around and place the angled edge of the pattern against the angle you just drew and mark the edge across the piece furthest from the end.

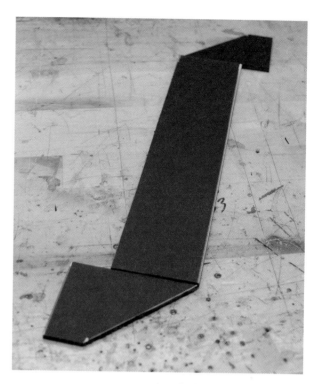

Cut both of those marks and you will have the three pieces shown in the illustration. Oh yes, you will of course wish to do this to both of the 2 3/4-inch wide pieces. Let's call the smaller ones the "head panels" and the larger one a "body panel."

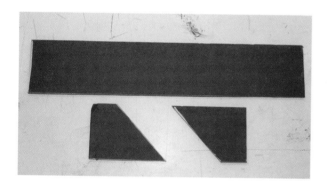

Step 2: Put the Pieces Together

Lay the pieces out in an "S" pattern as shown.

Use a piece of black duct tape to join the head panel to the body panel. Black duct tape gives you less interference and glare inside the periscope. Do this at both ends and keep them in an "S" shape.

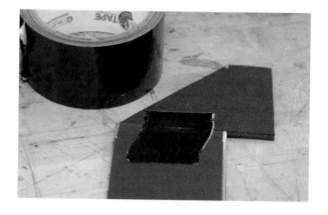

It's time to do the same thing to the other head panels and body panel, except your "S" will be backward. When both of them are taped and put next to each other, they should look like the illustration. These are now the "sides" of the periscope.

Now it is time to grab both 3 1/2-inch wide pieces. Measure, mark, and cut both of them to 12 1/2 inches. With one of the sides on the table, place one of the pieces you just cut, edge down on the table, against one of the body panels, and use

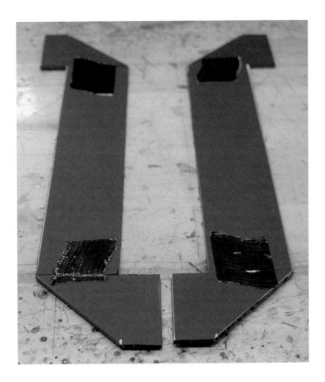

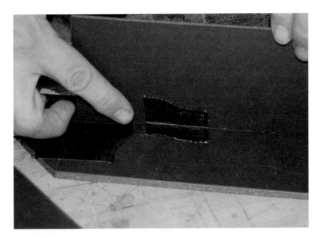

the ball-head pins to pin it in place, as shown next. About four pins should do. You only need to stick the pins in enough to hold the piece in place; no need to push them in all the way.

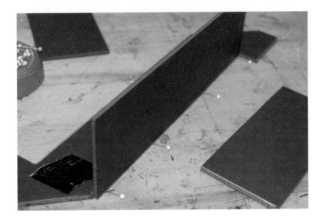

Tear off a piece of duct tape about 2 inches long and tape the inside of the sidepiece to the panel you have just pinned in place.

Do this in three places along where the pieces come together.

Measure from the outside of the panel you just taped in place to the edge of the head panel. You can use a measuring device or just hold the piece in place and mark it. Cut a piece of one of the remaining chunks of 3 1/2 × 5 1/2-inch foam board to that length. (I would just tell you what size piece to cut, but the foam board can be thicker or thinner, depending on what brand it is, so it is best to measure the space you actually have.) Either way it will be about 1 inch… and a bit.

Pin it in place; this time you will probably have to pin it from the inside. Use a piece of black duct tape to secure it. Don't forget to do this for the other end too.

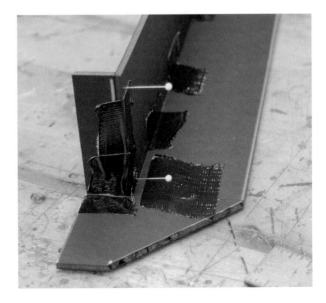

Now make the same measurement at the other end. Cut the piece and pin in place, then use duct tape to secure it.

Cut one 1 1/4-inch piece from each of the remaining pieces of the 3 1/2-inch foam board: Put the remaining pieces aside where you'll find them, because you're not quite done with them. The 1 1/4-inch pieces will be the very top and bottom pieces of the periscope. Pin and tape them in place as shown here.

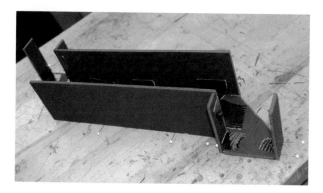

It's time to make the mirror mounting panels. From the remaining two pieces of 3 1/2-inch wide foam board you had set aside, cut two pieces 3 3/4 inches long. These are your mirror mounting panels. Select your two mirrors. If there are stickers, rubber feet, or anything like that on the back of them, please carefully remove them.

Next, cut a 2 × 2-inch (you don't have to be too accurate here) piece of double-sided duct tape and stick it to the back of each mirror. Then peel the backing from the tape and stick the mirrors, centered, on each mirror mounting panel. This is also a great time to clean your mirrors and get all the fingerprints off them.

Pin and tape the mirror mounting panels to the sidepiece in the same manner as the other panels, but make sure not to cover your mirror with tape. I know that is pretty obvious but you never know. This is a good time to mount that other 12 1/2 × 3 1/2-inch panel. It goes on just like the first one.

Hint

And now I am going to introduce an easy little technique to you. If you need to cut your duct tape down to make it narrower (as you will, in the next step), instead of trying to use your scissors, it may be easier to apply your duct tape right onto your clean cutting board. Then, use your straightedge and craft knife to cut it right down the middle or to whatever width you might need.

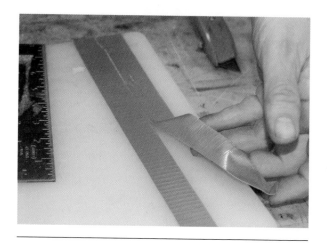

This is where you start taping it all together from the outside. Cut your gold duct tape in half and use these half-wide strips for the final assembly. Place the tape so that half the width is on one surface and the other half is on the one you wish to bind the first to.

When you come to a corner, it may help to make a cut into the edge of one side of the tape, as shown in the next illustration, to make it wrap smoothly.

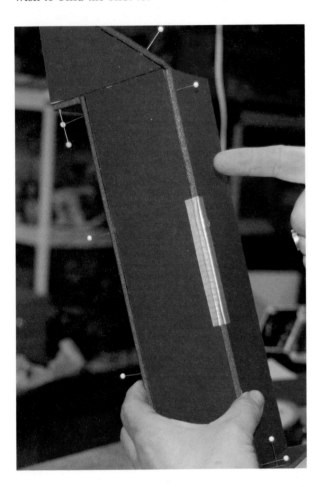

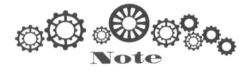

Note

As you can see, the gold duct tape is much more decorative and "brassy" than the black duct tape. In fact, this whole project could be even "steamier" if you could find brown foam board and perhaps use a marker to draw some wood grain onto the panels. I could not find any brown around here, but perhaps you will have better luck.

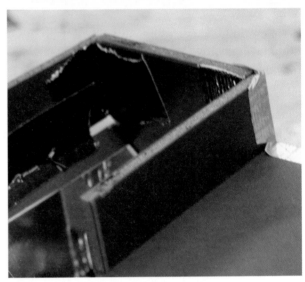

Step 3: Install the Lights

So, you have this thing all taped up but with one side open. Perfect. This is the time to install the signaling part of the signaling periscope. This is going to be so easy; you are going to want to put lights on everything!

The cool thing is that automotive stores and even some other stores with automotive departments now have a pretty good selection of pre-wired lighting. These things have the battery and the switch already hooked up. They are so good that I cannot imagine not wanting to use them. The set usually comes with two strips of LED lights, so when the package says "8 inches" on it, that means there are two 4-inch strips of lights. The good thing is they can be cut down to be shorter if necessary. They even have a little mark on the strips with a picture of a pair of scissors to show you where to cut. Always get them a little longer than the place you want to put them. They also have a very useful peel-and-stick backing. I picked up an 8-inch set for this project.

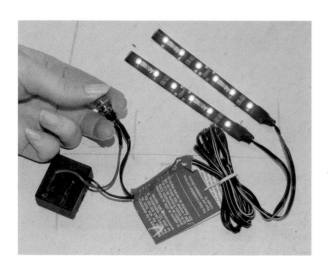

Decide which end will be the top opening of the periscope and measure its vertical length on the inside of the opening, along the sidepiece. Cut a 1/2-inch wide piece of scrap foam board the length of the inside of the top opening and use black duct tape to tape it in as shown. Be sure you make two of these pieces, because you will want one for the other side. These are where you will soon be mounting the lights, and they keep the light facing away from the mirrors so you are not blinded whenever you send a signal. Cut both of the light

strips to the length you need to fit on the piece of foam board you just installed. Peel the backing and apply the strip with the wired end toward the bottom of the periscope.

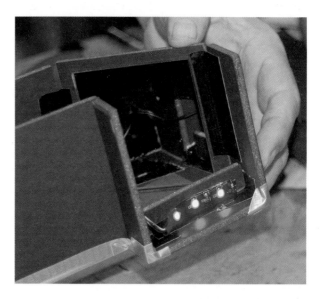

Run the wires connected to the switch and battery down the inside of the periscope to the bottom opening. At the bottom end, mark and make a notch in the top panel of the opening to accommodate the switch. This is a "momentary switch," so the light only goes on when you press it.

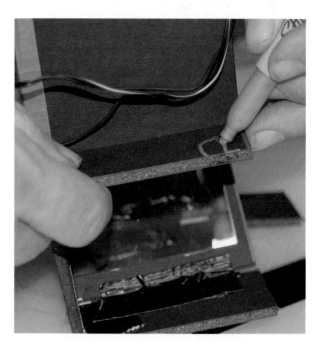

There is usually a small nut that helps hold the switch into a hole or, in this case, the notch you just made.

Run the wires leading to the battery through the space between the mirror mounting panel and the very bottom of the periscope. Use gold duct tape strips to secure the battery compartment to the bottom of the periscope.

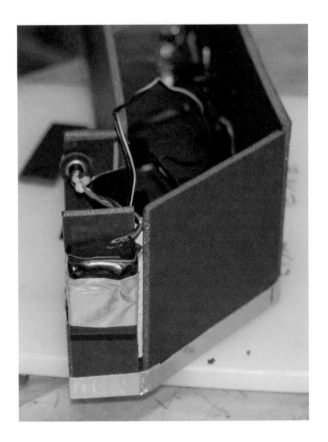

Tape the wires leading from the lights to the switch and battery down and out of the way with black duct tape so you get a clear line of sight from the bottom opening to the top one.

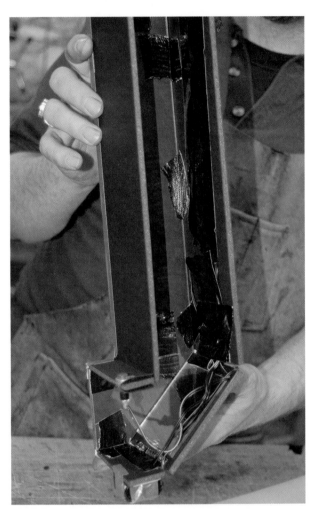

Step 4: Finish It Off

Time to close it up. But first…

This is the time to decide if you wish to add rivets or anything that needs holes poked through the sides of the body of this piece, because you are about to close it all up. I left it more sleek in the instruction,

but feel free to embellish as you wish; that's what all those extra split brads from previous projects are for.

Place the other (unattached) sidepiece within the panels just so the side surface is even with the edges of the panels. Use pins to hold the side in place and strips of gold duct tape to secure it.

Now you go crazy with gold duct tape, applying it to every edge, seam, and anywhere else you

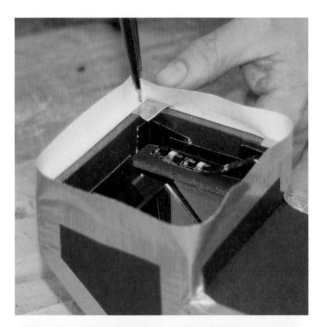

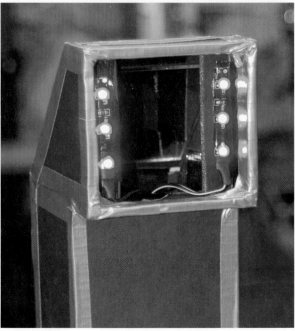

think it will look good. Don't forget to cut it in the corners so it will lie nicely.

It's a signaling periscope! But it needs a little something; I found this compass at the dollar store. I am just using a small piece of double-sided duct tape to secure it to the periscope. I also thought that a couple of mounting patches with valve handles on the side would give it a bit of mechanical fortitude.

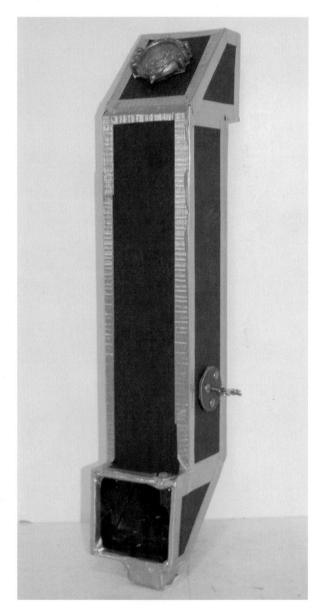

Now our heroes have the equipment to send the message, but who is on the receiving end?

Chapter 6

Goggles

Wherein our heroes prepare for a trip

Isaac pulled out the compass from his rucksack. HEC held the periscope while Isaac aimed it to 287 degrees. Isaac gave the notebook to his sister, who read off the dots and dashes for him to signal. When he was done, Amelia asked, "Can I see through the periscope?"

Isaac relinquished his place for his sister to have a look, while taking back his notebook. He asked, "Can we go back now? I would really like some tea."

HEC said, "I think that is an excellent idea."

Amelia called, "Wait! Someone is sending a signal back." She started shouting out dots and dashes, trusting her brother to write them down.

After he diligently wrote down the new code, he whined, "I was really looking forward to some tea."

"That was much shorter than our outgoing message."

"Maybe we will be lucky and it says, 'Well done. Have some tea.'"

"Let's put it through the decoder and find out what it really says." Isaac did so and gave a low, slightly whiny moan.

Amelia asked, "What's wrong?"

Isaac sighed and said while readying his pencil, "HEC Code 1876AG."

HEC dutifully stiffened, gave the same tone as before, and started blinking his eyes. Once the message stopped, HEC said, "My apologies. I seem to have a gap in my timer. What just happened?"

They returned to the waiting room to decode the message. As soon as they walked in, Isaac asked, "Can we please have some tea?"

HEC said, "Absolutely, sir," and left the room to make their tea.

Soon after, their mother walked in with the airman and others following, just as their tea was being placed on the table. "Oh, good, you are feeding the children. I am still coordinating the search for Adrian's ship."

At that moment, a woman in a major's uniform rushed in and handed Mrs. Griffith a note. She quickly read it and said, "Mummy's got to go. I will check in with you just before bedtime." She turned to HEC with a questioning look on her face and the children held their breath to see what she would ask him. HEC always answered truthfully and they dreaded the idea of their mother asking the wrong questions. "Are the children going to be all right?"

HEC answered, "Of course, they will. I shall see to it."

Mrs. Griffith said, "Excellent. Please get them some blankets and make sure they get some supper later. They will just have to stay here tonight." Then, she left with the crowd of functionaries in tow.

Amelia turned to Isaac. "Hurry! What does the message say?"

"Can't we eat first?"

"Come on, time could be very important. What does it say?"

"Give me a moment." He put down the piece of toast he was nibbling on and pulled the decoder from his sack. After a few minutes of work, with his sister staring at him the entire time, he announced with a frown that he was finished. "Done. It says, 'Meet me at the west end of the landing field of the Trenton supply depot at 23 hundred hours.' This was an emergency message left in HEC; there is no way it is meant for us. This is adult stuff and you are mad if you think we are going to Trenton! How would we even get there? It would take days! We have to go to Mum and Dad," Isaac insisted.

"We have already been through this. We don't know who the spy is and we have no way to figure it out. If the spy gets wind of our communication, we may never see Uncle Adrian again."

"But Trenton is a day's journey from here. There is no way we will get there by eleven tonight."

"It won't take that long. It is less than an hour by airship."

"What? An airship?"

"We are at an aeroport. I'm sure they can spare one."

HEC walked in with blankets for their bedding. Amelia turned to him and asked, "HEC, when is the next airship scheduled for Trenton?"

"There is a ship three times a day to the Trenton depot. The next one leaves at 20:00. It is a class three heavy cargo carrier."

"Perfect. We can to get to Trenton that way, correct?"

"Class three cargo carriers are not designed for passengers. They only have room for the pilot," he said.

"Can we ride in the hold?" she asked.

"It does not have a hold. It uses under-slung nets to carry cargo."

"So we can hang from the nets."

HEC was silent on this matter, hoping in his own mechanical way that this was not a question. Isaac, however, said, "Are you mental? I'm not hanging off an airship at a mile above the ground!"

"Don't worry. There is no way this can end badly," Amelia said

Isaac whined, "We'll freeze up there!"

Amelia turned to the voice of reason. "HEC, will we freeze up there?"

HEC replied, "Not if you wrap yourselves in these blankets."

"Is there anything else we will need?" she asked.

"It is quite windy when the airship reaches its cruising altitude. You will need goggles to protect your eyes," he said.

Amelia turned to her brother and said, "Then let's build some goggles."

Build the Goggles

People always ask me, "Why are goggles such a big thing in Steampunk?" The answer is quite simple. It's because goggles mean adventure is imminent! They are your protection from the explosions that will obviously be happening at any moment. Whether you're in the lab, aboard an airship, or driving an electro-coal motorized carriage, your goggles mean that you're ready for adventure at all times.

So in this chapter, we'll be making inexpensive, easy, and yet very wearable goggles.

Materials

- 1 12 × 9-inch sheet of Fleather (see Chapter 2)
- 1 yard of 1/2- to 3/4-inch braided elastic
- 2 2-inch diameter aluminum favor tins with clear lids, found in the bridal section of craft stores
- Brads, screw tops, small pieces of ornamentation (optional)
- 1 roll of double-sided duct tape

Tools

- Stapler (one with a short "nose" is preferable)
- Permanent marker
- Straightedge
- Scissors
- Tape measure
- Cellophane tape
- Awl, cooking skewer, or sharp nail (optional)

Step 1: Cut the Gasket Pieces

Get the pattern for the gasket (see Figure 6-1). You can download the file for the pattern at www.mhprofessional.com/steampunkadventurer. While

FIGURE 6-1 Pattern for goggles gasket

it is possible to use your teeth, a dueling saber, or a rotary saw, I recommend cutting it out with nice, sharp scissors.

Hint

See the sidebar "Resizing Any Pattern with Your Mad Scientist Math Skills" in Chapter 2 if the diameter of the tins you're using isn't 2 inches.

Take a tape measure, and mark 2 inches from the short edge of your Fleather at the top and bottom. Connect those points using a straightedge, and then cut along the line. Do this twice to get two pieces that are 2 inches wide and 9 inches long. Set the remaining piece of Fleather aside.

Center your pattern on one piece of Fleather and trace it; repeat with the second piece of Fleather.

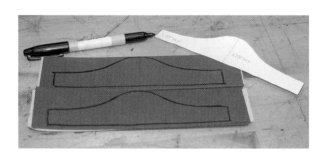

Hint

If you are worried about the pattern moving while your trace it, use cellophane tape to secure the pattern to the Fleather.

Use the scissors to cut the pattern from each piece of Fleather. Cut the ends slightly long in case your measurements are slightly off. You can always

trim down, but you can't add more. If your tins are bigger than two inches, simply make your piece long enough to fit.

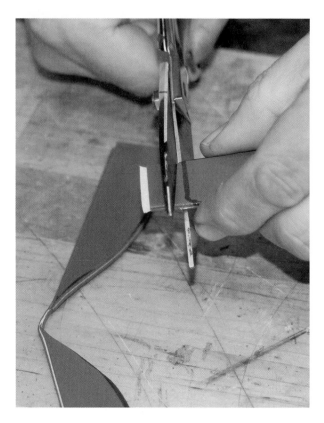

You now have two identical pieces that we will call "gaskets" from this point onward.

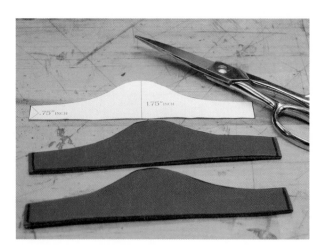

Step 2: Prepare the Lenses

Remove the clear lids from your favor tins. Put the bodies aside; they make marvelous storage boxes.

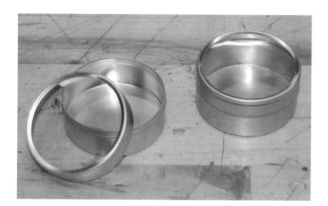

Cut a 2-inch long piece of the braided elastic. This will become the nosepiece, that bit that connects the two lenses. If there is a soft and pretty side, make sure it faces out. Fold over the final 1/4 inch of the braided elastic. Use a piece of the cellophane tape to secure the fold.

Place the elastic on the outside of one of the tins. Line up the elastic so that the fold is flush with the lens surface, and use another piece of cellophane tape to hold it in place temporarily.

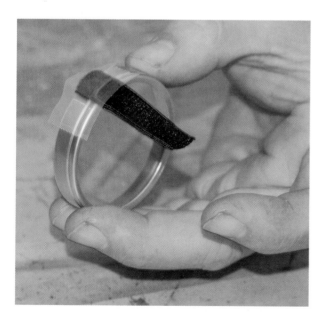

Staple the elastic to the tin. This is easiest to do if the head of the stapler is placed inside the tin. Peel off the tape.

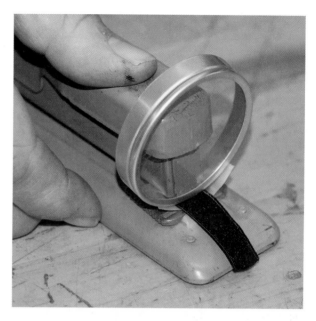

This part is why you will want a short-nosed stapler, because it will fit closer to the lens from the inside. (You can see the blue nose of the stapler on the left juts out farther than the nose of the gray stapler.)

Not so good stapler Good stapler

If threads get pulled off of the elastic, trim them; don't try to pull them out. The material is braided, so if you pull at the threads, it will unravel and you will have to start all over again, and I presume you want to start wearing these as soon as possible.

Fold over the other end of the elastic, tape it, and repeat the process, attaching it to the second

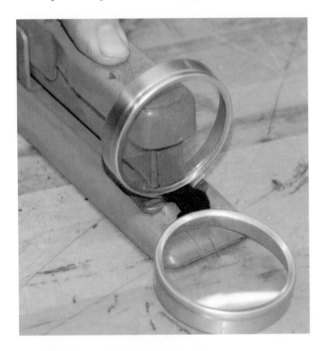

lens. Don't panic if it doesn't work perfectly. You can always take out the staple and try it again.

You can see that even now they are starting to look a bit "goggle-y." Onward!!!

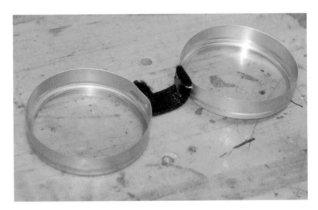

Cut two 12-inch sections of braided elastic. These will become the straps to keep the goggle on your head, or your hat. I hear that goggles on the hat are all the rage these days.

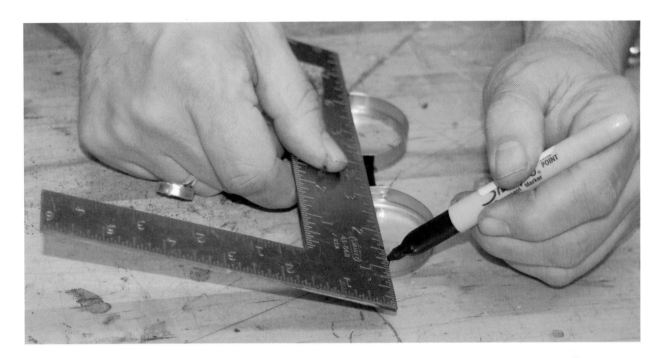

Lay your straightedge across the diameter of each lens and place a small mark on each outside edge directly across from the attachment point for the nosepiece. These marks indicate where to attach the straps.

Take one of your 12-inch sections of elastic and tape it to the lens on one of the marks you made across from the nosepiece. If you put your piece of cellophane tape across the elastic, right at the end, place the elastic so one of the long edges of the tape is even with the front of the lens. The main length of the elastic should be out in front of the

lenses. I know this may seem weird right now, but trust me, you will see how it goes. Repeat this for the other side.

Go ahead and staple the elastics to the lens rims and peel off the tape.

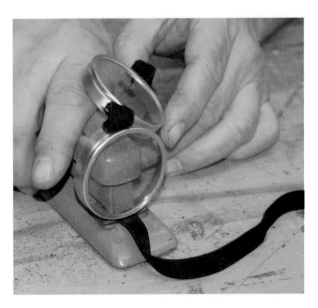

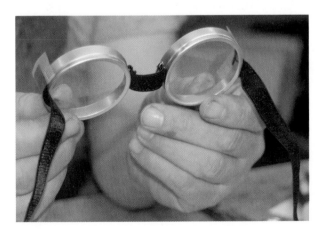

Step 3: Assemble the Gaskets and Lenses

Now it's time to assemble the gaskets. We'll complete one lens first, then you'll go back through these steps and complete the second lens.

Mark the center of the straight edge of the gasket piece and line it up with the center of one of the straps. The flat edge should be facing the front of the lens, and see that little indentation running around the lens rim? Try to line it up with that.

Fold the goggle strap back so it lies straight across the widest part of the gasket. Tape it down to keep it in place.

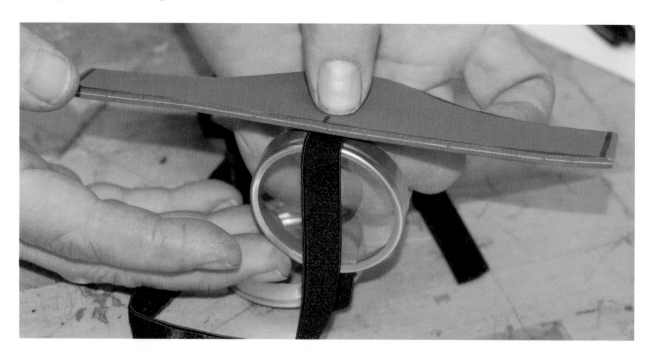

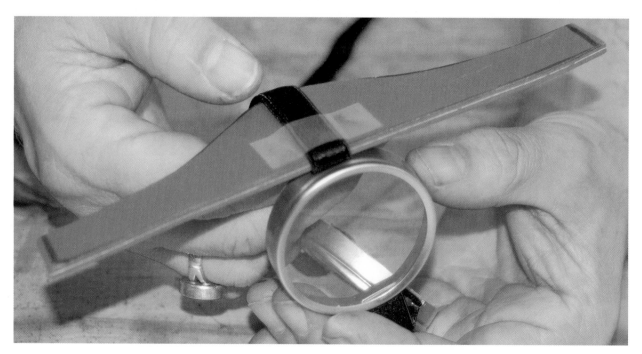

You guessed it! Time for you to use that stapler again. You are going to staple through the elastic, the gasket, and the aluminum lens frame, so you might have to push a bit harder than before.

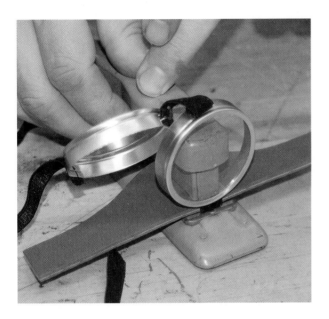

Carefully roll the gasket around the lens frame. The two ends should meet just in the middle of the nose strap. If the gasket ends are a little too long, just trim them a bit. You might wish to use small pieces of tape to help secure it. If it does not meet in the exact center of the nosepiece, seriously, don't worry about it. It will still look fine.

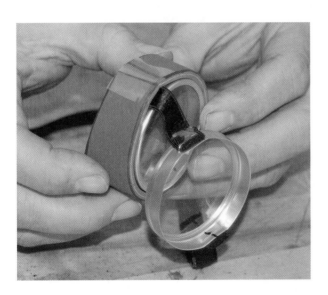

Line up the stapler where the gasket ends come together, just inside the lens, and staple it. Remember to try and keep the straight edge of the gasket even with the indent in the lens frame. Staple it once more about 1/4 inch in from the back edge of the gasket.

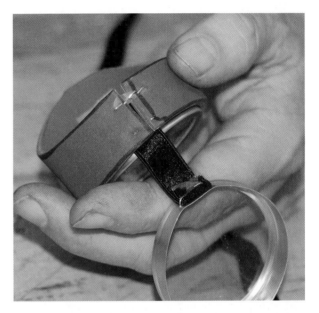

Rotate the lens frame and gasket about 90 degrees and staple the gasket to the lens frame right up close to the lens.

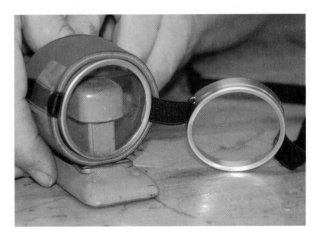

Then rotate it again and staple the gasket directly across from where you just stapled it.

Put a second staple to secure the strap to the gasket toward the rear to prevent unseemly

flopping and to make the joint stronger. Remove the tape.

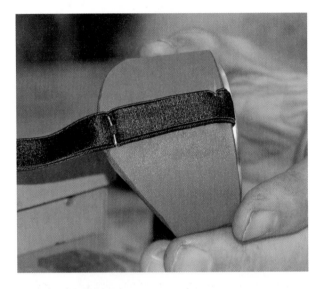

Now repeat all these steps to attach the other gasket to the other lens frame.

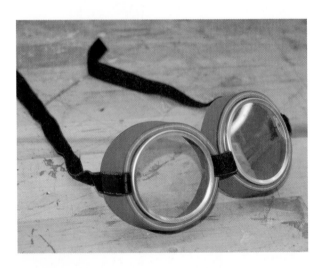

At this point, you are finished! Well, I mean you could stop here. All you have to do is put them on your head, tie off the elastic, and you have a perfectly wearable set of goggles.

However, you might find that your goggles are looking a bit plain, and perhaps you wish to give them your own personal touch. I always encourage this! Steampunk is all about being creative and putting your personal touch on your Mad Science!

Step 4: Embellish Your Goggles

You can use a standard permanent marker to draw filigree or other designs on the Fleather. Either make your own, or search the Internet for inspiring examples! Make sure to test your markers though, because not all types of markers work well with the Fleather. Remember, you can also use rubber stamps (see the "Embellishments" section in Chapter 2).

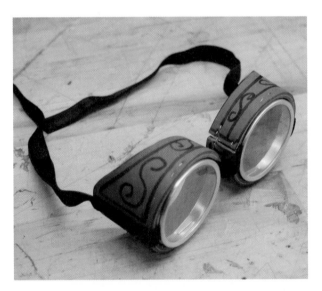

If you want to get even more ornate, you can use an awl, skewer, or even a sharp nail to punch holes in your gaskets.

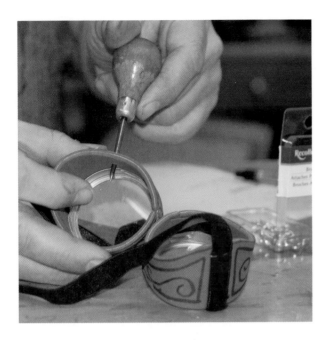

I usually recommend flat-head screws for Steampunk projects because the Phillips-head screw was not invented until the early 1930s by Henry Phillips. But if you want to use them, don't let that stop you.

Brads can be used to give the effect of rivet heads, and flat-head screw tops will add a more mechanical feel.

As I said before, be creative! The nice thing about these goggles being so easy to make is that you can create a number of pairs and try a different decorating technique with each of them! Enjoy your adventure!

Isaac and Amelia have their goggles ready and can now proceed with their adventure. Let's just hope they make it to Trenton on time! And who is it they are meeting there, anyway?

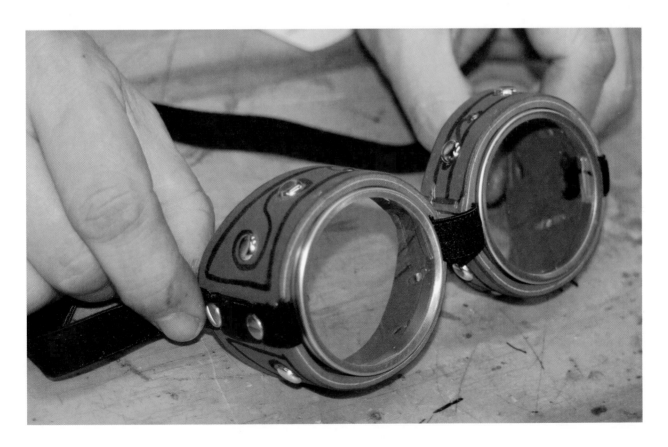

Chapter 7

Grappling Hook Launcher
Wherein our heroes get a lift

"We cannot leave until Mum tucks us in at 9 P.M.," said Isaac as he snatched a final biscuit from the tray left from dinner.

Like clockwork, Anna and Alexander Griffith came in to see about their children and wish them goodnight at exactly 9 P.M. As the door closed behind them, Isaac felt relief wash over him. He was finally going to be alone with his parents. The realization that he would not be falling to his death from the bottom of an airship later that night nearly made him jump out of bed. Amelia actually looked a bit disappointed.

Anna began to lean over Isaac. "Get some sleep. I know it has been terribly exciting but—"

"Mum, Dad, I have to tell you—"

Just then, Ensign Willoughby knocked on the door while opening it. Isaac almost shouted one of those words that taste like soap. "Madam Griffith, they have found the wreckage of the second interceptor. Admiral Pike requests your attention," he said, then waited for her.

"Yes, Ensign Willloughby, I will be right with you. What is it, Isaac?"

Isaac wanted to tell them everything, but what if Amelia was right? Anyone could be the spy.

"Isaac is still afraid of the dark!" Amelia blurted out, a bit too enthusiastically.

"You are? My poor dear, don't worry, we can leave a lamp on if—"

"What? No, I am not afraid of the dark! Amelia, what are you doing?" he yelled in a bit of a panic.

"All right, we will leave a lamp on low for you just the same. Both of you get some rest; you have school tomorrow."

Isaac asked incredulously, "You expect us to go to school tomorrow?"

In unison his parents said, "Yes." Then they went over to Amelia. They looked down on her and she looked up serenely. "Are you all right, dear?" asked Mr. Griffith.

She looked up at them skeptically. "Of course, I am fine."

"Ah. Well, don't worry, either of you," said Mr. Griffith. "We will find your Uncle Adrian."

As their parents went to leave, they asked HEC to come with them.

Amelia called out, "Mum, could you leave HEC here?"

Their parents stopped dead. Mrs. Griffith asked, "Why?"

Amelia said in her typically fearless tone, "I think Isaac would feel better with him here."

Isaac stifled the urge to throw something at his sister. Their parents looked at him for a moment, and then at each other. Mrs. Griffith gave a nod to Mr. Griffith and said, "All right, we will leave him here if it will make you feel better."

Amelia said, "Yes, yes! That would be great. Thank you."

Their parents said "Goodnight" in unison and closed the door.

Isaac waited a moment, then burst into a harsh whisper, "What is wrong with you?"

"I had to say something. You were being no help at all," Amelia insisted.

Isaac said, "I was trying to think of something clever to say."

Amelia said, "We did not have time for that. It would have taken all night and they would have left with HEC."

They pushed down their blankets to reveal that they were fully clothed and ready for the next part of their ill-advised adventure. They put their goggles onto their foreheads, rolled up their blankets, and tucked them under their arms.

As they walked toward the airfield, they could see the airship was tied down at post number five. It had dropped its incoming load and was waiting for any return cargo. Two large automatons were loading the cargo net.

"This is perfect. We will just sneak over to the loading area and climb into the net," Amelia said. "Nobody will notice us at all."

"Are you just going to slap a shipping tag on each of us?" asked Isaac.

Amelia stared at him for a moment, then at the blanket under his arm and at two small, discarded shipping crates next the loading area. He said, "Now I know you are crazy."

HEC approached the pilot compartment of the airship just as the pilot finished lashing himself in and the last bit of return cargo had been loaded into the net. "I am under orders to escort and deliver these two crates to the depot at Trenton." This was technically a true statement as Isaac had ordered him to do this, but he did say "please" first. The pilot gave the automaton an exasperated look.

"You will have to load them yourself and strap yourself in, or I will be late for liftoff."

HEC said, "Thank you, sir," and quickly walked to the back of the ship. There he carefully set down the crates and unwrapped the children.

Amelia nimbly climbed into the cargo net. HEC loaded the crates, and then climbed in afterward. Isaac was dragged up by HEC.

HEC said, "You might want to pull your goggles down now and wrap yourselves up. We are about to lift off."

They heard the hum as the charge to the helium expander increased and the airship firmly but gently pulled skyward. As the ground dropped away, so did Isaac's stomach. He could see the string of green-lit towers leading away to the northwest, probably to the Trenton depot. His sister was hanging half out of the net to see where they were going, so he looked at the engines and instantly felt better as his mind started removing each bolt and

quite accurately estimating how the whole thing was constructed. He had no idea how he did this; it just came naturally.

Just about the time that Isaac had redesigned the engine, to where he could almost guarantee at least 14 percent more power, Amelia shook him out of his thoughts.

"We are almost there."

Isaac hazarded a glance toward the ground. He could see the tops of dark trees rise in the night as the hum of the expander began to fade and they descended. By the time the ship landed, both of the children were repacked in their crates and quickly being unloaded and hauled away by HEC. The automaton unwrapped them both behind a warehouse next to the landing field.

They arrived at 22:54 hours and had only six minutes to meet their contact at the west end of the landing field.

Isaac pulled out his compass, "HEC, could you light this for me?"

"Of course, sir." And a light glow from his eyes illuminated the compass.

"That way." Isaac pointed toward some oddly shaped shadows with a green glow about them just under one of the navigation beacons at the edge of the field. As they walked he asked, "I just want to make sure I have this right. We have no idea who we are meeting and we do not know if they are a friend of Uncle Adrian's or possibly one of the people who took him. Have I missed anything?"

Amelia replied, "Yes, you left out the part about meeting them in a yard for derelict airships with plenty of places to hide and ambush us."

Isaac turned from her toward the shadows. The slowly flashing green light made them look hideous as the effect seemed to make the doors move and things look out of every port hole. When they got to the edge of the Airship Graveyard, Isaac stopped walking.

"Could they have chosen a creepier place to meet us? HEC, please don't let anything too bad happen to us."

HEC hissed slightly, spread his feet just a bit, and began to hunch down as his eyes turned from their usual pale yellow to red.

Then a woman's voice with a posh British accent came from one of the derelicts. "No, I could not find a creepier place to meet, and I really did try." HEC turned quickly and in an uncharacteristically aggressive manner toward the sound, as if he were going to attack. "Oh HEC, my dear, please do behave yourself. HEC Code 1877AG."

Upon hearing this, HEC stood up straight. His eyes turned back to yellow and he quickly yet gently grabbed one arm of each of the children. Then, his eyes went completely dark. Amelia tried to pull herself loose for just a second and then, realizing there was no chance of getting free, became immediately calm.

Isaac yelled at HEC while dangling slightly from one arm, and poking at the automaton with his free hand, "Let go! LET GO OF ME!"

"He will do nothing of the sort. HEC is completely shut down. Who are you both?" said the lady in an accusatory tone as she came out from the shadows. As she approached, her

tone softened considerably. "Why, you're just children. What on earth are you doing out here? Where are your parents? My god, they must be worried sick about you!" She seemed to be genuinely concerned as she holstered something she had been carrying in her right hand and approached them. "Are you orphans?" she asked as she got close enough for them to see her in the dim green light.

"No! I am Amelia Griffith and that is my brother."

"I *do* have a name. I'm Isaac Griffith."

"Griffith? I know–"

"And you already know HEC," Isaac interrupted, as HEC's eyes lit green and he released both of the children. Then, he quickly clamped both hands on to the lady's wrists.

"No! HEC CODE 1877, stop!" cried the lady, as she struggled.

"He can't hear you. In fact, he can't hear anything. While you were talking, I fiddled with a few controls on his rear panel, turned off his ears, and instructed him to let us go and grab the next person he sees."

Amelia walked up to the lady and said, "I'm sorry our introductions were so rudely interrupted. I believe you were about to tell us who you are?"

The lady was remarkably calm, given the turn of situation. "I was just about to tell you that I know your parents, Anna and Alexander. You are Adrian's niece and nephew. I am Professor Isadora Maelstromme."

"Mum and Dad are going to kill us!!!!" exclaimed Isaac, as he rushed to HEC's rear control panel.

"They are not going to kill us. I can't even get them to lock you in the attic. Why are you so worried all of a sudden?"

"This is Professor Maelstromme; the one that Mum and Dad talked about; the one who works with Uncle Adrian. She invented the helium expander!" he said just as he got HEC to release the professor's wrists.

"Oh, yes, she is quite important, but she started it."

"Thank you. Now that we have all of that out of the way, I must ask again, what on earth are you doing here? Where are your parents, or an agent from DARC?" the professor asked just as HEC spoke up.

"My apologies, I seem to have a gap in my timer. What just happened?"

"Sorry, HEC, I'll tell you later," Amelia said. "We got your message to meet us here. We need your help to rescue Uncle Adrian."

"I knew when I received that message from HEC's memory that Adrian had been captured by someone," said Professor Maelstromme. "We have been working on something called the Icarus Device. The helium expander works by boosting the negative charge on the outer part of the helium particles. The increased like charges repel each other, like when you try and put two north ends of a magnet together. This causes the helium to expand, taking up more space with less weight and drastically increasing its lift, making our airships much more practical.

"The Icarus Device cancels the effect of a helium expander and causes any airship near it to crash. At present, it is rather unstable and occasionally causes the opposite effect, making the helium explode. Any country with that power would rule the skies. I was working with Adrian on perfecting the device. So now they want to capture me, too.

"My sources tell me he was captured by Dr. Charles Claremont and is being held in an airship circling a navigation tower in the Pocono Mountains. At dawn they will head west to meet with some mysterious organization. I'm not sure which one. He plans on selling the device, Professor Grimmelore, and myself, to them. Here are the coordinates and my notes. Get this to your parents so they can figure out what to do."

Amelia said, "Yes, right away. Is there anything else we should tell them?"

Isaac opened his mouth to tell Professor Maelstromme about the spy, but Amelia shot him the "don't say a word" look.

"I really must leave now. Remember, take those to your parents as soon as you can."

"Wait! Where are you going?" demanded Isaac.

"I'm afraid I cannot allow myself to be caught." At this, she dodged away into the jumble of old airships. "Good luck to all of you," Professor Maelstromme called to them.

They could soon hear the sound of a steam car racing off into the night. Just as the sound faded, they turned as they heard the cargo ship's engines grow louder. It was leaving. There was no way they could catch it before it left the ground.

Isaac asked, "How are we going to get back and give this to Mum and Dad?"

HEC said, "The next supply ship to Lakehurst will be at 06:00."

Amelia said, "We aren't going to Lakehurst. We are going to the Poconos."

"Are you deranged? You told her we were giving this to our parents," said Isaac.

"She never would have given us the information if we had told here we were going after that airship ourselves, and since we still don't know who the spy is, we are the only ones who can help Uncle Adrian."

"How are we going to do that when we don't have any way to get to wherever he is?"

Suddenly, HEC turned, walked away toward a hulking, heavy lift automaton that was moving cargo. There was a sudden burst of noise and flashing eyes. HEC returned and said, "The next airship to arrive is scheduled in 19 minutes at the East Landing Field."

Amelia said, "Excellent. We can use that ship."

Isaac said, "Who is going to fly it? It's not a taxi. They are not going to just take us wherever we want to go."

HEC said, "I am programmed with the basics of aeronautical navigation and control systems."

Amelia said, "See. There is no way this can end badly. Let's get to the East Landing Field."

They walked over to the field to wait for the next airship to arrive.

Isaac said, "The crew is not going to just let us take their ship."

Amelia said, "We will figure out what to do once we are on the ship."

After a few minutes, the ship appeared out of the darkness. It stopped over the reservoir near the landing field and just hovered there for a bit. Then, they saw the airship was not going to land at all but instead dropped down a large hose.

Isaac said, "It's not landing."

Amelia said, "I can see that. We have to get up there! Unless you want to be here all night, you better think of something."

Isaac closed his eyes for a moment. The airship appeared in his mind, the distance from the ground, the weight of the children and HEC. Images came into view and a design appeared. "Oh, we just need a grappling hook and a way to launch it. I can make one from the parts in the airship graveyard."

Amelia said, "Of course you can. HEC, let's help him."

Make the Grappling Hook Launcher

I love this thing because it costs next to nothing to build and it is cool to carry around. People always ask, "Does that work?" and you blow into the tube and the grappling hook goes flying.

Materials

- 1 5-foot section of 1/2-inch PVC "feed pipe"
- 2 caps for 1/2-inch PVC pipe
- 2 T-couplings for 1/2-inch PVC pipe
- 2 45-degree couplings for 1/2-inch PVC pipe
- 1 3/4-inch to 1/2-inch PVC reducer coupling
- 1 piece of black foam pipe insulation for 1/2-inch pipe
- 1 roll of black duct tape
- 1 roll of double-sided duct tape
- 2 sheets of 1/4-inch thick black craft foam
- 1 12 × 18-inch sheet of tan craft foam
- 1 12 × 18-inch sheet of brown craft foam
- 1 12 × 18-inch sheet of black craft foam
- 1 100-count box of brass split brads

Tools

- Permanent marker
- Hacksaw
- Straightedge or ruler
- Scissors
- Rag

Step 1: Cut Your Pipe Sections

Mark and cut with the hacksaw the following pieces from your 1/2-inch pipe: 1 9-inch, 1 7-inch, 4 3-inch, 1 2-inch. Use a rag to wipe all the little fuzzy bits off the sections after you cut them.

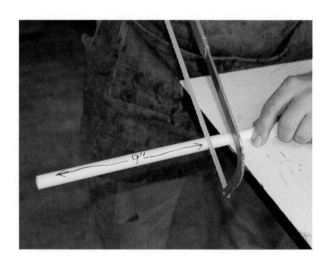

A metal cutting blade on a hacksaw is best, as it will easily cut the pipe and is rather unlikely to cut you. You should, of course, still be careful.

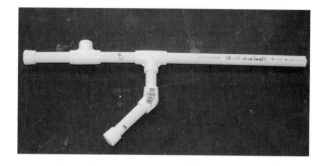

Step 2: Assemble the Launcher Mechanism

Push a 1/2-inch cap onto one end of the 3-inch piece, and a 1/2-inch T-coupling on the other end. Insert another 3-inch piece into the T-coupling directly across from the first. Insert this assembly into another T-coupling and insert the 9-inch piece into the hole directly across from that. Make sure the remaining openings on the T-couplings are pointing out from opposite sides of the whole assembly. Does it look like the picture? Good.

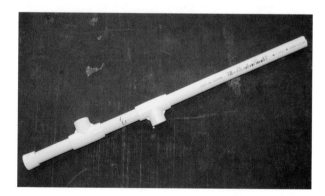

Insert the 2-inch piece of pipe into the remaining opening of the T connected to the 9-inch piece. Put a 45-degree 1/2-inch coupling on the end of that, with the remaining opening toward the capped end of the assembly. Push a cap onto a 3-inch section of pipe and insert the other end into the 45-degree coupling. You just put the handle on the launcher.

Step 3: Flesh It Out

Cut a piece of the black insulation foam 8 1/2 inches long. Take a look at it and find the slit running the length of the foam: it's not cut all the way through. Use your finger to open it up the whole length of the piece you cut off. Slide it over the back end of the launcher; that's the end with the cap on it behind the handle. Place it on your table with the handle up. You are going to want to push the foam forward so you need to notch it to go around the T. Mark the width of the T, and about an inch back from the leading edge of the insulation. Remove the insulation and use your scissors to cut this out, then slide the insulation back on to the launcher.

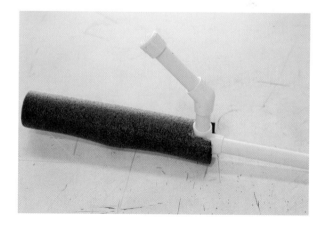

Turn the whole thing over: See the piece sticking up through the slit in the insulation? Mark a semicircle large enough to accommodate the T, remove the insulation, then notch the insulation, and replace it on the assembly to check the fit. Cut

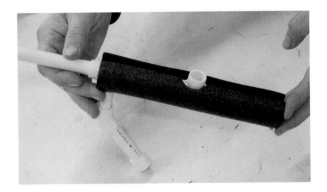

some more if you must; you will be covering this up later anyway.

Remove the insulation again. Wrap the part of the T that sticks up through the insulation with black duct tape and cut off the excess that sticks up. Use the permanent marker to color the top of the T fitting black. Then replace the insulation.

Measure the distance from the back edge of the part of the T sticking up from the insulation and cut a piece of duct tape that length. Pinch the gap in the insulation closed and tape it in place. Do the same for the gap in front of the T.

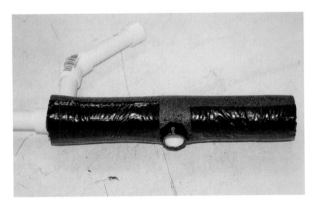

Now, to flesh out the handle just a bit. Make a 12-inch long and 3/4-inch wide strip of Fleather tape. Wrap one layer of Fleather tape around each of the pipe sections of the handle. This will make the pipe sections roughly the same diameter as the couplings so you'll end up with a even, flat handle. You may have to cut a piece in half the long way to get it to fit. Place the tape so the seams are all toward the front of the launcher.

Cut two 9 × 3/4-inch pieces of thick black craft foam, and back them with double-sided duct tape. Peel and place the first one around the profile of the handle, starting at the back just below the insulation, down around the bottom and up the front. Then, cut a piece to fit from just under the forward part of the T to the end of the first piece of craft foam. This way the two pieces will meet on a piece of PVC, which is stronger than having them meet on foam.

Make a piece of brown Fleather at least 4 × 12 inches. Lay the handle of the launcher on top of it and trace around the handle. Then flip the launcher and trace the other side.

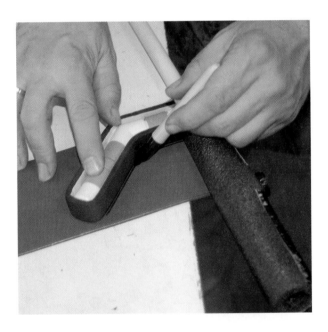

You have just traced the handle sides. Draw a line about 1/8 inch inside the one you traced: This will be the line to follow when you cut out the handle sides with your scissors.

After cutting out the handles, apply double-sided duct tape to the side you just marked, and trim off any excess tape. Peel the duct tape backing from the handle side and place it on one side of the handle. Then do the same to the other side of the handle.

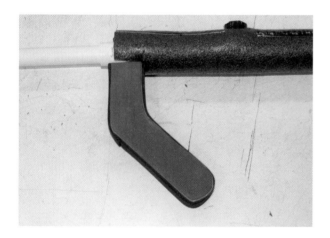

Make a 12 × 1/2-inch wide piece of tan Fleather tape. Run this down the center of the black part of the handle from the front under the T around the bottom and up the back. It should be pretty close to the insulation when you are done.

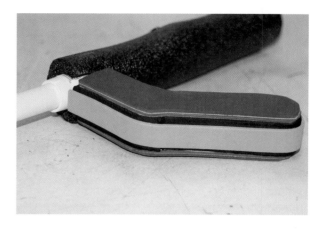

Step 4: The Tank

You are going to make the part with the insulation look like an air tank that holds the compressed air used to launch the grappling hook.

Make a piece of tan Fleather tape 2 1/2 inches wide and at least as long as the insulation, and mark the center point on one short end. This piece will be used to make the underside of the tank. Do not peel the tape yet! You need to notch it to fit around the back of the handle and end up flush with the front of the insulation. Place the launcher on its side and the tan Fleather tape on top of it with one short edge at the front edge of the insulation and the rest trailing off toward the back of the assembly. Mark the location of the backmost

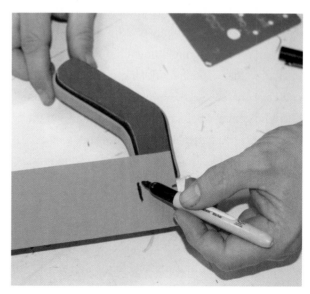

side of the handle in from that middle point mark you just made a moment ago. This way the notch will line up centered on the bottom of the tank.

Roll the launcher so the handle is sticking up. Using your center mark on the short edge of the Fleather tape, center that edge against the back of the handle, and mark the sides of the handle as shown in the illustration.

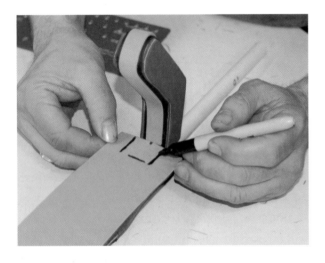

Cut those lines to make the notch in the lower tank piece to accommodate the handle. Do not peel it yet! Place the lower tank piece onto the insulation, with the handle fitted into the notch. Mark the back end of the insulation on the lower tank piece and trim off the excess Fleather so that it just covers the insulation from one end to the other. Remove the lower tank piece. With the handle still pointing up, look straight down the back of the insulation and make a mark straight back from the center of the handle. Use your straightedge to help keep the center when you make your mark on the insulation. Then, measure the lower tank piece's short side—the one without the notch—and mark the center of that (this is the back end of the lower tank).

Now you can peel the backing off the lower tank piece and place it on the insulation with the notch around the handle and the mark at the back

matching the mark on the insulation. Press it all down nice and smooth. I'm sure that what you have looks even better than the picture!

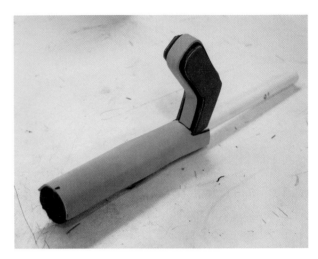

Let's make the upper tank piece. Measure around the exposed insulation from one of the lower tank edges to the other. If you are using the same materials I am using it will be just a bit under 2 1/2 inches, now subtract about 1/8 inch, which makes it a little narrower so the pieces will not overlap when applied. Now measure the insulation the long way. My piece is 8 3/8 inches long. Whatever your measurement is, make a rectangle of black Fleather tape that size. This is now the "upper tank" piece.

You are going to have to put a hole in the upper tank to accommodate the hole on the T that will stick out the top of the tank. You could do all kinds of measurements, you could guess, or you could do it the easy way. Let's try that one, shall we?

Put the launcher on the table with the handle hanging over the edge and the tank fully supported. Place the upper tank piece centered over the launcher with the back lined up with the back of the insulation and the tape side up. Gently but firmly press on the Fleather, over the hole on the T.

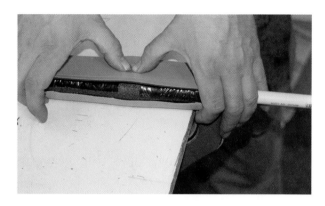

When you turn it over, you will see the impression of the T hole. Mark and cut this hole.

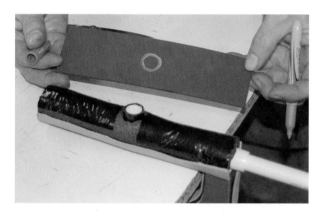

Do not peel the tape just yet. Test fit the piece by sliding it over the hole and make sure the back and sides line up. Adjust it if you need to. Don't worry if there are little gaps on the sides of the tank; you're going to cover them later.

Peel the tape and apply the top of the tank piece. Press it down nice and firm.

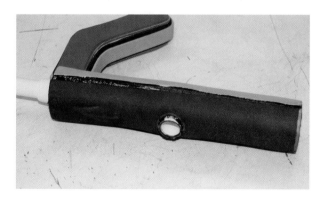

Make a 6 × 9-inch sheet of black Fleather and lay it flat on the table. Place the launcher with the back end of the tank, on top of the Fleather, near one corner. Trace around the tank and draw an "X" on the circle of Fleather. Cut it out just inside the line and check to make sure it just covers the back of the tank, with nothing sticking out. Repeat this so you have two round pieces of black Fleather. The "X" is so you can tell them apart later.

Put one without the "X" aside for the moment and make the other look like a round patch or a mount patch by adding some split brads and maybe something in the middle. I used a key I found in the scrapbooking aisle at the hobby store. Back it with some double-sided duct tape. You may notice that it is probably not perfectly round, so when you peel and stick it to the back of the tank, make sure you first rotate it to fit correctly.

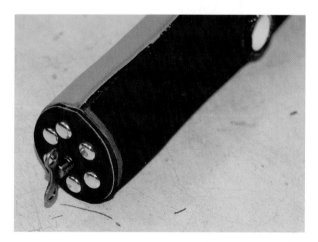

Remember how you notched the lower tank piece to accommodate the handle? You are going to do the same thing on the front of the tank. Select the round piece of black Fleather with the "X" on it that you had set aside; this is now the "tank front" piece. You are going to notch it using the same technique you used to accommodate the hole on the top of the tank. Remove the 9-inch pipe piece from the assembly. Press the T hole just above the front of the handle into the center of the

tank front on the side without the "X". This will leave an impression; mark the impression and make two lines from the edge of the inner circle to the outer edge. This way you are cutting a "U" out of the piece and end up with a piece that looks a bit like a horseshoe. Cut a little, then test the fit and if you have to, cut some more. Take your time. When it looks like it will fit around the protruding part of the T, cut the tips off the pointy ends of the "U" to accommodate the top of the handle. Then add some split brads and apply some double-sided duct tape to the back. Trim the excess tape and it should look a lot like this.

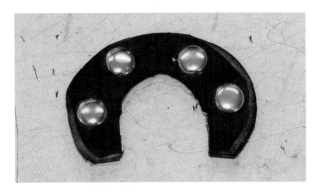

While the 9-inch section of pipe is off the front of the launcher, color the bit of the T sticking out the front with your black marker. Let that dry for about 10 minutes so you don't get it everywhere.

Peel the tank front and stick it on the front end of the tank.

While that is drying, make three strips of rivet tape (see Chapter 2), 1/2 inch wide and 12 inches long, with one "rivet," or split brad, every inch. Measure around the back end of the tank and cut a piece from one of the 12-inch pieces that length.

Wrap it around the tank with one long edge even with the end of the tank. I recommend starting at the bottom of the lower tank (tan side) so the seam where the two ends meet will be less noticeable.

Measure and cut a piece to fit around the front end of the tank. Apply it even with the front edge, starting at one side of the handle, around the upper tank, to the other side of the handle. Cut the other two pieces of rivet tape to fit, covering the seams down the sides of the tank so it looks like this.

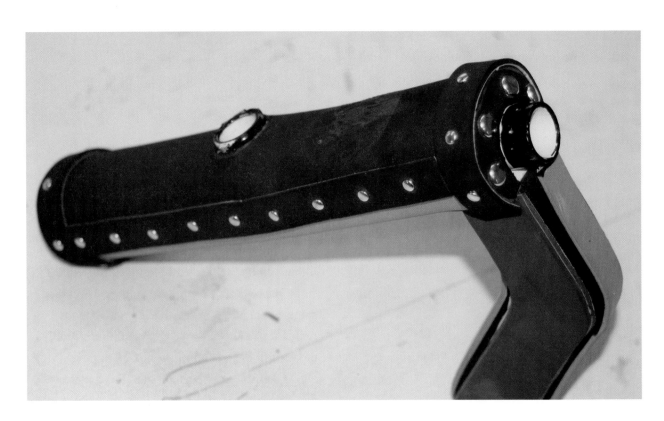

Remember those remaining pieces of pipe, and the couplings? Take the 3-inch piece of pipe and press it into the 45-degree couplings. Put the 7-inch section of pipe in the other side of the 45-degree coupling. If there is a label on the 3/4-inch to 1/2-inch reducer coupling, peel it off, then push the 1/2-inch side (with the smaller hole) of the reducer onto the end of the 7-inch pipe.

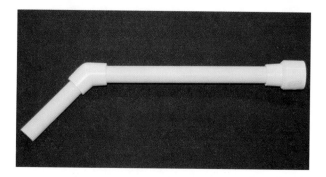

Color the bottom inch or so of the 3-inch piece with the black marker and let it dry completely.

Make two pieces of tan Fleather tape 1/2 inch wide and 18 inches long (by the way, you could substitute that with three pieces 12 inches long if that works better). Starting about 1/2 inch up from the bottom of the 3-inch piece of pipe, wrap the pipe with the 1/2-inch Fleather tape in a spiral pattern, pressing it down on the pipe as you go. Do this all the way up the tube; it should reach just below the reducer. You can make a piece of black Fleather tape 1 1/2 inches wide and at least 2 1/2 inches long to wrap just below the reducer, or you might just have a big enough piece left over from earlier.

Push the black end (the 3-inch pipe) of this assembly, which we will now call the mouthpiece, into the hole on the upper tank, with the top of the mouthpiece angled away from the front of the tank. Push the 9-inch pipe back into the front of the launcher.

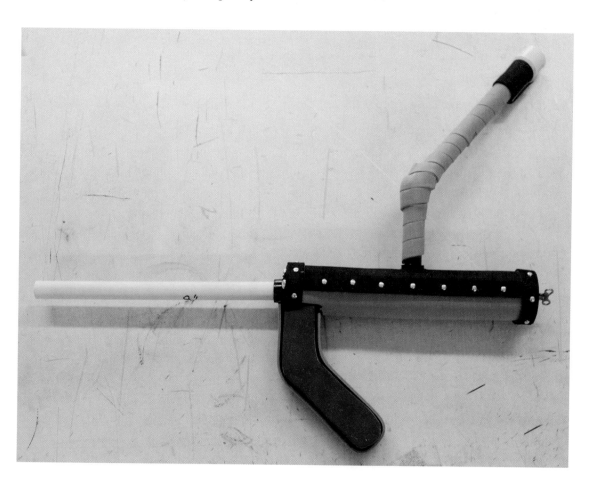

Step 5: The Grappling Hook

The launcher is nearly ready; now you need something to launch.

The pattern shown in Figure 7-1 is for what we will be calling the tines of the grappling hook. There are two pieces to the tines, conveniently named #1 and #2. See those two labels with the words "For #1 Cut Out" and "For #2 Cut Out"? Well, it will all make much more sense soon.

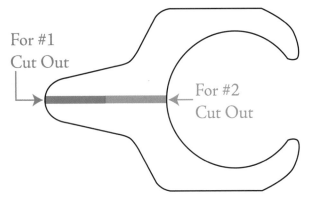

FIGURE 7-1 Pattern for grappling hook tines

Get the pattern and create two copies. (Remember, you can download the file for the pattern at www.mhprofessional.com/ steampunkadventurer.) Cut out the patterns. On one of them, you will cut out the rectangle at the tip (#1 cut out); and the other, you will cut out the rectangle on the inside (#2 cut out). If you lay

them side by side, they should just barely fit on a sheet of 9 × 12-inch, black 1/4-inch thick craft foam.

Trace the patterns onto the craft foam and carefully cut them out with your scissors so you have these two lovely pieces.

The slots you cut into each of them allow you to fit them together, so go ahead and test fit them. When they fit properly, the tips should meet and the part on the inside should be even. It's all right

if you need to cut the slots a bit deeper. Even if you overcut a tiny bit, it won't hurt anything.

Step 6: The Shaft

Measure and cut a 10-inch section of the pipe insulation. Choose an end—it does not matter which one—to be the tip. There is a slit straight down one side of the insulation. Put a mark 3 inches down from the tip along the slit. While looking at the tip of the insulation, you will make a mark directly across from the slit. And two more at right angles to the first two, as if you are making an "X" on top.

At each of those marks, draw a line 3 inches long straight back along the insulation shaft.

Cut along those lines so you are putting a point on each section. Let's be real fancy, and cut some of the thickness of the insulation near the point so it looks like this.

You can use a black marker and still see the lines. I used a silver marker just so you can see what I am doing better.

Cut straight down those lines. Now the tip of the shaft is in four sections. Make a mark in the middle of the end of each section and draw lines from that mark to the end of each 3-inch cut on all the sections.

You can probably guess what happens next. Push the shaft onto the tines by placing it inside the tines and pushing the sections of the tines down between the points.

Take about 18 inches of black duct tape and cut down the center the long way. (See the Hint in Step 2 of Chapter 5 for an easy way to do this.) This can be in shorter pieces that add up to about 18 inches. Cut those longer pieces into a bunch of 3- to 4-inch pieces. These smaller pieces are much easier to handle than long pieces of tape. Press the sections of the shaft down on the tines and tape them in place. Run some tape up to the tip of the grappling hook. Do this for all four sections and trim off the excess tape.

Try and keep the forward parts of the tines lined up so it forms an "X" when you look at it on end. Take a few small pieces of tape and seal the places where the shaft runs along the tines. Run some tape down to cover the slit, from the tip to the

back of the shaft. You should now have a grappling hook!

Slide the grappling hook onto the 9-inch pipe part of the launcher. There might be a bit of the white pipe that still shows. Let's fix that, shall we? Mark the place where the back of the grappling hook ends on the launcher pipe.

Measure from the front of the black T opening to the mark, and add a little bit to that to round it up. Mine came out to 1 1/4 inches, so I'm making it 1 1/2 inches. Now, make or scrounge a piece of Fleather tape as wide as your measurement and long enough to go around the pipe. Peel it, stick it, and press it.

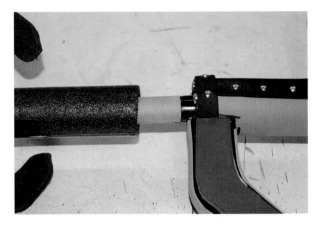

You now have a functioning Grappling Hook Launcher!

Here is the cool part: Put the grappling hook on the tube on the front of the launcher, and make sure it fits loosely. Point it away from everyone and anything valuable, blow hard into the mouthpiece at the top, and the grappling hook should fly off!

Step 7: Embellishments

I know you want to make this even more incredible. Here are a couple of suggestions. Try a mounting patch on the upper tank, between the handle and the mouthpiece. That will look like a pressure control valve. Add two large split brads on round pieces of Fleather tape near the bottom of each side of the handle to act as extra grips.

SAFETY WARNING

This may be one of the most important safety warnings in this book. The fact is that, in making this piece look so good, it also looks dangerous. Do not take it outside and start waving it around as you may cause alarm. Do not point it at anyone.

The Grappling Hook Launcher is complete, and just in time! That airship is not going to just wait around for Amelia and Isaac! They might only get one shot at this. Will they make it onboard? And how will they convince the crew to take them where they need to go?

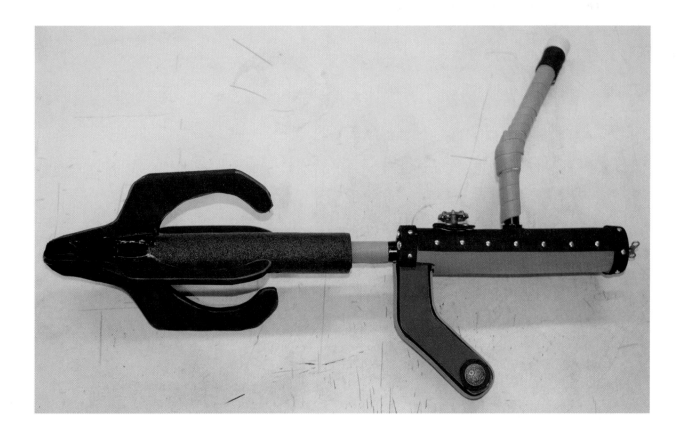

Chapter 8

Airship Harness
Wherein our heroes fly by night

"If we wait until just before they leave, the crew might not notice the pull of three extra passengers," said Isaac.

Amelia asked, "HEC, can you tell when they are about to depart?"

HEC said, "It will presumably be when they pull the hose from the reservoir."

Amelia waited until the hose started to disappear into the airship and fired the grappling hook into the lower hatch, where it caught on a rung of the ladder inside. She handed the grappling hook launcher to HEC, who connected the cable to a reeling device in his arm. She grabbed onto him, while pulling Isaac to her. Isaac grabbed onto HEC and hoped his sister wasn't as crazy as he suspected. Surprisingly, they survived the ascent and got into the airship through the hatch and up the ladder.

Isaac looked around, waiting for the crew to catch them. "How are we going to convince the pilot and crew to go to these coordinates?"

Amelia looked at HEC. "HEC, can you make the pilot take us where we want to go?"

"I can try to make a convincing argument but unless they attempt to directly harm you, I cannot harm them, so I may be incapable of forcing their cooperation," he replied.

Isaac said, "Well, that doesn't sound too promising."

Amelia said, "I know what I will say." She mimicked a plaintive voice, "I am a poor little stowaway and I need to get back to my mommy in the Poconos. Please help me." She proceeded to walk toward the bridge. Isaac reluctantly followed, trying, with every step, to come up with a better plan.

When they got onto the bridge, there was no pilot to be seen, just a huge metal box in the center of the floor with mechanical arms sticking out of it, clicking and clanking away, pulling levers and steering the ship. Isaac brightened because his sister's dreadful idea was not necessary. He went to the control box, examined it for a moment, and put the new coordinates into the piloting device. The ship slowly changed course.

They settled in for their flight. Amelia was looking out the windows as Isaac crawled all over the piloting device. He said, "This is amazing. It must be experimental. I've never seen such a thing. It's an automaton pilot. This makes sense. Most airships need to follow the light towers to fly at night. This automaton does not require seeing where it is going. It

works mostly on its compass and altimeter, so it can go wherever it's told, even if there are no towers." He looked over every nut and bolt of the device.

Amelia said, "Hey, I think there is something wrong; we are starting to head back east."

Isaac quickly ran to the control panel. The automaton had reset to the previous destination. He entered the new destination again. "I must not have done it right the first time." Then, he went back to his inspection of the fascinating machine.

About a half an hour later, Isaac was still staring at the machine. It was unusual because he could not just look at it and see how it worked.

Amelia said, "Hey, it is doing it again!"

Isaac said, "What? I know I put the coordinates in correctly this time. There must be some kind of fail-safe to keep people from commandeering the ship." He entered the coordinate again. "Let me see if I can fix this. HEC, can you tell me anything about this machine?"

HEC went over to it and examined it for a moment. HEC said, "It does not have a face."

Amelia asked, "What does that have to do with anything?"

HEC said, "Most automatons can communicate very quickly through visual semaphores by blinking our eyes and making various tones. This one only has a control panel. It is terribly antisocial. I cannot speak to it."

Isaac adjusted the controls and said, "I think I've got it this time." They waited for another half hour and Amelia began to yawn. It was quite past their bedtime. Isaac said, "Oh good. It didn't reset."

Amelia asked, "HEC, can you watch it while we rest?"

HEC dutifully responded, "Of course, I will wake you when we arrive in 37 minutes."

Amelia and Isaac sat in the empty pilot and copilot seats and closed their eyes. A few times one of the automaton pilot's arms brushed past them while it made minor adjustments, stirring them from their nap.

It felt like no time had passed when HEC woke them by announcing he could see the lights of a heavy-cruiser class airship circling above a navigation tower.

Amelia said, "That's probably it. I don't see any other ships around here."

Isaac asked, "What are we going to do now? And how are we going to get aboard?"

"Oh, that's the easy part!" Amelia said, "If we come in above and behind them, we should be able to lower ourselves down right on top of them."

Isaac wanted to say that would be a really crazy idea, but he knew that this whole adventure had gone way too far to try and throw sanity into it at this late point, so instead he asked, "With what?"

Amelia said, "We could use the hose attachment."

Isaac said, "That won't work. The hose is made of rubberized and oiled leather. It will be slick and hard to hang onto. We should have been thinking about this during our flight. Let's check and see what we have in the ship."

After a few minutes of going through the hold and taking inventory of what they found, Amelia said, "We have about a hundred feet of rope, various airship repair materials, and a huge crate of little dolls with big heads that wobble."

Isaac suggested, "I could build a glider to get us down."

Amelia said, "Why does it always have to be so complicated with you? One of us can be lowered down to the other ship's top hatch, and then tie a rope to the safety-line bolt. Then, the other two can slide down the rope."

Isaac said, "You do know that will leave us all stranded on that cruiser."

Amelia said, "We will just have to find a way off that ship when the time comes, but perhaps we can make a harness out of the safety restraints from the pilot and copilot seats."

As they were discussing this, the ship gave a jolt as it insistently tried to correct its course again.

Isaac went over to the automaton pilot to convince it to cooperate again while HEC and Amelia started removing the safety restraints from the chairs so they could quickly make a harness.

Make an Airship Harness

An airship harness, which is something you would use to lower someone down from an airship, or hang your tools at the ready, is essential equipment for the Steampunk adventurer. You will be using this design a few more times later on in the story.

Hint

I'm making this one rather small. When you make yours, check the fit every once in a while by trying it on, and add or subtract a few inches here and there to get it to fit just right. You can splice the straps together to make them any length you desire.

Materials

- 2 12 × 18-inch sheets of brown craft foam
- 1 "O" ring, 2 inches in diameter
- 1 roll of double-sided duct tape
- 1 roll of black duct tape
- 1 box of medium split brads
- 1 50-count box of 3/4-inch paper fasteners
- 1 1 1/4-inch belt buckle
- 2 1-inch belt buckles

Tools

- Scissors
- Tape measure
- Paint or permanent marker
- Straightedge or ruler
- Rotary hole punch
- Awl, skewer, or nail for poking holes

Hint

Your piece may look more professional if your "O" rings, buckles, and other hardware appear to be of the same type of metal—brass, copper, silver, etc.

Step 1: Make a Strap

The first part you need to make is the belt. Measure around your chest, just below the ribs. Be sure to add about 6 inches, so you can have some overlap. I'm going to make a belt for someone with a 28-inch rib cage, so the belt will be 34 inches long. Measure the width of your buckle on the inside, where the belt goes through. In this case, assume the inside of the buckle measures 1 1/4 inches wide.

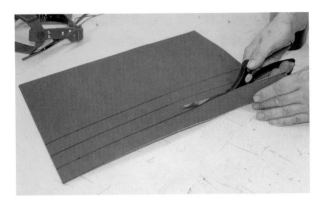

Since there is no way one 18-inch piece is going to be long enough to go around someone, you are going to have to connect at least two pieces, end to end. How do you do that? you might ask. Easy.

From one of the pieces, cut two sections 3 inches long. Trim about 1/4 inch off the corners of both. On the front of one of the 3-inch pieces, measure and mark a pair of holes 1/4 inch from each end, and another pair of holes 1 inch from each end. Next, apply a 1 × 2-inch piece of double-sided duct tape to the center of the back of both pieces.

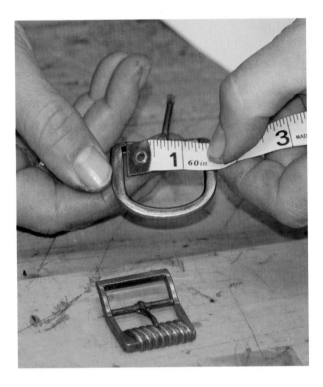

Use the two 12 × 18-inch sheets of brown craft foam to make one 12 × 18-inch sheet of reinforced Fleather with your double-sided duct tape and a final layer of black duct tape on one side (see Chapter 2 if you need to review how to make reinforced Fleather).

Measure and cut three strips 1 1/4 inches wide and 18 inches long from this sheet of Fleather. If the belt needs to be just a bit bigger, you should, of course, cut more.

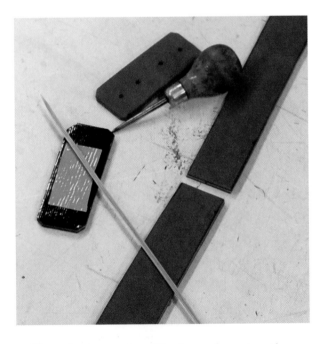

Place the two ends of the long pieces together, peel the backing off the 3-inch pieces, and

sandwich the belt pieces between them. Use your awl or skewer to poke through the holes you marked. Make sure you go through all three layers.

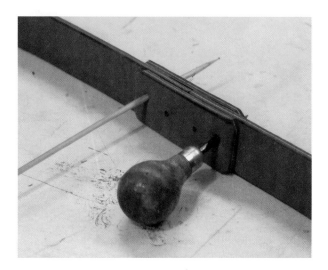

Insert a 3/4-inch paper fastener in each hole. Cover the backs of each fastener with a piece of black duct tape. See how easy that was?

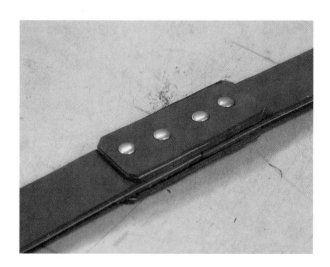

With this and any other project, covering the backs of the fasteners and split brads with a bit of tape when you can makes them less likely to be scratchy and more likely to stay put.

Step 2: From Strap to Belt

You need a buckle to make it a belt, otherwise all you have is a strap and that is not very impressive at all, now, is it? If your buckle is about the same size as mine, measure back from one end of the strap 2 1/2 inches, and put a small mark right in the center. Draw a line about 3/4 inch long with your mark in the middle of it.

Set your rotary punch to the largest size and punch a hole at each end of the line you just drew. Take your scissors and make two cuts along the line, connecting the edges of the two holes. This will give you a very oblong slot.

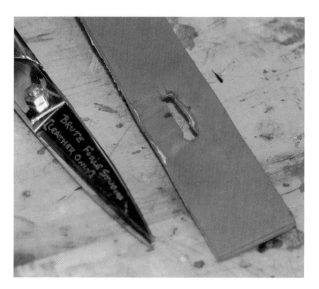

Trim the corners off the end of the strap. This makes it look more like something you made on purpose and less like you just chopped the end off of a part of an old coat or something.

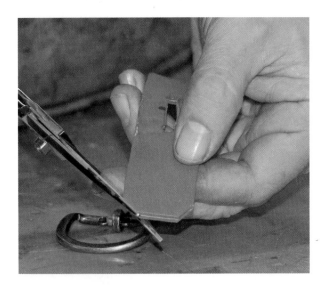

Insert the "tongue" of the buckle—the long, thin, pointy part—through the hole you made and fold the end of the belt back under it.

Hint

Buckles only work right in one direction, so check to make sure you have it on correctly, and the tongue will hit the outer ring on the top.

One inch back from the fold, punch two holes next to each other about 1/2 inch apart. Punch another hole 3/4 inch behind that one, right in the middle of the belt. Make sure you go through both layers. Fill these holes with 3/4-inch paper fasteners. You should have something looking an awful lot like the illustration.

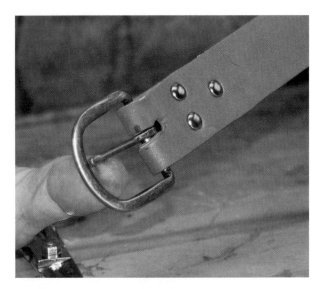

From the remaining piece of 1 1/4-inch wide reinforced Fleather, measure and cut a strip 1/2 inch wide and 4 inches long. You are going to use this to make a belt loop to hold the extra part of the belt that sticks out when you buckle it.

Punch two holes, in line with each other and each 1/4 inch from the center of the strap and 1 inch back along the belt from the single hole you made, going away from the buckle.

Punch one small hole 1/4 inch from each end of the 4-inch loop piece. Put a paper fastener through one of the holes in the belt and through the back side of one of the holes in the loop.

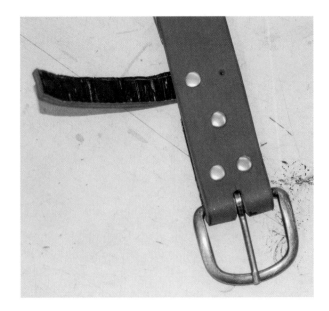

Wrap the loop around the belt and secure the other end with a fastener.

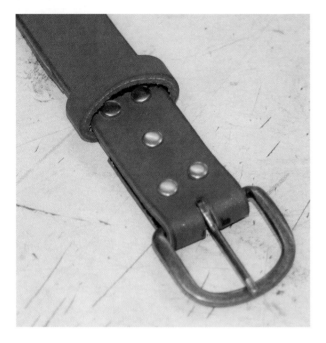

Cut the non-buckle end of the belt into a point. Wrap the belt around your waist (not too tightly) and put the pointed end through the buckle to determine where you need to punch the hole you will eventually use when you buckle the belt. Mark where the pointed end covers the back end of the buckle, in the center of the belt, and with your rotary punch on the largest setting, punch a hole at the mark. Staying in the center of the belt, measure 1 inch from the hole you just made toward the point and punch another hole. Repeat twice to make three holes 1 inch apart. Then, punch three holes 1 inch apart on the other side of the first hole you punched.

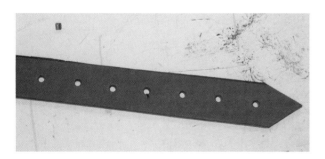

Try the belt on. If it is way too long, feel free to cut a bit off, but remember to cut a point at the end, if you need to cut it off. Now, if you just wanted to make a belt, you can stop here! You're finished! If you want to make the rest of this unbelievably awesome harness, read on!

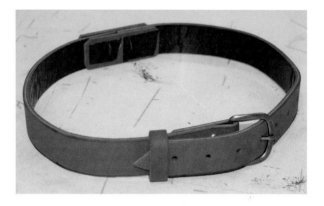

Step 3: The Back Strap

Cut five 1 × 18-inch strips of reinforced Fleather. From one of these, cut a section 9 inches long. Trim the corners of this piece. Measure and punch a hole 1/4 inch from each end.

Now, pick an end, any end. Measure 2 inches from that end and make a mark. Then, 3 inches from the same end and make another mark. Punch small holes at each of these marks and place a fastener through the front of the piece, in the hole at the 2-inch mark. Wrap the closest end of the strap around the 2-inch "O" ring, and run the end of the fastener through that hole you made 1/4 inch from the end.

Insert a fastener into the hole at the 3-inch mark, curl the other end of the strap down like a loop, and run the end of the fastener through the back of that other hole that is 1/4 inch from the end.

Slide the loop over the belt; the loop should be big enough to let the place where you joined the belt pieces slide through. Take the loop with the ring off and set it aside for now.

Step 4: Shoulder Straps

Select two of the 1 × 18-inch strips. Trim the corners just a bit. Poke a hole 1/4 inch from one end of each strip, measure 2 inches from that end, and mark and punch another small hole.

Fold the end of each strap over the "O" ring and run a fastener through the front of the holes at the 2-inch mark and through the backs of the holes near the ends.

Step 5: The Up Straps

Next we'll make the "up" straps. They will use the two smaller buckles so you can adjust the fit on the harness, just like you can with the belt.

Take your two remaining strips of 1-inch wide reinforced Fleather, and cut them to 12 inches long. Trim all the corners by about 1/4 inch.

Remember how you made that oblong slot for the tongue of the buckle for the belt? You are going to do that again on both of these straps.

Make the center of the slot 2 1/2 inches from the end on both pieces. Insert the "tongue" of the buckle (the long, thin, pointy part) through the hole you just made and fold the end of the strap back under it.

One inch back from the fold, punch two holes next to each other about 1/2 inch apart.

Punch another hole 3/4 inch behind those, right in the middle of the strap. Make sure you go through both layers. Fill these holes with 3/4-inch paper fasteners.

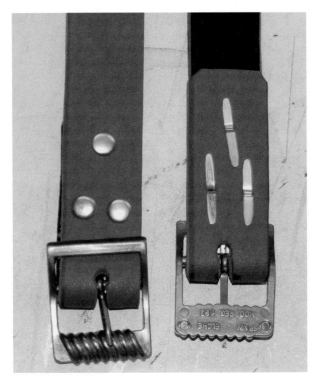

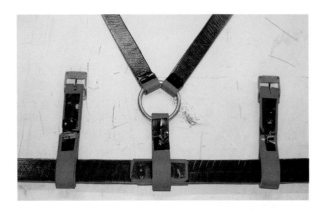

Lay the belt on the table with the black duct tape up. Run it through one of the up strap loops, then the loop with the ring and the shoulder straps, then the other up strap loop, as seen in the illustration.

Put on your harness, run the straps over your shoulders and into the buckles of the up straps. Find the length of strap that feels comfortable, mark that spot, and make a hole for the tongue of the shoulder strap. Punch a few extra holes at 1-inch spacing on both sides of that hole for good measure.

Congratulations! You're finished!

These buckles do not require a loop, but if yours do, go ahead and put one on there.

Make a hole 1/2 inch from the no-buckle ends of the up straps, and another hole 6 inches from the same end on both. Run a fastener through the front of the hole at the 6-inch mark and through the back of the hole near the end, making a loop. Well, two loops, because you are going to do this to both pieces. Cover the fasteners' backs with duct tape as shown in the illustration.

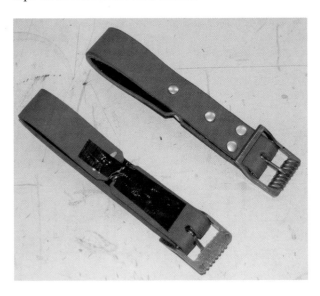

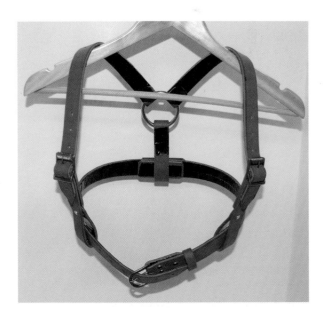

They have a harness, but will they be able to get the ship to hold still long enough? Will the harness be strong enough? Who will they lower down first?

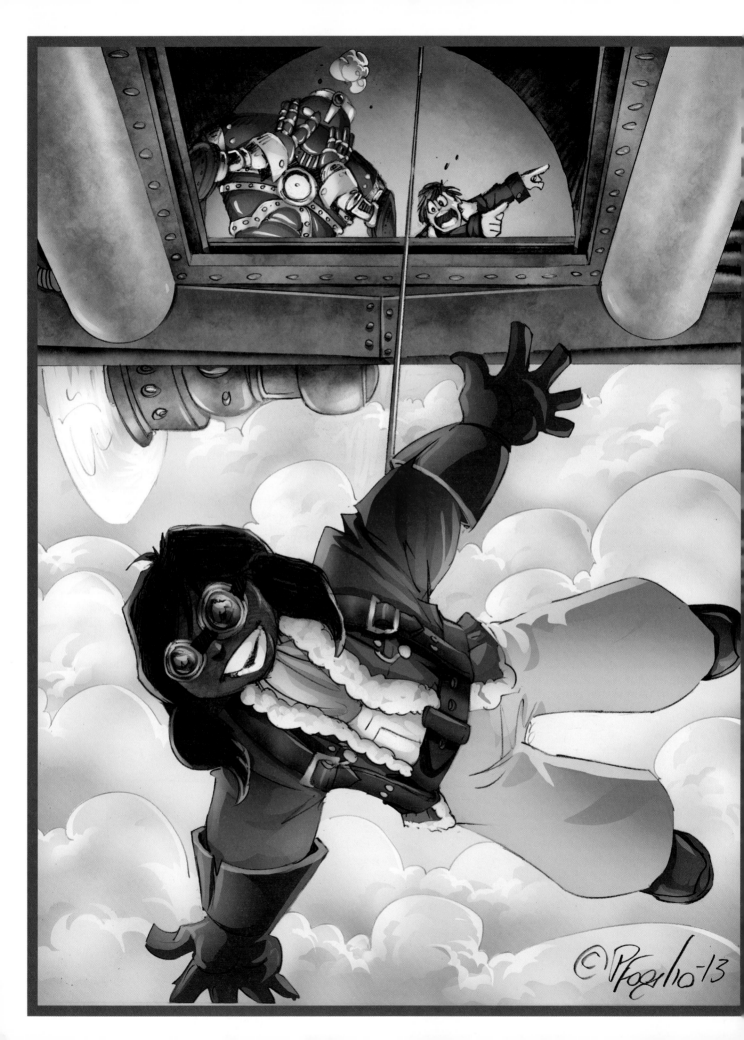

Chapter 9

Glider Wings

Wherein our heroes get separated

Back at the control panel, Isaac said, "I can tell this machine to get us to a certain place, but I cannot make it follow that other ship."

HEC said, "I can steer this ship to follow the cruiser if you can disengage the automaton pilot."

Isaac said slowly, "All right... wait, who will we be lowering down to the cruiser first?"

"It can't be you, because you would have your eyes closed the entire time," Amelia said as she put on the harness and pulled down her goggles.

Isaac said, "You are mad as a bag of snakes!"

"Have you got a better plan?" Amelia demanded.

"You mean better than going home and telling Mum and Dad?"

Amelia said, "Yes, better than that!" as she grabbed the rope and walked purposefully toward the lower hatch. When she got there, she looked down at the top of the cruiser. She measured several lengths of the rope from her chin to her outstretched hand, handed the rope to her brother and said, "Tie this off at exactly this place to the third rung up on that ladder."

He took it and began to tie it off. "How am I going to lower you down? I'm not strong enough and HEC is busy steering the ship."

As he was finishing the knot she said, "Oh, that part is easy. Watch, there is no way this can end badly!" and she jumped straight out the hatch.

Isaac screamed and hastily finished the knot, just as the rope went taut. He looked out the hatch to see his sister holding onto the top hatch of the other airship with her hands and feet. She then reached back and unclipped the rope from her harness and clipped it to the safety-line bolt next to the hatch. His heart jumped again when he realized that she was attached to nothing.

He was ready to yell out to HEC to come down and slide with him down the rope, when he noticed Amelia was opening the hatch of the cruiser and climbing inside. Suddenly the cargo ship jerked violently to one side. The bolts in the ladder groaned. He took a few steps toward the bridge to yell to HEC, "What are you doing up there?"

HEC said, "The automaton pilot has reengaged and is attempting rather forcefully to correct the course."

The ship jerked once more and the bolts on the ladder did not just groan, they snapped. The ladder and the rope were pulled through the lower hatch. Isaac stood wide-eyed, realizing

that he could have been killed, his sister was on the cruiser alone, and there was a rope with a ladder hanging off the back end of the cruiser. The cargo ship began to accelerate away from the heavy cruiser like it was trying to make up for lost time.

Isaac yelled as he ran toward the bridge, "Amelia is on the other ship and we don't have any more rope! Are you fighting with the automaton pilot?"

As he walked into the bridge he saw that HEC was indeed fighting with the automaton pilot. Three arms were engaging him while the other navigated the ship back to its original destination. HEC disengaged himself and retreated to meet Isaac at the door to the bridge.

Isaac said, "We need to regain control of this ship, Amelia is trapped on the cruiser!"

HEC said, "Then we have to completely disable the automaton pilot. Remember when I said I can try to make a convincing argument, but I am incapable of forcing cooperation? That was assuming the pilot was a person. If you would like, I could present a much more forceful argument to this pilot."

Isaac screamed, "Please do!"

A tone came out of HEC and then his eyes did a quick succession of blinks and glowed red. He stepped forward and one of the automaton pilot arms reached for him. HEC grabbed it with his left arm and then his right arm, planted his foot against the side of the pilot and then pulled the arm free of the case. He then used the arm to bludgeon the other arms and fight his way toward the controls.

HEC seemed to be doing quite well, but the pilot, equally willing and capable of defending itself, still outnumbered HEC arm for arm and began to push HEC back toward the door. As he retreated, HEC swung his improvised club at the main body of the automaton pilot. He managed to break loose one of the panels before the automaton pilot pushed him back toward the door again.

Isaac now had a clear view of the inner workings of the pilot. As soon as he saw that, his mind quickly evaluated the device, the images flying through his head.

"HEC, if you can keep the pilot from getting to me when I go to that panel, I should be able to completely disable it. Could you give me a wrench please?"

HEC asked, "What type?"

Isaac said, "Large and adjustable." HEC opened his chestplate and produced a large wrench. "We will go on three: one, two, and three."

Isaac dove for the panel as HEC grabbed another one of the pilot's arms and tore it free as two more engaged him. Isaac looked at the exquisitely made precision machinery and felt he would make a few fine adjustments. He then jammed the wrench into the machine, smashing gears, push-rods, and delicate glass tubes. He twisted it around until he heard a metallic scream. The pilot stopped moving. HEC pried himself free of the hands that gripped him and removed the ones gripping the ship's controls.

HEC said, "The ship is now fully under our control," as his eyes shifted back to their usual soft yellow.

"Please take us back to that cruiser, HEC. How long will it take us to get back there?" Isaac asked.

HEC said, "Close to twenty-eight minutes."

Isaac thought about his sister and uncle trapped on the cruiser, and all the parts and supplies he had left, and how they were going to get onto that airship. He had no more rope. Maybe sometimes it *is* just that complicated. It was time to build HEC some glider wings.

Build a Pair of Glider Wings

These wings were one of the hardest things to design in this whole book. Of course wings are hard to make: If they were easy, people would be flying all over the place!

Materials

- 2 12 × 18-inch sheets of tan craft foam
- 4 12 × 18-inch sheets of brown craft foam
- 4 12 × 18-inch sheets of black craft foam
- 1 9 × 12-inch sheet of thick black craft foam
- 1 100-count package of small split brads
- 1 box of 1-inch (or longer) round-head fasteners
- 1 roll of double-sided duct tape
- 1 roll of black duct tape
- 1 harness from Chapter 8

Tools

- Scissors
- Tape measure
- Permanent or paint marker
- Cellophane tape
- Rotary hole punch
- Awl, nail, skewer
- Ruler or straightedge

- Computer and printer
- 2 heavy books
- 1 roll of wax paper

Step 1: Lay Out the Patterns

There is one pattern for this project, but it is in four pieces. Download the four files from www.mhprofessional.com/steampunkadventurer and print.

As you'll see, there are six registration ("X") marks in each pattern piece and that the images in the pieces overlap somewhat. Place one on top of the other and match up the registration marks, using Figure 9-1 as a guide. Use cellophane tape to secure each piece as you go.

Here is it, all taped together and ready to cut.

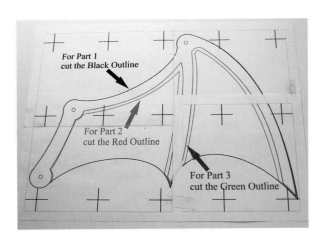

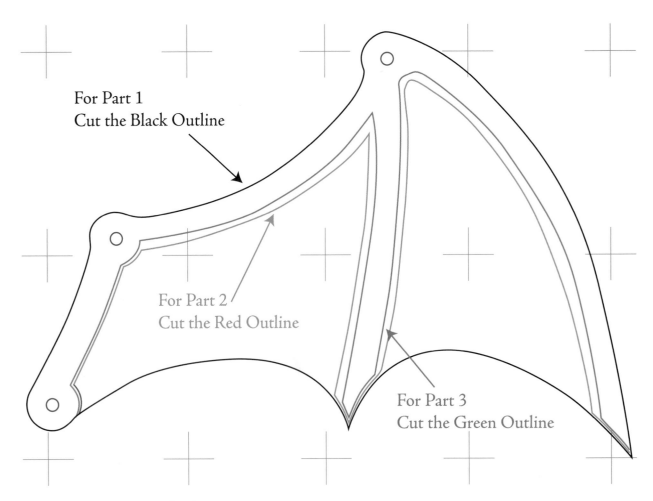

For Part 1
Cut the Black Outline

For Part 2
Cut the Red Outline

For Part 3
Cut the Green Outline

FIGURE 9-1 Layout for the wing patterns

Do not print the pieces on card stock or heavy paper because you want to see the registration marks through the pieces on top to match them up. Also, if you are a little crazy about such things, you will notice a few small gaps in the pattern after you tape the pieces together. Feel free to draw in those bits with a marker if it bothers you too much.

Cut out the outline of the pattern for Part 1, and use the rotary punch, set on the largest hole size, to punch the holes.

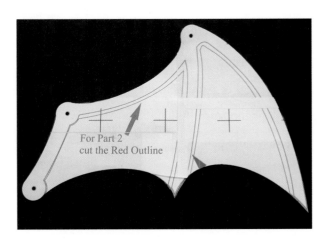

Step 2: Cut Part 1 of the Wings

Center the pattern on top of a 12 × 18-inch sheet of tan craft foam. Make sure the pattern is not sticking over any of the edges. Carefully trace around the edges of this pattern. Don't forget to trace the holes. When you are done, flip the pattern over and place it on another 12 × 18-inch sheet of tan craft foam. Let's call the side of the pattern with the print on it "Side A" and the other side, "Side B."

Hint

When using a large paper pattern like this, weight it down to keep it from moving as you try to trace it. A couple of heavy books should do the trick. Keep the pattern completely flat, take your time, and cut it exactly on the lines.

Use your scissors to cut along the outline of both of the pieces you just marked; again, remember to punch the holes. These are now your Part 1 pieces of the wings.

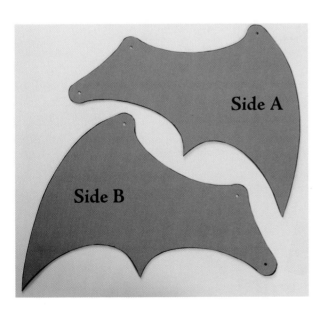

Step 3: Cut Part 2 of the Wings

Let's put the Part 1 pieces aside and get back to the pattern. It is time to cut Part 2 of the pattern; for that you will be following the red lines.

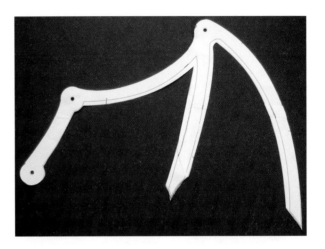

Center the pattern on top of a 12 × 18-inch sheet of brown craft foam. Use some cellophane tape to hold the pattern down in a few places. Carefully trace around the edges of this pattern. Again, don't forget to trace the holes. That hint about using a book or two to hold the pattern down would work here, as well.

When you are done tracing the pattern, don't cut them out just yet! Draw an outline about 1/4 inch outside of the outline you just drew. No, it does not have to be exactly 1/4 inch, so you can eyeball it.

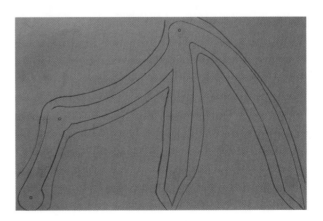

You are going to need to trace four of these— two of Side A and two of Side B.

Cut the pieces of brown craft foam along the outside lines that you eyeballed, not the inside ones (of the pattern outline), and do not punch the holes just yet.

Hint

I know what you are thinking: "If they are all basically the same, can't I stack them and cut them all at once and save myself loads of time?" The answer is: No. If you do that, the ones on the bottom will be a different shape and size than the ones on top. I've tried it.

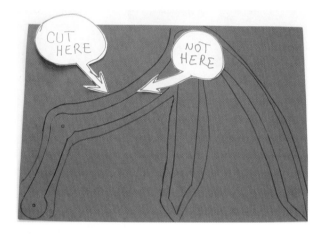

You should now have four pieces that look like the following picture. (Well, two like that, and two facing the other way.) If you do not have these pieces, then fire your lab assistant and try again. Good minions are hard to find.

These are your Part 2 pieces.

It is time to revisit our best friend, double-sided duct tape. Lay down some waxed paper to protect your work surface. Select one of the Part 2 pieces and lay it on the table with all the lines and tracing facing down and the clean side up. Cover the back with the tape. Do not worry about trimming the excess, and don't worry about any gaps that are under 1/4 inch or so wide and do not worry about covering every little bit. Press the tape down, nice and smooth. Do not overlap the pieces of tape, because that will make the backing hard to peel off later. Also, do not peel off the backing just yet. If it looks roughly like what's shown here, you are doing fine.

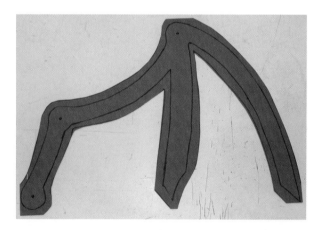

Guess what? You got it! Do this on all four pieces.

Flip one of the Part 2 pieces over so the marked side is facing up. Cut around the remaining outline (the line you traced from the pattern) and punch the holes.

Now I will tell you why you did that bit with the extra outline. It is easier to cut the tape when it is covered on both sides. You may have noticed the exposed tape is *really* sticky, which is great when you want to hold things together, but not so much as you are cutting it and it's getting caught in everything. It also leaves a much better edge this way than to try to just trim it off.

Do you now have four of these? Good!

Step 4: Cut Part 3 of the Wings

Set the Part 2 pieces aside for now, and remember, don't peel the backs. Since you are already in a cutting and tracing mood, it is time to cut the pattern following the green lines for Part 3.

Center the pattern on top of a 12 × 18-inch sheet of black craft foam so the pattern is not sticking over any of the edges. Carefully trace around the edges of this pattern, and as before, don't forget to trace the holes. You are going to

need to trace four of these: two of Side A and two of Side B. Just like with Part 2, you will draw an outline about 1/4 inch outside of the outline you just traced from the pattern.

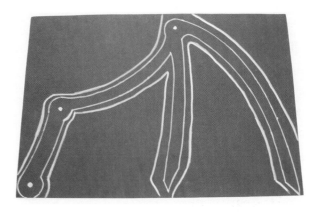

You can draw on the black foam with a black marker and still see it. You can see an example of how the black marker shows up on the black Fleather in the next illustration, if you doubt me. I used a silver marker in most of the illustrations so you can see it better. The silver markers are much more expensive and will leave a silver line on the edges, so I recommend the black markers.

Cut all four pieces along the outside line, just like you did with the Part 2 pieces, but do not put any tape on the backs! I know you were thinking it was time to do that, but it's not. Instead, this is where we embellish them a bit. Usually you would do that at the end of the project, but this time it is easier to do it now and you will see why.

I'm going to show you how I would do it. You can do it any way that works well for you. I know this will sound terribly artsy, but it is about what you want your piece to say. Rivets say, "Look how strong these things are!" so I tend to use them a great deal. You could just put some split brads that look like rivets around the edge, and it would still look really good.

Go to your craft store and look around and you will find inspiration. There are just a few simple rules: Nothing too heavy, or the wings will droop, and there is nothing worse than droopy wings; nothing sharp, because it might catch on someone else's outfit or on them. Now, onward!

Step 5: Embellish the Wings

Choose a wing, any wing. Each wing will have two Part 3 pieces, one for the front of the wing and one for the back. Start with the front one. Lay it flat on the table with the marks facing up. Select the hardware you plan on using and lay it out on top of the Part 3 piece. I've selected a large, round split brad for the hole at the top of the wing and some metal trim that looks like it belongs on the cover of one of those big old books you see in the movies.

Poke a hole at the mark at the top of the wing and push the large split brad through. This will look like a pivot point on a mechanical wing.

The metal trim pieces have a sticky backing on them, but I do not trust that to hold on during the

rigors of flight, so we'll also need to reinforce them. First, stick them in place, then use two larger split brads to hold them at the ends. Separate the two pointy parts of the brads so they can fit around the piece of metal trim.

Using a nail or the smallest setting on your rotary punch, put a hole on either side of the metal trim, just behind the decorative element at the end of the trim.

Separate the split brad slightly and push each point through the holes you just made so that the brad head is straddling the metal trim.

Instead of flattening the ends of the brads so that they point away from each other (as you would normally secure a brad), cross the ends over each other so that they secure the metal trim to the piece.

Repeat this at the other end of the metal trim and then do the same for both ends of the other piece of metal trim.

Use a large split brad to cover the gap between the two metal pieces.

Time for rivets! Start at the large brad at the top of the wing and mark every inch along the top edge.

Use your rotary punch or nail to poke a small hole at each of those marks and insert and secure a small brass split brad.

Turn the piece over and back it with double-sided duct tape.

Turn it back over, and cut the Part 3 piece to the pattern line and punch the remaining two holes. Kind of like you did on the backs of the Part 2 pieces.

I know this may seem a bit complicated, but remember, you can decorate this most any way you like. The cool hardware you find may be attached in a completely different way.

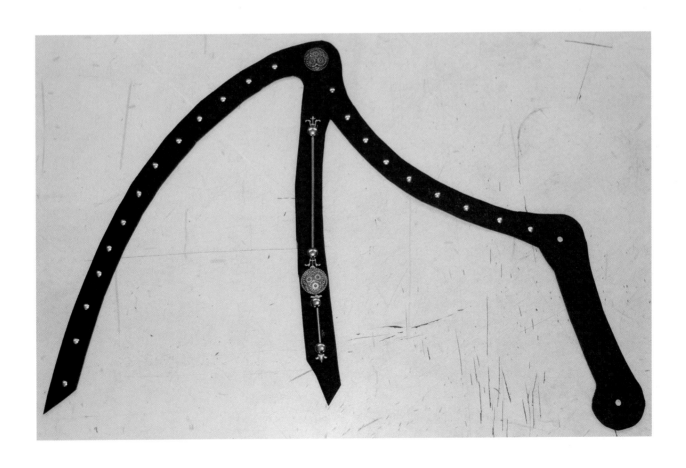

Make the back Part 3 piece a little simpler, as it will not be seen quite as much. Insert one large split brad at the top of the wing and seventeen of the screw-head split brads roughly evenly spaced on the rest. Apply the tape to the back and cut it along the pattern line, just like you did for the front piece.

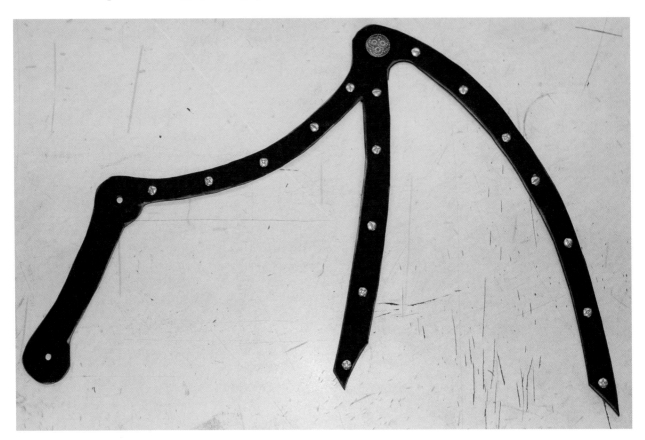

Step 6: Assemble the Wings

You should have two Part 1 pieces, four Part 2 pieces, and four, nicely embellished Part 3 pieces (two for the front and two for the back).

Place a Part 1 piece on the table with the top of the wing pointing away from you. Just for fun, start with Side A (see the illustration in Step 2: Cut Part 1 of the Wings).

Looking at the Part 2 pieces, it is easy to see that two of them would fit on top of this Part 1. Either will do. Peel the backing off the tape on your Part 2 piece. Apply the brown piece so the outer edge is flush with the outer edge of the tan piece and ensure that the point of the middle "rib"

of the brown piece matches the point on the bottom of the tan wing. Press it down and make sure it is completely smooth.

Flip it over and do the same thing to the other side.

Flip it again. Take the front Part 3 piece (with the extra embellishments) that fits this Part 1, peel off the backing tape, and place it on top of the Part 2 piece you just attached. Again, keep the outer edges even and the piece in the middle in the center of the brown piece beneath it.

And more flipping. Apply the appropriate Part 3 piece to the back side of the wing just like you did with the front.

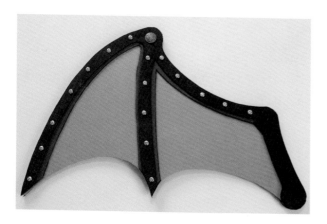

Make sure all the edges are even and all the points match. Trim them a little if needed. If you have not punched the last two holes all the way through yet, now is a good time to do so.

Now repeat all of the steps you just did for the other wing and you should have a pair of wings like these.

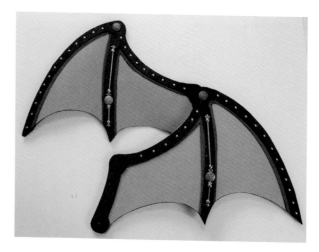

I noticed that the wings did not want to stand up as much as I would like, so it is now time to stabilize the wings just a bit. Place the wing on the table with the front side face down. See the two holes at the base of the wing? Make a mark 1 3/4 inch straight up from the bottom hole and make a small hole there in the wing. Of course you need to do this on both wings.

Somewhere, you should still have a sheet of thick black craft foam sitting about; it's 12 inches wide and 9 inches long. From that, cut two pieces 2 inches wide and 9 inches long. Round off the corners just a bit. Make a mark 1/2 inch in and centered from each end. Punch a small hole at each of those marks. These are the wing braces.

You will probably have to get the 1-inch long "round-head" fasteners at an office supply store. I took a picture of them so you can see how big they are and what they look like. They are basically really big split brads. Just show the store clerk that picture and they will get them for you if you can't find them.

Insert a 1-inch long round-head fastener into the hole at one end of each brace and through the back of the hole you just made in each wing. Place a small piece of black duct tape over the split ends. Don't worry, even though this is on the front of the wings, nobody will see that part.

Rotate the brace until the hole at the other end is right over the center of the black foam piece at the top edge of the wing. Push your awl, or whatever pointy thing you have, through the hole, and mark the spot on the wing.

Swivel the brace out of the way and punch a hole in the wing at that mark. From the front of the wing, insert a 1-inch long round-head fastener into the hole and through the hole in the brace. Do not spread the split parts.

Look at the front of the wing; notice how you can see a bit of the brace sticking up? Mark the edge of the wing on the brace. Remove the round-head fastener, rotate the brace, and trim away the protruding part. The brace on the right in the following illustration hasn't yet been trimmed; the brace on the left has.

Replace the braces onto the fasteners and open the splits. Place a small piece of black duct tape over the splits.

Now you will have a great looking pair of wings that are much more stable!

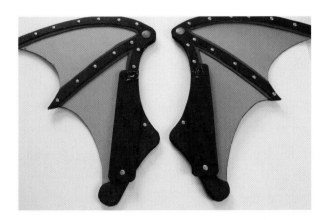

You will notice that the edges of the stacked pieces are a mix of colors. If you find this distracting, use a black marker to color the edges.

Step 7: The Harness

Rather than repeat the whole process of making a harness to support the wings and make them wearable, I'm just going to refer you to Chapter 8. Go ahead and follow the instructions for making a harness; I'll just wait here until you are done.

I assume you now have a lovely and functional harness.

Now you are going to add a mounting plate for the wings to this harness.

With your scissors, cut your remaining piece of thick black craft foam to 9 inches long and 7 1/2 inches wide. To make it look a bit more professional, cut about 3/4 inch off each of the corners.

With your silver marker, draw one line down the center and one 3/4 inch in from the top and bottom edges. Put a little arrow at one end of your centerline to indicate the top of the mounting plate. Along the top line, put a mark 1 1/2 inches out from either side of the centerline. Along the bottom line, put a mark 2 1/2 inches out from either side of the centerline. Put a small hole at each of those four cross marks along the lines at the top and bottom and out from the centerline. It should look like this.

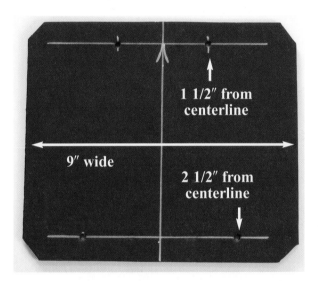

Lay your harness out on the table as in this picture. When you are wearing the harness, the loop that goes around the middle of the waist belt should be at the center of your back.

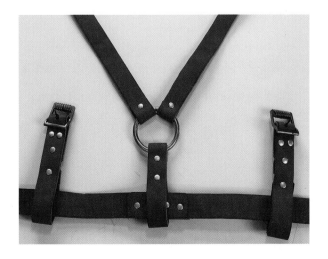

Place the mounting plate over the harness with the bottom edge of the plate aligned with the bottom edge of the harness waist belt.

Position the shoulder straps so you can see them through the holes near the top of the mounting plate. Use a pen or nail to push through the holes and make a light mark on the straps and belt under the plate. Remove the plate and adjust your marks so they are in the center of the straps and belt, then punch holes in them at the marks. Using the 1-inch long round-head fasteners, attach the mounting plate to the harness. It should look like this.

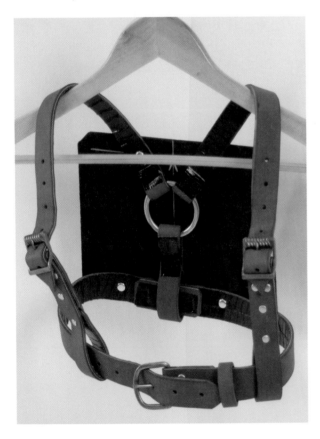

Place a piece of black duct tape, about 1 inch square, over the bent tines of the split brads to make them more secure.

Step 8: Mount the Wings

Place the harness on the table with the wing mounting plate on top and the top of the plate away from you. Draw a line 1 inch in from the left edge of the mounting bracket. Then repeat this for the right side. Draw a cross mark about 1/2 inch long on each of those lines 1 inch down from the top of the bracket.

Place the left wing on the mounting plate, with the front facing down and the two remaining holes over the line on the left side of the mounting plate. Slide the wing so the top hole is over the cross mark. Use your awl, or whatever you are using to poke small holes, to poke a hole through the top hole of the wing and into the mounting plate.

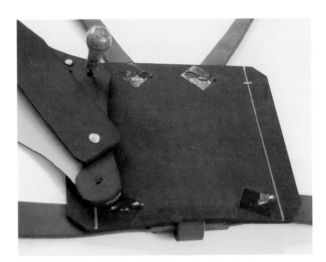

Do the same with the hole at the bottom of the wing. Repeat this on the other edge of the mounting plate with the other wing.

Push a 1-inch long round-head fastener through each of these holes, from the underside, to secure the wings to the plate.

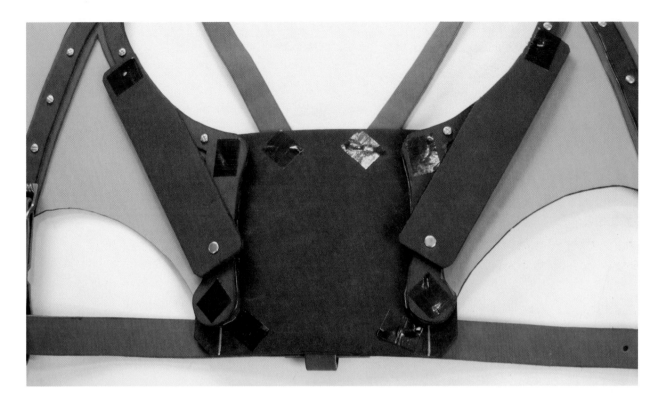

Place a 1-inch square of duct tape over the split end of each fastener to secure it to the plate.

There you have it! Your own set of Steampunk Glider Wings!

Now Isaac has the wings to act out his insane plan. Will these wings hold HEC in the air? If they don't make it, what will happen to Amelia and Professor Grimmelore?

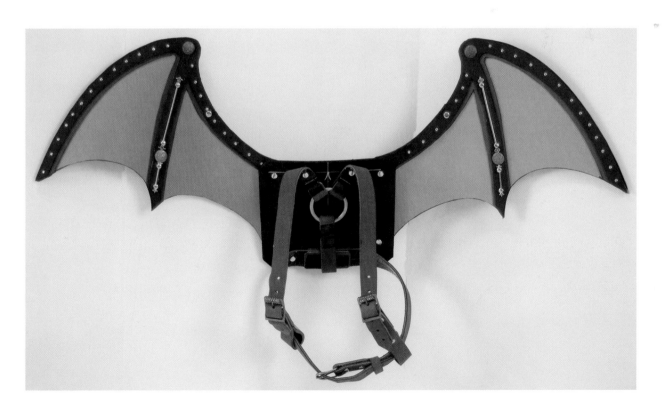

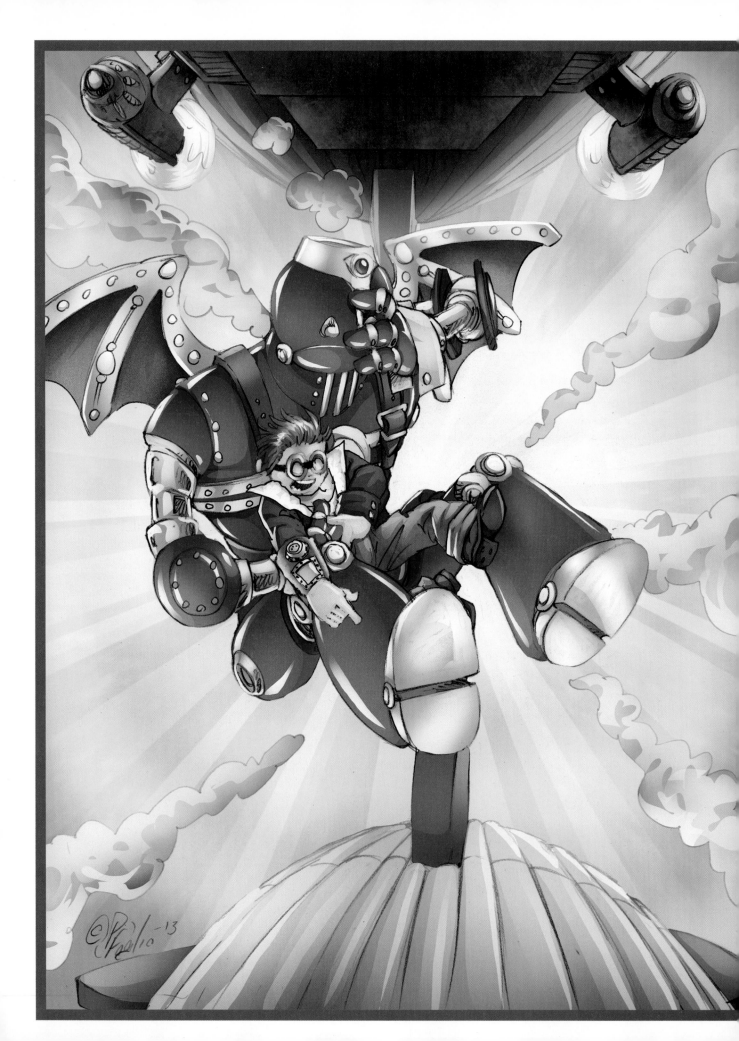

Chapter 10

Rivet Gun (Modded Nerf Blaster)
Wherein our heroes get stranded

HEC and Isaac had to time it just right. They maneuvered the cargo ship well above the cruiser on a course to pass over it, giving them just enough time to rush from the flight deck down to the cargo bay and out the large cargo door at the back of the ship. HEC would never fit through the lower hatch with the wings mounted on him.

Isaac pulled down his goggles and yelled over the rushing wind, "Jump now!" then closed his eyes until he felt the solid thump of them landing on top of the cruiser. He noticed the rope was still tied to the safety bolt. This was a good sign. Perhaps the crew was still unaware Amelia was aboard. He saw the cargo ship heading off with the controls locked in place as the cruiser continued to circle the light tower. They folded HEC's wings to enter the hatch. Just as they were climbing down the ladder, they heard a loud "Boom!" and looked up as they heard another explosion. The cargo ship was falling out of the sky, on fire. The cruiser had shot it down. They quickly entered the ship.

"We have to search for Amelia and Uncle Adrian. This thing is huge, so we should split up. I will take the lower decks and you, the upper, and we will meet back here in 30 minutes."

HEC replied, "Yes, sir," and headed toward the front of the ship as Isaac worked his way down a ladder to the lower decks.

After a few minutes of sneaking around the lower decks, he felt a light push at his backpack. At first, he had to stifle a yelp, thinking someone had caught him, but when he turned there was nobody there. Then he realized a ship this size would have a massive helium expander, and as he got closer its magnetic field would pull just a bit at the metal things in his sack. He walked a bit further and noticed the small metal buttons on his shirt were beginning to pull ever so slightly. His fascination with this effect was interrupted by hearing "Psst! Isaac, it's me," coming from a small vent at the bottom of a door.

"What are you doing in there?" he asked, as Amelia opened the door and grabbed his hand to pull him into the small room. He noticed this was the maintenance cupboard, probably for the helium expander.

"While you were taking your sweet time getting here, I've found out something useful. In fact, I've found out several useful things. Uncle Adrian is indeed on this ship and Professor Maelstromme was right: Dr. Claremont is the one who captured him. He is actually working

for a group called Fenris. They've been waiting for a message from someone named Willoughby."

Isaac interrupted, "That is the name of Admiral Pike's aide at the base! He must be the spy!"

"I knew his name sounded familiar. Anyway, they are keeping Uncle Adrian and the Icarus Device on the bridge guarded by automatons. The ship seems to be mostly crewed by automatons with about four or five people walking about. These automatons are not clever ones like HEC, but there are at least four huge ones guarding the bridge. Do you have some brilliant way of getting past them?"

Isaac began to look around the room they were in. It was packed with tools. His hands were beginning to sweat. So many tools, so many ideas, he felt that with enough time in here, he could build anything, but he did not have that much time: an air drill, a bucket of rivets, a few Visbaun chargeable magnetic coils. The images in his head came together. It would be awesome.

"I have an idea! I told HEC I would meet him at the upper hatch—do you think you can find your way back to there?"

She responded by rolling her eyes.

"Good, bring HEC back here and I should have something ready when you get back."

Build the Rivet Gun

With this project you will be learning the ancient and time-honored skill of "modding." That is where, instead of building something from raw materials, you will be taking a pre-existing object—in this case a toy gun that shoots foam darts—and modifying it to look loads cooler. As a bonus, it will still shoot foam darts just as well as it did before. In this chapter we will be using the ever-so-popular Nerf Maverick REV-6, but the same ideas can be used on almost any foam-dart gun.

Materials

- 1 foam-dart gun
- 1 can "rusty metal" primer spray paint—the red stuff
- 1 can of dark bronze hammered spray paint
- 1 9 × 12-inch sheet of 1/4-inch thick black craft foam
- 1 9 × 12-inch sheet black craft foam
- 1 9 × 12-inch sheet brown craft foam
- 1 9 × 12-inch sheet tan craft foam
- 1 roll of double-sided duct tape
- Various split brads
- 1 empty paper towel roll

Tools

- 1 metal shirt hanger
- Scissors
- Straightedge or ruler
- Tape measure
- Permanent marker
- Nail, hole punch, or awl

Optional Tools

- Copper paint marker

Step 1: Paint the Gun

Note

Whenever you or someone helping you is using spray paint, always follow the instructions on the can and always do it in a well-ventilated place. And keep it away from your pets! It's really hard to get paint out of fur; I know, because I have had to do it more than once. Be careful!

First thing, of course, would be to remove the foam-dart gun from the box. By the way, this is a little harder than you might think. There are a bunch of little things binding it into the packaging. Make sure to remove them all first, instead of just pulling harder and risking breaking something.

Then, do not load it. Well, okay, you will probably load it and fire it a few times, but make sure it is unloaded before you proceed.

The Nerf Maverick comes in a few colors, but in general it should look like this. But not for long.

Now that you are done playing with it for a while, it is time to put the first coat of paint on it. This will be the rusted red primer.

Pull back the slide on the back of the top of the gun, as if you were going to fire a dart. Place the hook of the hanger though the hole at the back of the slide. Now you can hang the piece up with the hanger and still spray almost every angle, and it will hold the slide back while you paint under it.

And now is a good time to find a place for you to hang this when it's time for the paint to dry. This is a much better idea than waiting until after, and running around the house with a wet, painted Nerf blaster.

Read the instructions on the can whenever you use spray paint. Spray a nicely even coat onto every available surface. Hang it up and let it dry for at least two hours. Seriously: don't touch it or check it. Leave it alone for two hours. After all, it looks pretty good just hanging there.

After the two hours have passed, the piece should be dry enough to touch. If it still feels sticky, let it go another hour, and try again. Temperature and humidity may affect the drying time so you may have to do this a few times until it's not sticky.

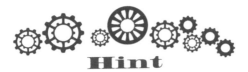

Hint

While you are waiting for the paint to dry, you can read ahead and prepare materials for the steps you will be taking later in the project.

On the left side, if you were holding the gun by the handle, just behind the revolving chamber that holds the darts, there is a button that allows the chamber to pop out a bit. Pop it out. See all that unpainted part? Wait, there is more: If you revolve the chamber a bit, there are a couple more unpainted places to expose. You may even have to rotate, paint, let it dry, and repeat. Also, make sure to check both sides of the piece.

When this is all done, relax and let it dry completely overnight. Trust me, if you try to rush this, and put the next coat on when it just feels

"dry enough," the second coat may bubble and peel and not in a good-looking way.

So, now it is the next day or so and you are ready to spray on the real color. I chose dark bronze hammered spray paint, but any of the metallic hammered paints would look pretty cool.

Use the hanger to hold your piece and paint it just as you did with the primer coat, except now you are not going to pull back the slide.

This paint is a little thicker and may gum up the action of the slide, so avoid getting this paint on too thick. The rusty red actually looks pretty good showing through a bit, and much of the piece will be covered with other materials.

Remember to hit it at every angle and to open the chamber and turn it. Paint lightly in here, too.

Now, again, comes your favorite part. Let it dry overnight.

Step 2: The Handle

Good Morning! Did you use the drying time to get the other materials ready? Like making your Fleather tape and such? Good! Because take a look at what we'll do to the handle.

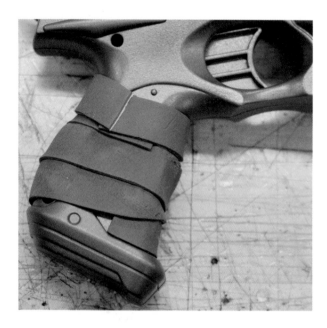

Cut two 3/4 × 9-inch pieces of your brown Fleather tape and wrap the handle with them, from the bottom up. This is actually not quite enough, so you can cut another piece about 6 inches long to finish it off.

Step 3: The Slide

Next will be the covering of part of the slide. As I mentioned earlier, that is the part you pull back to fire the darts. This will be interesting, as I'm not going to give you a pattern for this step. Instead, I'm going to show you how to make a pattern for some of the more simple shapes. After all, you may be using a different base object than I'm showing you here.

When you push Fleather against something hard, it leaves an impression, and this can be used to make a pattern.

Cut two 1 1/4 × 5-inch pieces of brown Fleather tape. Place one with the tape side up on the side of the slide so it completely covers the slide, and press down firmly.

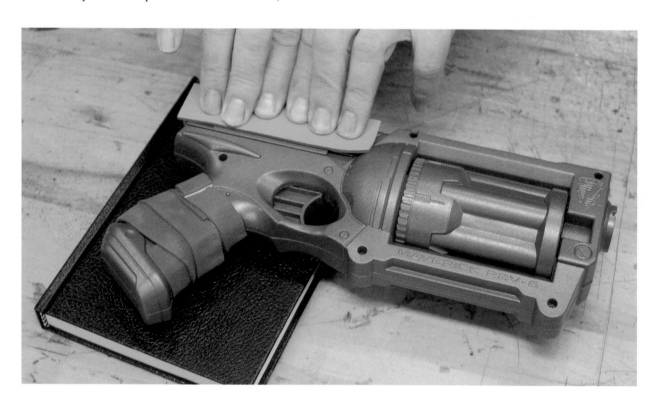

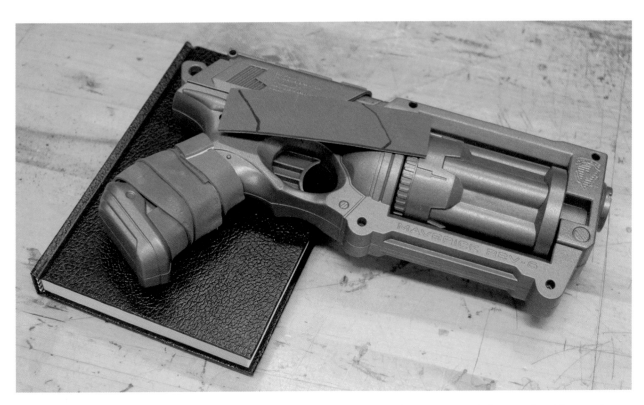

When you turn it over, you will see a slight impression; use a marker to trace out the impression, which you can see I've done in the illustration.

Cut the piece out along the lines from the impression.

Since this piece is a mirror image of the piece on the other side, you just made the pattern for the opposite side of the slide. Flip this piece over and trace it onto the other piece of brown Fleather tape for this side.

Cut a piece of black Fleather tape 1/2 × 9 inches long. Cut that into six pieces, each 1 1/2 inches long. Then cut the tops and bottoms off at a bit of an angle, three in one direction and three in the other. Poke a hole in the center of each piece of

black Fleather Tape. Peel the tape backing and insert a split brad into each hole.

Place the brad-studded black Fleather tape pieces, evenly spaced, three on each slide cover.

Peel the backing off each slide cover and apply each to the side of the slide where it belongs, as shown in the illustration. Your gun is beginning to look riveting.

Step 4: The Top Ridge

Along the top of the piece above the chamber is a bumpy part that we will now mod.

Cut two 1/4 × 5-inch pieces of black Fleather tape.

Peel the backing and place each one on either side of the ridge as close to the edge as possible and flush with the front of the piece.

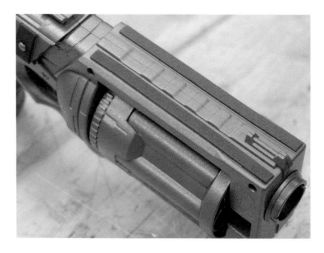

Cut a 1 1/4 × 8 inch-piece of 1/4-inch thick black craft foam. Back this piece with double-sided duct tape and trim away any excess tape.

From this piece, cut a piece 5 inches long. Notch one end of the 5-inch piece of craft foam to accommodate the site sticking up on the end of the piece. Peel the backing from the foam and apply it like this.

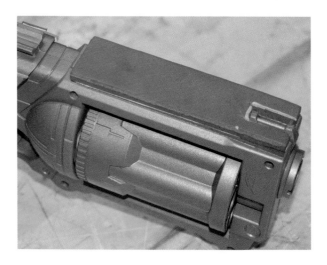

From the remaining 3-inch piece of 1/4-inch thick black craft foam, cut four pieces 1/2 × 1 1/4 inches. Place them across the top of the piece you just applied. The first section should be 1/4 inch from the back and the others a 1/2 inch apart. Now, a clever person will remember that these pieces are 1/2 inch wide, so you can just use one piece to space the others down toward the front end.

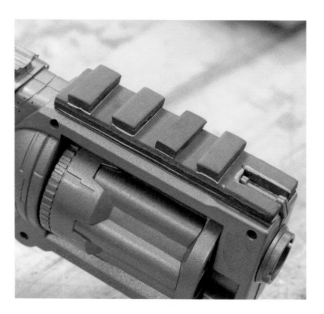

Step 5: The Magazine

Cut two 3 × 4-inch pieces of the 1/4-inch thick black craft foam. Place double-sided duct tape on one piece and sandwich the two pieces together. Trim off any excess tape.

The easiest way to make sure the tape goes all the way to the edge of the foam is to have it go past the edge, then trim off the excess. Taping to the edge makes it stay on better.

Cut two 1 1/4 × 8-inch pieces of thick black craft foam, and two pieces 3/4 × 2 3/4 inches. Back these last two pieces with double-sided duct tape. Do not remove the backing.

Cut one of the 8-inch pieces in half to give you two pieces 4 inches long.

Remember that 3 × 4-inch piece of thick black craft foam you sandwiched together? Apply double-sided duct tape to all four of the edges and trim the excess tape.

Press the two 4-inch long pieces of thick black craft foam you cut earlier onto the long edges of the block, with the block edges centered on the 4-inch pieces.

Place the remaining 8-inch piece across one of the shorter ends and a bit past the outer edge of the 4-inch pieces you just applied. Cut off the excess foam from the 8-inch piece. This is now the magazine body.

Press the remaining tape edge of the magazine body to the center of the piece directly below the chamber.

Peel off the backing and apply one of the 3/4 × 2 3/4-inch pieces you had prepared to one side of the piece, directly under where it says "MAVERICK," bridging the magazine body with the piece of plastic there. Do the same thing to the other side.

Cut six pieces of brown Fleather tape 3/4 × 3 inches long. Here is a hint: Make two strips 3/4 × 9 inches long, and then cut them each into three pieces that are 3 inches long. Peel off the backing and place one of these pieces horizontally in one

side of the magazine body, 1/4 inch from the bottom. Place another horizontally in the side of the magazine body, 1/4 inch from the top of the magazine, and the third in the middle between the other two. Do the same to the other side of the magazine body.

Cut two 1/2 × 12-inch long pieces of thick black craft foam, and back them with double-sided duct tape. Cut two 3 1/4-inch pieces from each of these strips. Yes, I know you have two 5 1/2-inch pieces left, and no, I do not know what you are going to use them for. No doubt you'll come up with something. Save them in the meantime. Do not peel off the backing yet!

Place the black craft foam strips vertically in the side of the magazine, across the brown Fleather tape pieces.

Make three marks down the center of these pieces where the centerline of the brown tape would be. This is where you are going to put "rivets."

Use your awl or nail to poke a hole at each mark. Now peel off the tape backing and insert a split brad into each hole. Put the pieces back where they were when you marked them, and press them down.

Turn the project over and make and place the remaining two 1/2 × 3 1/4-inch pieces of thick, black foam on the other side of the magazine.

Using the black craft foam, make two 1 × 3 1/2-inch pieces of rivet tape (see Chapter 2 if you haven't already created a readymade supply of this amazing stuff). Do not peel the backing yet!

Place one piece so the top edge just hits that line above the word MAVERICK and the center rivet is centered on the magazine.

Notch the tape to accommodate anything that will keep it from lying flat and trim it to keep it from interfering with the chamber reload mechanism. Then peel the tape backing and apply it. Remember, do this for both sides.

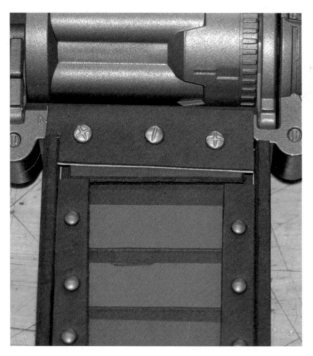

Step 6: The Barrel

If you are looking at this and thinking, "Wow! That looks pretty good just like it is. I want to play with it now!" you could stop here. But think about how it will look even better with only a bit more effort!

I'm also going to discuss something a little more advanced. It's the idea of "breaking the silhouette." The Nerf Maverick has a very recognizable profile and overall look. The more you change that look, the more it will become your own creation and less like just another painted toy. Go forward and create!

Draw a mark around a paper towel roll 3 inches from one end, and use your scissors to cut it off.

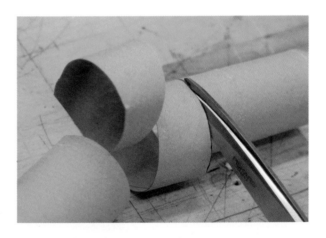

Hint

The way to cut out the barrel without making a mess of it is to cut straight across the roll about midway, and then cut in a spiral toward the line you drew.

You need to cover this with a piece of black Fleather tape 3 inches wide and long enough to just go around the tube. Mine is 5 3/5 inches long,

but use your measuring tape to measure yours just in case. Remember, if you make it a little long, you can always cut a bit off. This is probably a good time to color the edge and the inside of the tube with a black marker.

To make things easier, we're going to call this the barrel from now on. With the seam on the bottom, place the barrel over the existing hole where the darts come out.

You will notice there is a bit sticking out just above that hole. Mark the location and notch the barrel just enough to accommodate that bit and to make the barrel sit flat against the piece. (You can see the notch if you look three illustrations ahead.) The notch now indicates the back of the barrel.

Time to place the site on the barrel. Cut a piece of black Fleather tape 3/4 × 8 inches long. Peel off the backing and carefully, starting at the seam at the underside of the barrel, butt the two ends of the tape together so the long edge of the tape is flush with the barrel front end, and the excess loop of tape is at the top of the barrel. The illustration shows exactly how you want it.

You might think this looks good enough, but you can do even more, if you like.

Cut a rectangle of black Fleather tape 1 1/2 × 2 inches long. Cut this into a triangle with a 2-inch wide base and 1 1/2 inches tall in the middle by folding it in half and cutting diagonally from an outside corner to a fold corner. Peel off the backing and fold this over the top of the site on the front of the barrel.

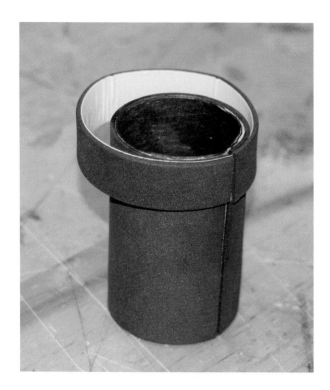

Smooth the tape along both sides toward the top of the barrel, keeping them even so the extra tape will stick up at the exact top of the barrel.

Pinch the extra bit at the top together.

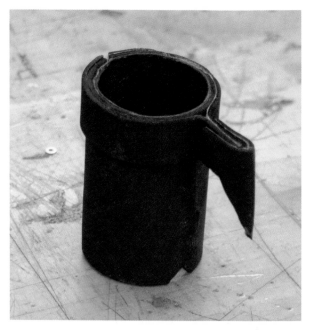

Cut a piece of black Fleather tape 1 × 4 inches long and another 1 × 3 1/2 inches long. Run the 4-inch piece of tape from the front of the barrel on the bottom, covering the seam, with the seam along the centerline of the tape. Run the 3 1/2-inch piece along the top of the barrel from just behind the site straight back past the rear of the barrel. Fold the two pieces sticking back from the barrel along the sides of the barrel.

Cut two 1/2-inch wide pieces of double-sided duct tape 2 inches long. Be clever: The tape is usually 2 inches wide to begin with, so just cut 1/2 inch off the end, twice. Peel the backing off one

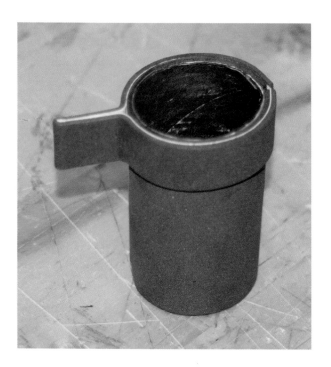

side and apply a piece to the inside of the back of the barrel at the side, 90 degrees around from the top. Place the other piece of tape directly across from the last one.

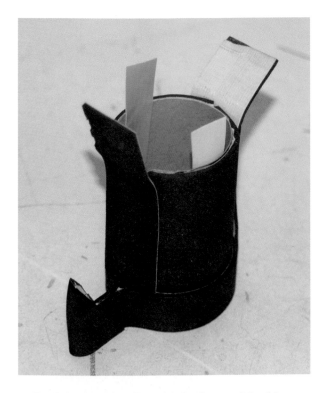

Peel the backing from both pieces of double-sided duct tape. While holding all the various pieces of tape out of the way, place the barrel centered over the hole with the notch and site upward, then slide the barrel up until the rim of the hole on the piece hits the bottom of the barrel.

Press the two exposed pieces of tape against the main body of the project. Run the bottom piece of tape down the front of the piece, and the top piece along the piece above the chamber.

Make a piece of rivet tape 3/4 × 5 inches long, with five rivets on it 1 inch apart, beginning with the middle one in the center of the tape. Stick this right behind the barrel with the center rivet right on top and the rest of it running down the sides of the gun.

You are almost done! I know, it does look rather awesome and I do not blame you for being impatient. After all, you had to let that paint dry and then paint it again; you are tired of waiting! Go ahead and stop if you want, but someone else is going to keep going and then their piece just might look even cooler than yours.

Trust me, it won't take that long.

Step 7: Further Embellishment

Since this is a Rivet Gun, I used a copper paint marker to color the cylindrical parts on the chamber to make them look like copper rivets. I used a plain black marker to color the parts of the chamber between the rivets; this makes them look even brighter.

There are 1/4-inch wide strips of tan Fleather tape down the middle of each of the brown strips in the magazine. These add some detail and make it just a bit more interesting. I made a piece of rivet tape, 1 × 12 inches long. It has two rows of small copper split brads spaced 1 inch apart. I have run this around the outside of the magazine. This not only looks rather spiffy, but also makes the magazine more durable.

What diabolical plans do you have for yours?

Will it work? Untried and untested, our heroes will just have to wait and see if this thing will be effective against the combat automatons.

SAFETY WARNING

As with your formidable Grappling Hook Launcher that you made in Chapter 7, be sure to heed this **most important safety warning**: In making this piece look so good, it also looks dangerous. Do not take it outside and start waving it around. Do not point it at anyone. If you run into Giant Killer Automatons, however, fire away!

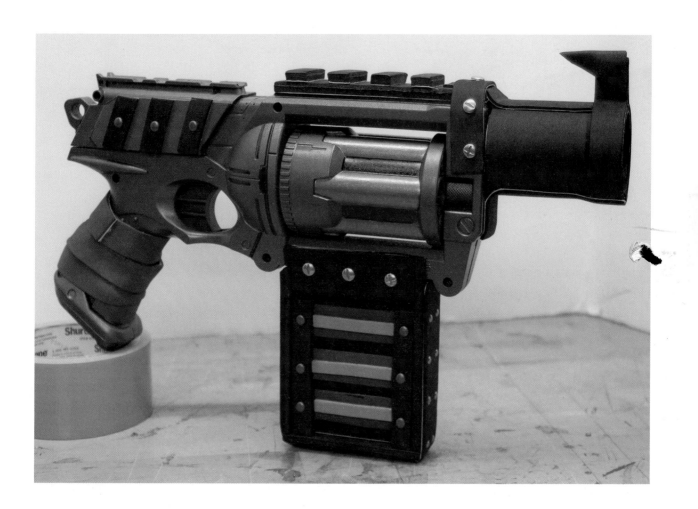

Chapter 11

Power Armor and Magnetic Amplification Gauntlet

Wherein our heroes are reunited

When Amelia returned with HEC, the shop was a wreck. There were wires and coils everywhere and half the tools seemed to have been cannibalized to make whatever Isaac was working on. He handed the device to Amelia. It was a bit scary how much she liked things like this.

"What is it?" she asked.

Isaac said, "It's an Improved Rivet Gun. It will drill a rivet into armor plate at a distance. At least, I am pretty sure it will. I'm betting it will be very loud though, so I have not tested it yet. To fully charge it, you just have to get it close to the helium expander for a few minutes."

"HEC, did you find out anything useful?"

"Yes, I did. I made the acquaintance of a small maintenance automaton and persuaded it to tell me the layout and complement of this ship. There are seven humans on board, counting Professor Grimmelore and Doctor Claremont. There were eight small maintenance automatons of various duty lines, now there are seven. There are two Mark I Visbaun Patent Light Combat Automatons patrolling throughout the ship. I have confirmed Professor Grimmelore and the Icarus Device are indeed on the bridge behind a heavily armored door, which is guarded by four Mark II Visbaun Patent Heavy Combat Automatons."

"Why such heavy guard, while they are in the air?" Isaac wondered.

Amelia said, "They probably felt it when the cargo ship pulled away while tied to this ship and thought they were being attacked."

"Right, and then shooting the cargo ship out of the sky. I guess they are a bit on edge. Is there any way to sneak past the guards?"

HEC responded, "I am afraid there are not any conveniently large and unguarded air vents or hatchways into the bridge. The main hatch, guarded by those brutes, is the only way in or out."

"Do you think you can handle the guards?"

"I am a Type V Grimmelore Patent-Pending Experimental Model General Purpose Automaton. Though my main function is not combat, my superior programming and calculation abilities would give me a seventy-eight percent chance of turning a single Mark I

Combat Automaton into a rather uncomfortable piece of furniture with minimal damage to myself. However, though a Mark II Combat Automaton is about as clever as a small ground squirrel, its heavy armor and superior strength would make it quite formidable, and four of them would make a complete mess."

Amelia said, "So, at present, we have a rivet gun, our own automaton, and you. Against six automatons and six people, you need to even these odds."

"What? Why are you pointing at me? This whole thing was your idea!" Isaac protested.

"Yes, it was my idea, but you came along anyway, because you knew there was no other way to save Uncle Adrian. Now we are here and we cannot just go back. I am not afraid of just charging right up to those brutes and demanding they hand him over, but I am also not stupid. So now we need you to make this work. Can't you make a ray gun or another rivet gun or something?"

Isaac said, "Maybe, if I had the parts, but I don't. I used up most of the useful bits I had here making the rivet gun. I need more parts."

Amelia rolled her eyes. "That's all you need? HEC, didn't you say you could easily take a Mark I?"

HEC straightened and it seemed to Isaac that he was almost puffing out his chest. "Not a problem, miss."

"There you are. I bet those things are full of parts!"

Isaac's head began to swim just a bit as designs began to form in front of his eyes.

"When you catch it, try not to destroy it too much."

HEC's eyes turned red. "I will be gentle."

Amelia pulled back the actuator on the rivet gun and smiled, "Me, too."

As Isaac watched them go, he closed the door and mumbled, "There is no way this can end badly."

When they returned about half an hour later, Amelia was carrying its head while HEC dragged the rest of the pieces of the Mark I into the very crowded room.

Amelia said, "Sorry we took so long, we wanted to be sure we captured it as far from the bridge as we could so Dr. Claremont wouldn't hear us. The rivet gun works great. In fact, it riveted this thing's arm right to the bulkhead, so after HEC disabled it, it took us a while to pry the arm loose. The bad news is the rivet gun only fired three rivets. Then, it stopped."

Isaac said, "I bet you forgot to charge it by placing it against the side of the helium expander for a couple minutes, didn't you?" Isaac could almost feel her rolling her eyes as he greedily began looting the automaton for parts.

Amelia said, "So what is your latest ingenious plan?"

Isaac answered, "If we cannot go around those big automatons, we need to go through them. I knew the rivet gun would be quite effective against them, but I don't think that will be enough. We need HEC to help us. I know he is not built for this—yet."

The children both looked at HEC.

HEC slumped a bit and said, "There is no way this can end badly."

"I'm going to make you some armor, but not just any armor. I'm going to modify the magnetic coils from this Mark I to bond the armor and make it five times as strong and the coils will enhance your strength, too. It will be Power Armor."

Amelia said, "So I have the rivet gun and HEC will have the battle armor. Are you going to just stay here and wait until the fight is over?"

"No! After making the armor for HEC, I will have just enough parts to make a Magnetic Amplification Gauntlet. It will be magnetically propelled so that once you get it moving, almost nothing but the one controlling it can stop it."

"That sounds exciting!"

"There is only one problem. These things require an enormous amount of energy. We have to charge them straight off the helium expander power cables. When we do this, the ship will drop in altitude enough that the crew will know something is up. Oh, also these things can only hold a charge for a few minutes at most, so we have to get from the center of the ship, fight off the automatons, get through the armored door, rescue our uncle, and grab the device, all before we run out of power."

"That's two problems," Amelia said smugly.

"Actually, it's three problems."

"What's the third problem?"

"You are sitting on my work bench. Please stand over there, out of the way, and guard the door. HEC, take these things apart so I can get to work."

"Yes Sir."

You may be wondering why there are two projects in this one chapter. It could be because the Power Armor and the Magnetic Amplification Gauntlet are of a similar construction but the real reason is there was no way to make them separately in the story. We can't just leave Isaac in the maintenance closet and let Amelia and HEC have all the fun, now can we? No! So, they are both happening now. Let's get started.

Build the Power Armor

This is probably the biggest and most challenging piece in the whole book, but I know you can do it! I made the measurements as generic as I could. You may need to adjust them to fit your needs. Go on! Be bold! Make this any color you like. Use the basics I show you here and make it yours.

Materials

- 2 12 × 18-inch sheets of red craft foam
- 2 12 × 18-inch sheets of black craft foam
- 2 9 × 12-inch sheets of black craft foam
- 1 9 × 12-inch sheet of red craft foam
- 4 9 × 12-inch sheets of 1/4-inch thick black craft foam
- 1 roll of double-sided duct tape
- 1 roll of black duct tape
- 1 roll of clear, wide packing tape
- 3 boxes of 50 paper fasteners (like big, 3/4-inch or 1-inch long split brads—they are an office supply thing)
- Loads of split brads

Tools

- Scissors
- Tape measure
- Permanent marker
- Straightedge or ruler
- Copier or computer with a scanner and printer
- Awl, nail, or skewer
- Rotary hole punch
- Cutting board

Step 1: The Chest Plate

Take two full sheets of 12 × 18-inch red craft foam and make them into one full sheet of Fleather. Review Chapter 2 for the proper Fleather-making techniques. I recommend you run the tape across the 12-inch edge and work your way up the sheet. It will work better this way, trust me.

Place the sheet of Fleather on the table, with the long side horizontal to you.

Measure 13 inches from the left to the center of the lower long edge and make a mark there; repeat for the upper long edge.

Use your straightedge or ruler to draw a line connecting these marks and then cut carefully along this line because you will need both pieces for this project.

The 5-inch piece will be the "back plate" and the larger piece will be the "chest plate." Put the back plate aside awhile and let's get started on the chest plate.

We're going to use a few patterns for this project, as you can see in Figure 11-1. See Pattern 1 with the circles labeled 1, 2, and 3? Download that file (and the other patterns, while you're at it) from www.mhprofessional.com/steampunkadventurer.

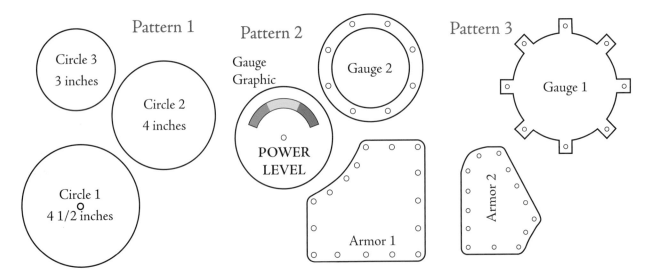

FIGURE 11-1 Patterns for the Power Armor

Print it on card stock or heavy paper if you have it available, but regular printer paper will do. Carefully cut out all three circle patterns. Take your time, and if you mess one up, just print another.

Select the 12 × 13-inch piece of red Fleather, and find the exact center of one of the 12-inch edges. Now, you may have had to trim the Fleather a bit to get it just right, so this edge may not be exactly 12 inches. Find the center of what you do have instead of just measuring 6 inches from the long edge. This will be the top of the chest plate.

From the center mark, measure 5 1/2 inches straight into the middle of the chest plate, and make another mark.

Select your cutout of the Circle 1 pattern. Find the small circle at the very center of Circle 1, and poke a hole there big enough to see the mark on the chest plate.

Place the pattern on the chest plate with the mark visible through the hole in the center and trace around the edge of the Circle 1 pattern.

Trace a 1/4 circle to round off the corner of the chest plate. Repeat this for each corner. Trim the corners to these marks.

Make a mark 3 inches to the left of the mark at the midpoint, along the top of the chest plate, and then make another to the right.

Use your straightedge to draw a line from the mark on the top left down to the point in the center of the circle and another from the top right mark. It will look like a "V" going into an "O."

Select the Circle 3 pattern. Place it on the corner of the chest plate so it just touches two of the edges.

It's time to cut out the "V" and then the "O." Do this carefully; as always, take your time. When you are done, draw a black dot, like a little eye, on the circle with a "V" cut out of it. This has nothing to do with the project: I just think it's funny.

Step 2: A Bit of Armor

It is time to get back to the patterns for this project. Take Patterns 2 and 3, print, and cut out the pieces labeled "Armor 1" and "Armor 2." I recommend you use the smallest setting on your rotary hole punch to make the small holes where indicated around the edges of these patterns.

Place the pattern pieces on a 9 × 12-inch sheet of thick, black craft foam, while keeping in mind that you are going to use the patterns twice to cut a total of four pieces (study the illustration to see how I arranged the patterns).

Trace around the edge of each pattern piece and mark all of the hole locations. Then, flip them over, place them in the leftover spaces on the sheet of foam, and trace them again. This will make left and right pieces.

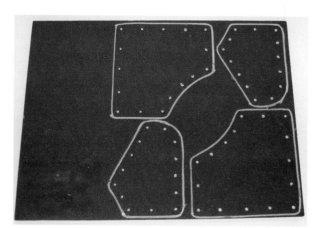

I know I have told you before that you can mark on the black foam with a black marker and it will leave a faint but usable mark. This time I am going to recommend you use a silver water-based paint marker. If you have it, why not use it?

Cut around the outlines of the pieces, and then punch the holes using the smallest setting in your punch.

Flip the armor pieces over so the marker marks will not show when you mount them on the chest plate.

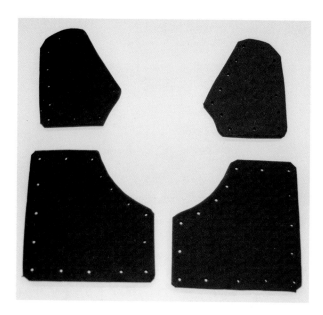

Now you are going to carefully place the armor pieces on the chest plate and I'm going to tell you how to do that. But first, this would be a good time to put a piece of double-sided duct tape on the underside of each of these pieces. You do not need to cover all of it; a 2-inch square piece right in the middle should do rather nicely.

Place the left Armor 1 piece so the bottom edge is 2 inches from the bottom of the chest plate and the left edge of the armor is 1/2 inch from the left edge of the chest plate. Peel off the tape backing and stick the piece in place.

And because bilateral symmetry is kind of fun, do the same thing on the right side.

Then, take your pointy, pokey thing and push it through the holes in the Armor 1 pieces and through the chest plate. Fill these holes with 3/4-inch paper fasteners, which are long enough to go through all layers.

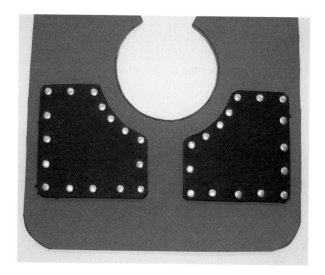

Your work table may be quite a mess, but find both of your Armor 2 pieces. Apply a small piece of double-sided duct tape to the back of each.

Position the pieces with the top edge 1/2 inch down from the top of the chest plate and the sides 1/2 inch from the outside edges. Peel the backing off the tape and press down hard to keep the pieces in place.

Use your pointy thing and push it through the holes in the Armor 2 pieces and through the chest plate. Fill these holes with 3/4-inch paper fasteners.

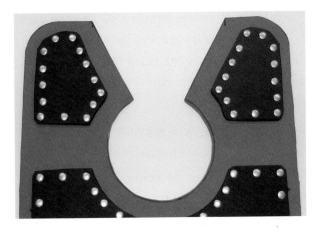

You can leave out the top fastener for now because you're going to attach a strap there later.

Step 3: Make the Belt

Use two 12 × 18-inch sheets of black craft foam to make a single 12 × 18-inch sheet of black Fleather.

Cut a 1 1/2 × 18-inch strip from one long edge. I had to trim mine a bit so it came to 17 inches, and that is fine. This is now the waist belt.

Find the midpoint of one of the long edges and make a small mark 1/4 inch in from the edge. Make four marks at 1-inch increments to the right of this mark and then four more on the left. You should end up with nine little marks, 1 inch apart, 1/4 inch from the edge and centered on the length of the belt.

Do the same thing along the other long edge. And then use your sharp, pokey thing to put a hole in the belt at each mark.

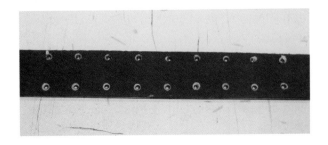

Cut a piece of double-sided duct tape 1 × 9 inches. Apply this to the back of the belt, right in the center.

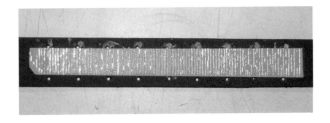

Peel the backing off the tape and place the length of the belt centered on the bottom of the chest plate, with the bottom edge of the belt even with the bottom edge of the chest plate. Press it down nice and hard to make it stick well. Use your sharp, pokey thing in the holes of the belt to push holes through the chest plate. Insert a 3/4-inch paper fastener in each hole.

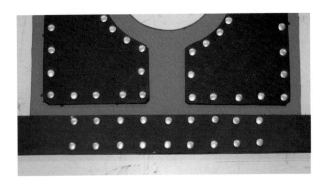

When you are using paper fasteners or split brads near the edge of a piece, be sure to rotate them so the pointy parts do not stick over the edge.

See the one on the bottom right in this picture? Yeah, don't do that.

Step 4: Make the Riveting Details

Cut a 9 × 12-inch sheet of black craft foam in half the long way, giving you two pieces 4 1/2 × 12 inches. Make one of these pieces into a sheet of Fleather tape, with the tape running the long way.

From this, cut a 1 × 12-inch strip. From this strip, cut the following pieces: two 2 inches long, one 2 3/4 inches long, and leave the remaining piece as it is. Do not peel the backings off of these just yet.

Peel the backing from the 2 3/4-inch piece and apply it to the chest plate, evenly spaced between the bottom armor pieces and with the lower end touching the belt.

Peel the backing from one of the 2-inch pieces and apply it to the chest plate, evenly spaced between the two right-side armor pieces and with one end spaced 1/2 inch from the outer edge of the chest plate. Repeat this for the left side.

I thought this looked a bit plain, so I put two rows of small dots, spaced 1/2 inch apart about 1/4 inch from the edges of each piece. And because I cannot get enough of these little fake screw-head split brads, I punched a hole and put one at each of those marks.

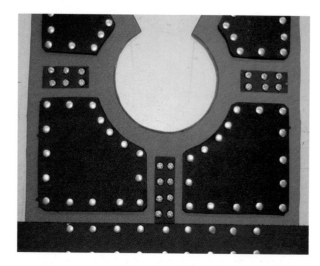

Step 5: Form the Chest Plate

It is time to form the chest plate. Even flat like this, it looks pretty cool, but not good enough for you! You still have that long piece left over from the piece of Fleather tape you cut in Step 4. It should be about 5 inches long. If not, make a new piece 1 × 5 inches. Peel the backing off this piece, and place it along the opening at the top of the chest plate, starting 1 inch above the circle and off the edge of the top, with the tape half on and half off the edge there.

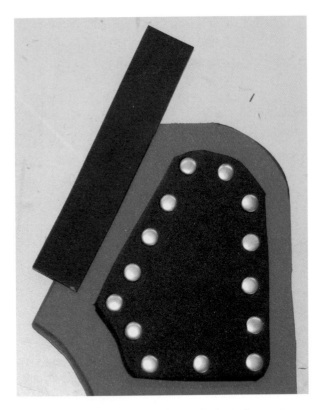

Bring the two sides of the "V"-shaped opening together and use the Fleather tape to seal the gap. Fold the tape sticking out the top over and onto the inside.

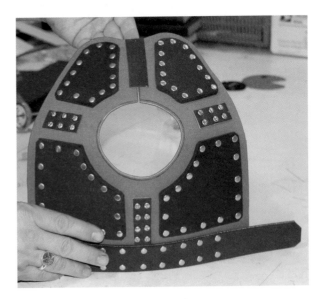

Use a piece of black duct tape to cover the gap on the inside from the top of the chest plate to the edge of the circle. This will add strength to the seam here.

Embellish this the same way you did the other pieces of Fleather tape.

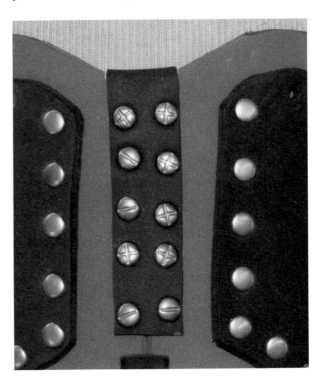

Step 6: The Gauge

It's time to fill that big hole in the chest plate with the gauge, and we'll need the patterns to do that. You probably already have them from when you made the armor patterns. The pieces you need are Gauge 1, Gauge 2, and Gauge Graphic (refer back to Figure 11-1). Print them up, cut them out, and punch all the holes.

You probably noticed I did not cut right to the edge on the gauge graphic. That's because I will back it with double-sided duct tape. The extra paper will make it easier to trim, so go ahead and apply that double-sided duct tape to the back and trim the graphic to the outline.

Hint

Maybe when you printed these, you had to use a black and white printer. If that is the case, use red, yellow, and green markers to color in the gauge.

You should still have half a piece of black craft foam about 4 1/2 × 12 inches, lying about somewhere. Cut a 5-inch piece off of one end and make that into a piece of Fleather tape.

Trace the Gauge 2 pattern on the front of it with a black marker and don't forget to mark the holes. Cut the piece from the Fleather tape. Do not peel off the backing.

Grab another sheet of 9 × 12-inch black craft foam and cut a 6 × 6-inch piece from one corner. Make this into a piece of Fleather tape.

Trace the outline and holes of the Gauge 1 pattern onto this piece of Fleather tape, cut it out, and punch the holes. No peeling, yet. You should have three pieces that look like what's shown in the upcoming illustration.

The gauge graphic needs a needle. You can draw one in if you like. I tend to make all gauges point to the red zone. It makes it look like there is always something dangerous just about to happen.

Some craft stores have clock hands and such. I found a package of little hands at my craft store and will be using one of those.

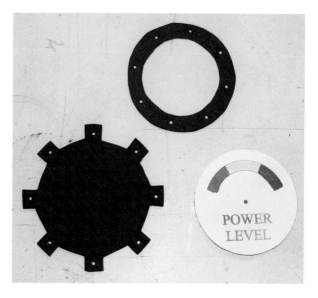

Another thing worth doing is making the gauge look like it has a glass face. A really easy way is to cover the face with shiny, clear tape. Wide packing tape is best.

Peel the backing off the Gauge 2 part and center the piece on the gauge graphic with the top of the graphic directly between two of the holes on the Gauge 2 part.

Peel the backing off the graphic and center it on the Gauge 1 part with the top of the graphic directly under one of the holes on Gauge 1.

Punch the holes from Gauge 2 and the hole in the center of the graphic, all the way through the back of Gauge 1. This is now officially the gauge.

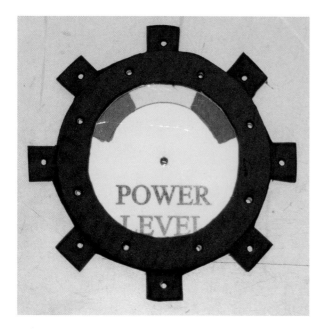

Peel the backing off the gauge. Fill each hole in Gauge 2 with a split brad in your color choice. I'm using copper. I am also putting the clock hand on at this time, using the small brad that came with it. This allows it to spin so you can "Power Up" and run out of power at the most dramatic moments.

Place the gauge directly over the hole in the chest plate, with the top tab straight up toward the top of the chest plate. Press the very sticky tabs onto the chest plate.

Poke the holes from the tabs through the chest plate. Fill the holes with your choice of split brad.

Step 7: The Back Plate

It turns out the piece of red Fleather that is left from the making of the chest plate is the perfect size to make the back plate. Yay! Cut that piece down to 4 1/2 inches by 11 1/2 inches. Use the Circle 3 pattern to mark all four corners of the back plate and trim the corners.

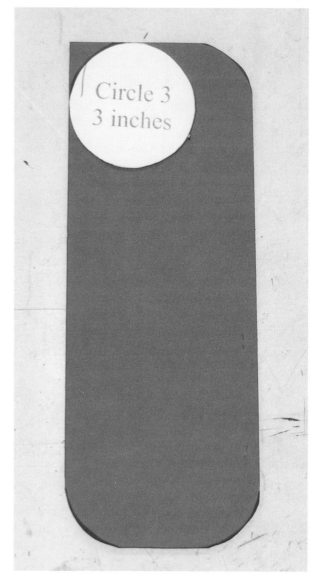

You should also have one big piece of black Fleather remaining, about 10 1/2 × 18 inches. From that, cut a 1 1/2-inch strip down the 18-inch side. Cut off a 7 1/2-inch piece from this, and

round off each corner, cutting about 1/4 inch in. This is now the back belt.

Place the back belt centered on top of the back plate with the bottom edge even with the bottom edge of the back plate. Mark two holes, 1 3/4 inches apart, centered on the length of belt and 1/4 inch down from the top edge. Do the same for the bottom edge. Secure the belt to the back plate with four 3/4-inch paper fasteners.

You should have some thick black craft foam left over from cutting out the Armor 1 and Armor 2 pieces. Back this piece with double-sided duct tape, then cut it down to 3 1/2 × 9 inches.

Use the Circle 3 pattern to mark and trim the two top corners. Peel off the backing and stick it in the center of the back plate, 1/2 inch above the belt.

Mark and punch holes all the way around, about 1/2 inch from the edge and 1 inch apart. Insert a 3/4-inch paper fastener into each hole.

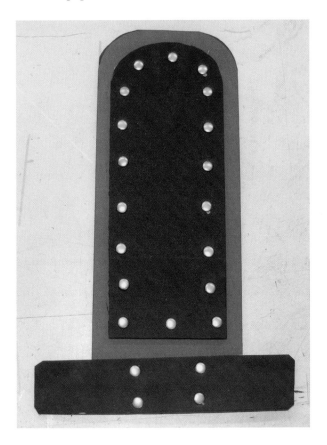

Step 8: Strapping

I've been keeping track of the supplies, so I know you have a piece of black Fleather 1 1/2 × 10 inches, or thereabouts, tucked away somewhere. Cut a 1/2-inch strip off one of the long sides. From this, cut two 3-inch long pieces (you'll have about 4 1/2 inches remaining).

Punch a small hole 1/4 inch from both ends of each strip and a hole in the center of each. We will call the center one Hole Number 2 for a while and the pieces are now the side straps.

Place one of the side straps centered on the end of the back belt so that Hole Number 2 is 1/4 inch in from the edge of the belt. Push a 3/4-inch paper fastener through each hole and do the same for the other strap on the other end of the belt. Don't forget to poke the holes through the belt first.

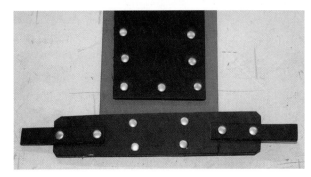

Put a 1-inch square of black duct tape over each fastener's back.

Now let's switch to the chest plate for a bit and make some shoulder straps. From your stock of black Fleather, cut a 3 × 11-inch chunk out of one corner.

From this, make two 1 1/2 × 11-inch straps. Cut about 1/2 inch off each of the corners to make it look nice.

Use the biggest setting on your rotary punch to make a hole 1/2 inch in from each end of both straps. Pick an end, no matter which, and mark and punch six more holes 1 inch apart.

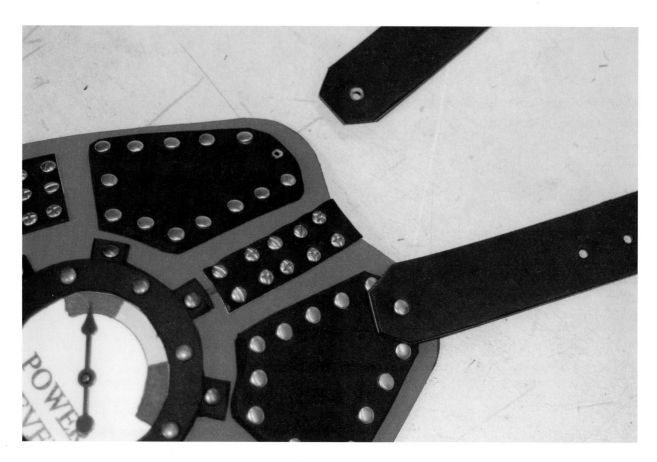

Place the single hole on the strap over the hole in the top piece of the armor and insert a 3/4-inch paper fastener through the strap and the chest plate. Do this on both shoulders.

On to the back plate. Remove both of the fasteners on either side of the top center fastener on the armor. You are going to need help with this part. Hold the chest plate and back plate onto your

chest and back, run the straps over your shoulders, and have someone mark the holes that make it fit you best.

You will most likely have to remove the fastener from one of these straps each time you want to put the armor on or take it off, so once you have the back adjusted, just leave it like that and use one of the fasteners in the front as they are easier to reach.

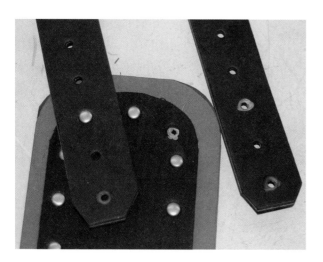

Cut two strips of black Fleather 1/2 × 11 inches long. Cut a point at one end of each and punch a small hole 1/4 inch from the other end of both. Punch another hole 1 inch in from the last hole.

Place the strap centered on the width of the belt, with the second hole 1/4 inch in from the belt end.

Punch the two holes through the belt and secure them with 3/4-inch paper fasteners. Cover the backs of the fasteners with a 1-inch square of duct tape.

Begin at the pointed end; measure, mark, and punch small holes every 1 inch to the belt.

Make another strap for the other end of the belt.

There are two side straps, so I am going to show you two ways to connect the front straps to the back straps.

This first way is super simple. You put the piece on and line up the correct hole on the front strap with the hole on the back strap and insert a fastener.

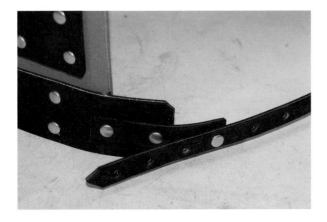

The second is to find and attach a small buckle. The one in the picture came in a pack of six and

attaches to the end of the back strap with a small split brad that comes with it. How cool is that?

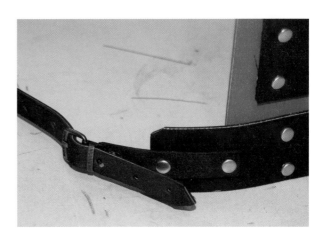

Step 9: Finishing Touches on the Body Armor

It all looks pretty good on the outside. On the inside there are a few things to clear up, like the big sticky part in the middle of the chest.

Trace the outline of Circle 2 onto any piece of black craft foam you have left and cut it out.

Press that onto the sticky underside of the gauge.

Then, use black duct tape to cover any of the fastener backs that you do not need to be able to remove for fitting or dressing. This will make it all much more comfortable.

Step 10: Shoulders

You are about to do some pretty heavy 3-D geometry. Don't worry, it will be fun. There are two arms, so there are two shoulders. A piece of shoulder armor like this is called a "pauldron." Both are the same so you'll need to make two of these. Got it?

Place a 9 × 12-inch sheet of thick, black craft foam on the table, with a long edge facing you.

Draw a line 3 1/2 inches in, parallel to the right edge and a line 3 1/2 inches in, parallel to the left.

Then, draw a line 3 inches parallel to the top and one 3 inches parallel to the bottom.

Make a mark 1 1/4 inches from the left side along the top edge and the bottom edge, then make a mark 1 1/4 inches from the right side along the top edge and the bottom edge.

Cut just enough to remove the parts containing the "X." Then, cut about 1/4 inch off the tips of the pointy bits.

Draw a line from the marks you just made on the long edges to the nearest intersection of the other four lines, then draw an X in the four-sided, irregular-shaped areas, or trapezoids, you just made in each corner.

Cut a piece of 9 × 12-inch red craft foam in half the long way and make a piece of 4 1/2 × 12-inch Fleather tape by backing it with double-sided duct tape.

Cut four 1-inch wide pieces off the short end to get four pieces, 1 × 4 1/2 inches long. Round off the corners slightly at one end.

You are going to make that odd-shaped flat piece of thick black craft foam into a sort of bowl shape.

Peel the backing off one of the pieces of red Fleather tape. While bringing together two sides of one of the "V" shaped cuts, start with the rounded end of the Fleather tape at the point of the "V" to seal and hold the two sides together.

Wrap the excess tape over the edge.

Use your remaining 1 × 4 1/2-inch pieces of red Fleather tape to close each "V." This is now the pauldron of the armor.

Remember, do all of this again so you have two matching pauldrons.

Now we're going to add finishing details to the pauldron.

Place a 9 × 12-inch sheet of thick black craft foam on your cutting board and cover one side with double-sided duct tape. Run the tape the short way for the best results.

From this piece, cut two 1 1/2-inch × 9-inch long strips. From one of these strips, cut five 1-inch pieces and five 1/2-inch pieces.

Peel the backing off one of the 1/2-inch pieces and apply it centered on one of the 1-inch pieces.

Poke a hole in the center of the 1/2-inch piece and through the 1-inch piece. Repeat this for the other 1/2-inch and 1-inch pieces. These are now gear teeth.

Trim the corners from the remaining 9-inch long strip.

Peel the backing from the bottom of one of the gear teeth, insert a 3/4-inch paper fastener through the hole, and then apply the gear tooth to the center of the 9-inch piece of foam.

Peel another gear tooth, insert a 3/4-inch paper fastener through the hole, and then place it 1/2 inch from one end of the long strip.

Prepare another gear tooth and place it evenly between the last two. Repeat this process from the other end.

Poke a hole 1/4 inch from each end of the long strip and you should have something that looks like this.

Peel the backing from the strip with the gear teeth and place it, running the short way, directly down the center of the pauldron.

Poke holes through the ones at the ends of the strip and through the pauldron, and then insert 3/4-inch paper fasteners.

At 1/4 inch in from each of the long edges of the red Fleather tape, mark four evenly spaced spots for you to poke holes and insert 3/4-inch paper fasteners.

You should have a 4 × 6-inch piece of black Fleather there somewhere: cut this into four 1 × 6-inch pieces.

Select two of these pieces and poke a hole 1/4 inch from one end of each.

Open one of the paper fasteners from one end of the gear strip on the pauldron and run the fastener through the hole on one of the strips you just made, then close the fastener.

Step 11: Arm Pieces

There is supposed to be a piece of black Fleather, about 4 × 18 inches, left over from previous parts. Cut this in half, giving you two 4 × 9-inch pieces. Now cut those each down to 3 1/2 × 9 inches. Trim about 1/4 inch off each corner. These are your upper arm pieces.

Select the two remaining 1 × 6-inch pieces of Fleather. Trim a bit off each corner. Punch a small hole 1/4 inch from one end of each, then another 1 1/4 inch from the same end. These are the arm straps.

Place one of the arm straps on top of an upper arm piece with the second hole 1/4 inch in from the short edge.

Punch through the holes on the straps and through the upper arm piece. This image shows what you should have now.

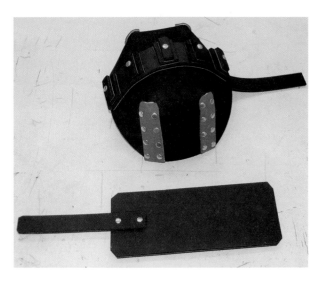

Punch the following holes:

- The center of the top (one of the long edges) of the upper arm piece, 1/4 inch in from the edge.
- The center of the end of the upper arm piece that does not have the strap, 1/4 inch from the edge.
- One at 1/4 inch from the end of the strap.

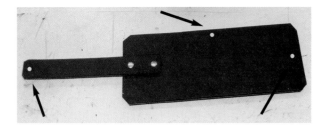

Place a fastener in the hole at the end of the strap and connect that to the hole at the other end of the upper arm piece, making the upper arm piece into a tube.

Open the paper fastener on the side of the pauldron that does not have the strap on it and run the fastener through the hole on the top of the upper arm piece, then close the fastener to connect the upper arm piece to the pauldron.

Use a 3/4-inch paper fastener to connect the strap at the top of the pauldron to the shoulder strap of the armor. You will have to try it on to get the fit and location of the holes just right.

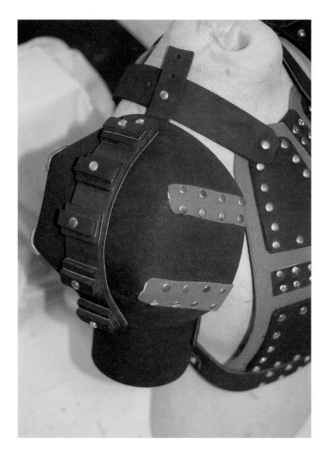

I know this has been a big project, but it's almost done! Some embellishment, and some clean up, and you will be ready to fight off those Mark II Combat Automatons.

Step 12: Embellishments

You can use whatever you like or can find to get the effect you need. The split brads and paper

fasteners are great, but I found some faux pearl stickers in the scrapbooking section of my local craft store. Just peel and stick them on. They actually stay on pretty well, too.

The only thing left after adding your personal touches is to go through the whole thing and put some black duct tape over any pointy bits you can find inside the armor.

Look at that! While wearing this, no automaton will stand a chance against you!

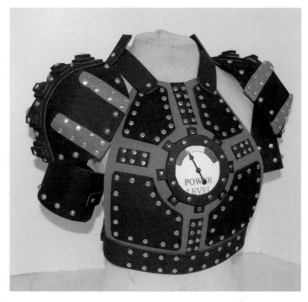

FRONT VIEW

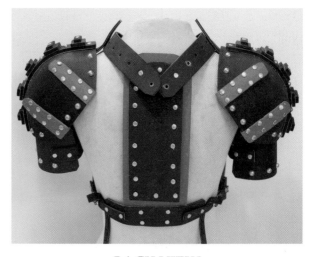

BACK VIEW

Build the Magnetic Amplification Gauntlet

This is the Magnetic Amplification Gauntlet. It is pretty simple to make, especially after making that armor! Imagine another adventure, where you have the armor and one of these gauntlets on your arm: You would be near unstoppable . . . that is until you ran out of power.

Materials

- 2 9 × 12-inch sheets of brown craft foam
- 1 9 × 12-inch sheet of black craft foam
- 1 9 × 12-inch sheet of tan craft foam
- 1 roll of double-sided duct tape
- 1 roll of black and brown duct tape
- Assorted split brads
- 1 yard of 1/2-inch wide braded elastic ribbon
- 1 glove, black or brown (you choose which hand), preferably lightweight leather, or cotton

Tools

- Copier or computer with scanner and printer
- Scissors
- Straightedge or ruler
- Awl, nail, or skewer
- Permanent marker
- Standard pen or pencil

Optional Tools

- Rubber stamps
- Ink

Step 1: Cut Out Your Patterns

As with the previous project in this chapter, there are some patterns you'll need for this one (see Figure 11-2). Download the patterns from www.mhprofessional.com/steampunkadventurer and print the ones labeled "Grill," "Armguard

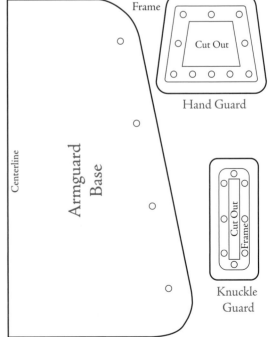

FIGURE 11-2 Patterns for the Magnetic Amplification Gauntlet

Base," "Knuckle Guard," and "Hand Guard." Card stock would be best for these, but regular printer paper will do fine.

Cut out all of the pattern pieces, and punch all the holes.

The Armguard Base pattern has the word "Centerline" printed on it. This is only half of the pattern for the armguard base. Print, copy, or trace another copy of the armguard base, flip one of them over and match this line on both. Taping them together wouldn't hurt. That will give you the complete Armguard Base pattern.

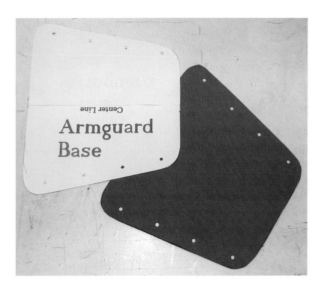

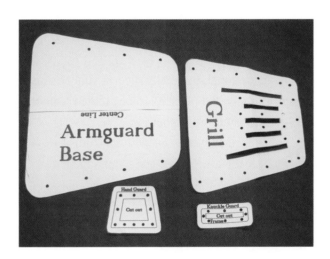

Step 2: The Base of the Arm Guard

Use two pieces of 9 × 12-inch brown craft foam to make one 9 × 12-inch piece of brown Fleather.

Trace the Armguard Base pattern on the brown Fleather and cut it out.

Punch the holes along the edge with your rotary hole punch on the largest setting.

Step 3: The Grill

Use one sheet of 9 × 12-inch black craft foam to make a full sheet of Fleather tape.

Trace the Grill pattern onto this piece of Fleather tape.

Cut the outline, punch the holes, and cut out those strips that make it actually look like a grill. Do not peel the backing yet.

Step 4: Put Them Together

Center the grill piece on top of the armguard base. Use your marker to mark the location of the vents in the grill onto the base. Remove the grill piece.

Use gold duct tape to cover the marks of the grill on the base. Cover well outside the marked area, but not so far as to stick out from under the grill piece.

This is optional, but really nice. A rubber stamp design can give the piece a look of tooled leather. Feel free to try this on other projects.

Peel the backing from the grill piece and place it centered on top of the armguard base.

Punch your holes through the grill piece and through the base.

Fill the holes with your choice of split brads.

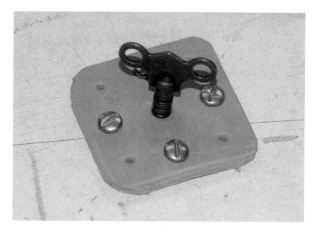

It is again time for your good friend Mr. Split Brad. Fill each hole with a split brad.

This is a good time to wrap the piece around your arm and see how it looks. If it is too big, you can trim a little off the edge and punch some new holes. Only take off about 1/4 inch at a time and remember to do it from both edges to keep it even. Does yours look like this? Of course it does.

Step 5: Steampunk Tailoring for the Arm Guard

Cut a single sheet of 9 × 12-inch tan craft foam in half the long way and make it into a 4 1/2 × 12-inch sheet of Fleather.

From this piece, make a 2 × 2-inch mounting patch with a split brad 1/4 inch in from the midpoint of each edge.

Mark a spot near each corner.

Add a gizmo of some sort (I used a key; I like wind-up things) in the middle.

Peel the backing off the mounting patch and place it centered on the large, blank part of the grill piece.

At the marks on the corners of this patch, poke the holes though the patch and the base.

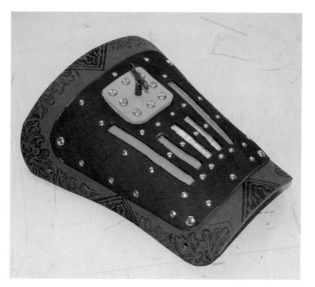

Step 6: Hand and Knuckle Guards

Select the Hand Guard and Knuckle Guard patterns. Trace them onto the brown Fleather and cut them out. Do I really have to remind you about the holes again?

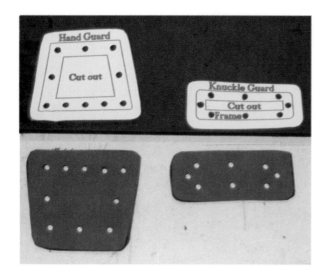

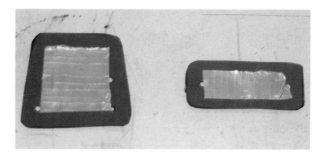

Trim away the outline of both the Hand Guard pattern and the Knuckle Guard pattern, and cut out the part that says "cut out." This will leave you with two frames.

Trace the frames onto a piece of black Fleather tape. You probably have enough left from the grill. Cut them both out so they look like this.

Peel and stick the hand frame centered on the hand guard piece. If the tape happens to be covering some of the holes, use the pokey thing to clear the holes.

Fill the three middle holes in the row of five holes across the top, the holes along the sides, and the three across the bottom with split brads. Leave the rest empty.

Apply the frame for the knuckle guard, clear the holes if needed.

Fill the two rows of three holes with split brads and leave the ones on the ends empty.

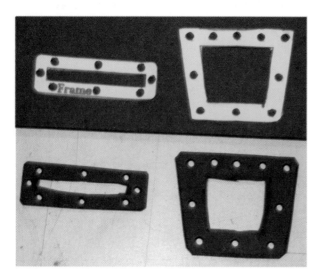

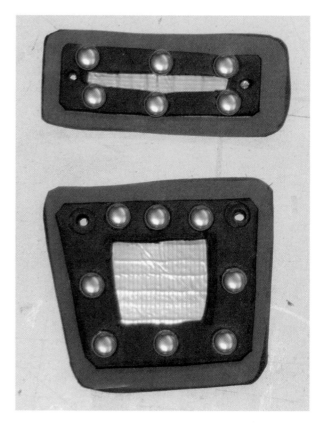

Put some gold duct tape on the middle of both the hand guard and the knuckle guard. You want to cut a piece that just covers the holes but does not go far outside them, so it will fill the cutout area but not stick out from under the frames.

Open two of the brads on both ends of one of the rows of three on the knuckle guard. Open the two brads near the corners of the wide end of the hand guard and the one in the middle of the narrower end.

Cut three pieces of 1/2-inch wide braded elastic ribbon 2 inches long.

Fold about 1/4 inch of one end over and punch a hole near the fold on each.

Put one of the open brads on the hand guard through the holes on each of the pieces of elastic with the other end hanging out over the edge.

Fold 1/4 inch of the ends of the two at the wider end of the hand guard and punch small holes in each.

Place the open brads through the holes, close up all the brads, and you will have something that looks like this.

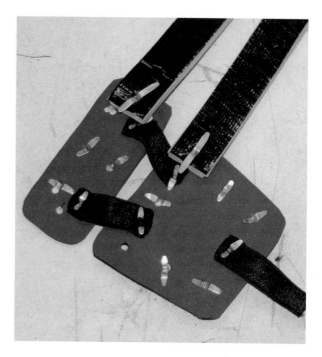

Put on the glove you selected to wear with this project. Place the hand guard on the back of your hand with the knuckle guard over your fingers. Wrap the strap for the hand guard around the palm of your hand and up over the top of the guard. Mark it just about 1/4 inch past the hole at the corner of the guard.

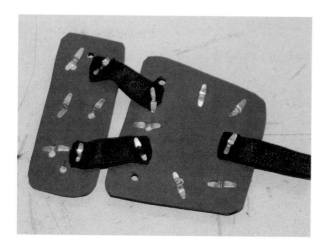

You still have plenty of tan Fleather left over from making the mounting patch. Make two strips 3/4 inches wide and at least 10 inches long; back them with black duct tape to make them stronger.

Punch a small hole 1/4 inch from one end and, using 3/4-inch paper fasteners, secure one of the strips to one of the open holes on the side of the hand guard and one to the open hole on the knuckle guard.

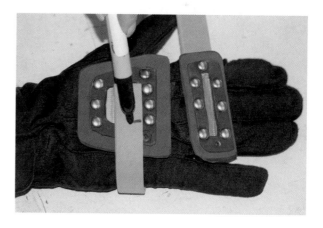

Cut the strap off at the mark and punch a hole 1/4 inch from the end of the strap. Line the hole up with the underside of the hole in the guard and put a 3/4-inch paper fastener through the hole in the guard and the strap.

Wrap the strap for the knuckle guard around your fingers and up over the top of the guard. Mark it just about 1/4 inch past the hole at the corner of the guard.

Cut the strap off at the mark and punch a hole 1/4 inch from the end of the strap.

Line the hole up with the underside of the hole in the guard and put a 3/4-inch paper fastener through the hole in the guard and the strap.

Make sure the straps are long enough to let you close your hand before you cut them off.

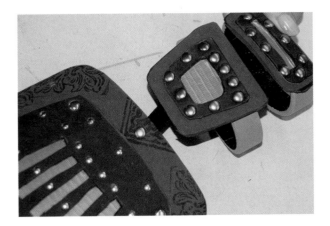

You should widen the holes along the edge of the arm guard. Use a pen or a pencil to push through the holes.

With a 24-inch long piece of the 1/2-inch elastic, lace the arm guard closed. The elastic is a bit wide, so you may need to use that pen or pencil to push the lacing through the holes.

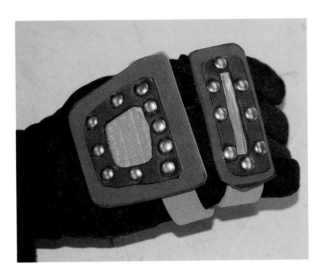

Step 7: Put It All Together

It is now time to connect the hand to the arm. That sounds much more dramatic than it is!

Punch a hole in the middle of the narrower edge of the arm base 1/4 inch in from the edge.

Fold over 1/4 inch of the last piece of elastic sticking out of the hand and punch a small hole in it.

Secure the elastic to the underside of the arm guard with a split brad.

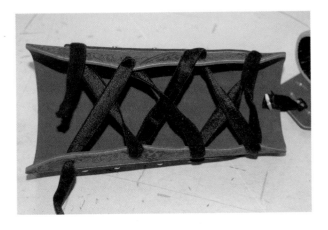

Right now, you should have an effective arm guard! It has that hint of brass showing through and would probably intimidate any Mark I Combat Automaton you would be likely to meet, but what if you meet a Mark II? Perhaps you need a little more. . .

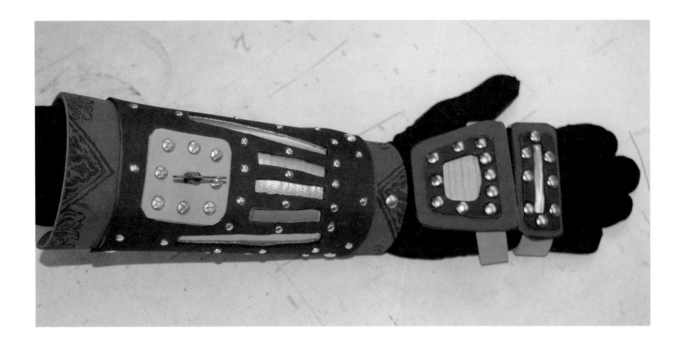

Step 8: Embellishments

This thing should "Glow with Power!" Remember the lights you used when you made the signaling periscope from Chapter 5? If you decided to jump around and have not made that project yet (how are Amelia and Isaac going to get this far without it?), well I won't make you go all the way back there. You are probably too anxious get started on this project, so here it is again.

Automotive stores and even some other stores with automotive departments now have a pretty good selection of pre-wired lighting. These things have the battery and the switch already hooked up. The set usually comes with two strips of LED lights, so when the package says "12 inches" on it, that means there are two 6-inch strips of lights. The good thing is they can be cut down to be shorter if you need. They even have a little mark on the strips with a picture of a pair of scissors to show you where to cut. So always get them a little longer than the place you want to put them.

The long vents on the grill panel are about 5 inches long, so I picked up a 12-inch light set (two strips, each 6 inches) and cut them down to fit.

Then I used the scissors to cut a small slit at the end of the vent near the wrist. I made this just wide enough to snake the strip of light through from inside.

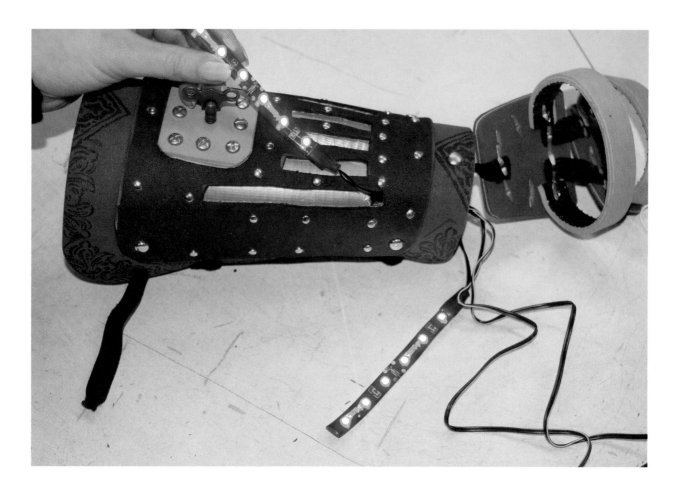

The strips usually have a peel-and-stick backing, so once you get them though the slits, peel them and stick them in the vent. I don't quite trust the stuff to stick near the end without the wires, so I punched a small hole right at that end and put a split brad there to hold it down. Of course, you would do the same for both strips.

The switch is what is called a "momentary" switch. That means it only goes on when you push the button down. This one has a little ring around it that screws off—perfect!

Put a hole in the hand strap about where your thumb would be able to press it easily.

Take the little ring off the switch, push the switch up through the hole, and screw the ring back on.

Use some brown (or black, it does not matter) duct tape to tape the battery pack into the palm of the hand part.

Maybe you are good with electrical wiring, but I am too lazy to deal with it. The wires that come with these lights are way too long for my needs, so I just lay them on the inside of the arm guard and cover them up with brown duct tape. Go through and make sure the backs to all the split brads are covered with a piece of tape so they will not be poking you.

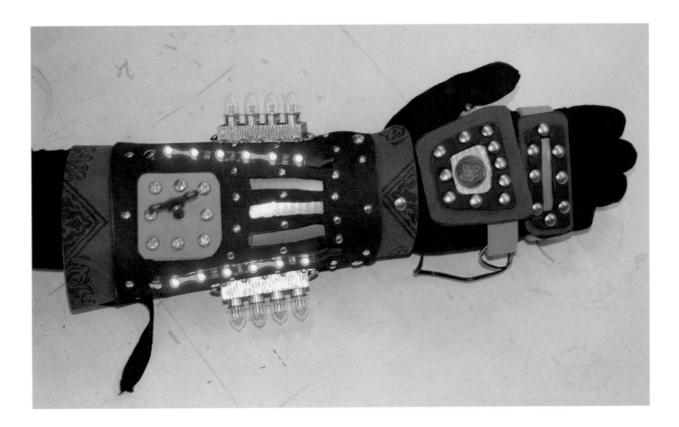

For extra detail, I added a large split brad at the back of the hand, and I found those light bulb things in the jewelry section of the local craft place.

When looking at things like that, always make sure there are loops or holes for you to put a brad through to mount them on the piece.

Isaac, Amelia, and HEC now have an impressive arsenal of Mad Science at their command. But time is running out. They have to save Professor Grimmelore before it's too late! Will they get to the bridge before they run out of power?

Chapter 12

Rocket Pack

Wherein our heroes visit their uncle

They felt the ship lurch downward a couple minutes after they hooked up the power to charge the armor and the gauntlet.

"What are you going to do when someone comes down here to see what's wrong?" asked Amelia.

With a rather smug look on his face Isaac said, "It's absolutely diabolical what I have done with the helium expander wiring. I have created something that will look like it needs a simple fix, but fixing it will actually cause a small problem. When they fix that, they will look at it and think it just does not look right. It will drive them mad trying to fix it, because it's not broken; I just changed the color of two of the wires."

Both Amelia and HEC stared at him for a moment. Amelia soon declared, "You are a very cruel little boy."

"Thank you. Now, let's stay here behind the expander housing so nobody sees us."

They could hear the two technicians arrive at the main panel and, like clockwork, within five minutes they were arguing, mostly with the wiring. About then, the crude power meter Isaac had mounted to the armor indicated a full charge.

"We need to get to the bridge as fast as possible and that is on the other side of those men. I know you cannot hurt them but they do not know that. I have a plan." After Isaac explained his plan, the children stepped out from behind the curve of the expander housing.

"What in the sky are you doing here?" one of the startled technicians demanded.

"I think we found our technical problem. We should take these little orphans to Dr. Claremont."

"We are not orphans!" yelled Amelia.

"We're with *him*!" said Isaac.

HEC then stepped out on to the gangway. His eyes were the hottest red. Isaac had fashioned the armor with heavy gears and spikes, to be as effective and terrifying as possible. HEC gave a roar and crushed the guardrail on both sides of him, then he thrust his faceplate forward and with a voice like grinding gears he yelled, "RUN!" The technicians were more than willing to oblige.

Amelia ran after them. "Let's go! You said we only have a few minutes!"

"If you would both be so kind as to follow me," HEC said as he took the lead toward the bridge.

Amelia spoke as they ran, "We need to do this quickly, I have a brilliant plan!" Isaac thought he felt his stomach fall right into his shoes as she uttered those dreaded words that had always proceeded them getting into trouble: "Don't worry, there is no way this can end badly."

At this, HEC crashed through the last door before the bridge, completely flattening the last Mark I automaton that just happened to be standing behind it. Now they faced the four Heavy Combat Automatons standing two deep and two wide, just as Amelia had expected. Each one had a right hand shaped like a mace that could open and close for a grappling attack, and the left arm had a massive circular saw blade on the end of it.

"These things are HUGE!" said Isaac.

HEC picked Isaac up, while leaning a bit forward.

"Of course they are!" said Amelia as she ran up HEC's back, then rapidly fired four rivets, pinning the feet of the first two brutes to the deck. Then, HEC threw Isaac at the now partly immobilized guard on their left. The Magnetic Amplification Gauntlet hummed and glowed as the defending automaton brought up its left arm in an attempt to fend off the projectile child. The gauntlet crashed through the arm and still proceeded to knock the guard's head clean off. Isaac landed on its chest plate as its knees buckled, and it fell backward, setting the one behind it off balance.

Meanwhile, Amelia jumped off HEC as he stepped forward with his arms up like a guarding boxer. The second automaton swung with his spinning saw blade toward HEC's unarmored head, but he easily blocked the blow with his right arm, and when the saw blade contacted the Magnetically Hyper-Bonded Steel of HEC's power armor, saw teeth flew everywhere. The armor on HEC's left arm crackled with power as he countered with a blow that tore through the Mark II's chest plate. HEC grabbed some random parts he found inside it and pulled them out. The second automaton collapsed just like the first. It had taken just under two seconds to disable the first two guards.

HEC straightened and looked menacingly toward the two remaining guards. Isaac stood next to him with the gauntlet glowing and Amelia brandished the rivet gun. The two remaining guards tried to back up a step and hit the bulkhead.

After a moment, the one on the left raised its saw arm and lifted one foot to step forward. Six rivets tore through it in a diagonal pattern from its raised hand down across the chest plate to the slightly raised foot, pinning the guard to the bulkhead. The sole remaining Mark II Visbaun Patent Heavy Combat Automaton backed against the wall, its head shaking from side to side. Its saw hand pointed at the automaton pinned against the bulkhead, and it raised its other hand with fingers open, making some piteous tones and flashing its eyes wildly.

HEC stepped forward a bit, flashing his eyes and making tones in response. After only a second or so, HEC pointed right at the faceplate of the last functioning guard. It hunched down, and pulled its arms in as it went completely silent, the eyes went dark, and it shut down.

The children were a bit stunned by this, and they both asked, "What just happened?"

HEC responded, "Ah yes, Number Three here (that is his designation) wanted me to inform you that any further action on his part would constitute a direct violation of his warrantee and he really should shut down for maintenance, anyway. Oh, and he was not very fond of these other chaps, so no need to worry there."

"Really? Why didn't you just, well, disable him like we planned?" asked Amelia.

"I believe this was a much wiser choice as—" HEC was interrupted by a loud clang as pieces of the armor began to hit the floor. All this activity had near completely depleted its charge. This was punctuated by the sound of the last piece hitting the floor.

"I think I have enough charge to open the door, but that will be it," said Isaac.

"Can't you make something, or go charge everything up from the expander again?"

"I don't think we have the time." Isaac looked about the place. There was the doorway from which they had entered, one small door on either side of the room, and the armored door to the bridge. Next to that was a set of speaking tubes with little levers on them; one had a little light blinking next to it. He flipped the lever.

"–ber Two, What is going on out there? Have you defeated those intruders yet? Report! Number Two answe–" blared out of the tube.

He let the lever close. The other two doors led to a pair of escape hatches. Isaac had to hope the gauntlet had just enough power left to do the job. He walked to the door, located the locking mechanism, pulled his arm back, and with the gauntlet activated, he swung for all he was worth.

Recently, on the bridge…

Professor Grimmelore was bound to a wheeled chair with a magnetic brake that locked it to the floor to keep it from moving about with the pitch and roll of the airship. He had managed to keep a small piece of wire hidden on him when Dr. Claremont's agents captured him aboard the *Bristol*. He was presently using it to disable the magnetic restraints holding his wrists and ankles. His left hand was free and he was pretty sure his right hand would only take a moment more.

He was not sure he could take hearing another speech from the good doctor about how DARC was "Hindering all of mankind by restraining the free flow of science to the world," and how the Fenris Alliance was going to take over the world and make it into a "Technological Utopia" where everyone would have complete exposure to even the maddest of scientific advancements, as long as they swore their allegiance to Fenris. He knew that DARC was probably the only thing keeping some inventions from wiping out everything "for the good of mankind."

A signal had just been flashed from the ground, telling the doctor where the rendezvous point would be to hand him over to Fenris. Adrian had no intention of being present for this exchange. He was certain that once he was free from this chair, he would devise an incredibly clever plan to escape with the Icarus Device.

Then, one of the doctor's assistants went to the speaking tubes near the door. He listened for a moment, opened the armored door, and closed it after admitting two

absolutely terrified technicians to the bridge. One fainted as soon as he entered. The other began ranting, "There is a rogue automaton out there destroying the ship! We need to abandon ship! I think it ate two orphans!"

Dr. Claremont turned from the forward window and asked his assistant, "What is he going on about? Rogue automatons? Preposterous! We are half a mile above the ground. What was the problem with the expander and why is that man lying on the floor?"

The terrified technician grabbed the front of the doctor's coat and yelled, "I'm telling you, there is an orphan-eating monster out there!" At that moment, a muffled crash and a shock were felt throughout the ship. The technician screamed, "It's here!" then fainted to the floor.

The doctor ignored the men on the floor as he said, "The Mark IIs will destroy anything—" more bangs, crashes, and clangs interrupted him, "that tries to get past them," he finished. A moment of silence broke with six rapid shots, leaving the ends of rivets in the bulkhead next to the door.

Dr. Claremont pointed at one of his assistants and ordered, "Find out what is going on out there!"

The assistant hit the switch next to the speaking tube and called to one of the Mark IIs, "Number Two! Number Two, what is going on out there? Have you defeated those intruders yet? Report! Number Two, answer me! Number One? Number Three?"

While the assistant tried to contact the guards, the doctor ran over to Professor Grimmelore. He leaned forward to take him by both arms and said, "Is this your doing? Is it yet another of your miraculous escape attempts? I say 'attempt' because there is no way you are getting away from here! I will turn you over to Fenris!" The doctor stood up straight and turned away while he continued, "Soon we will capture Professor Maelstromme! Then both of you and the Icarus Device will serve Fenris! Do you hear me, Grimmelore? You will serve Fenris!"

Adrian knew he should just keep his mouth shut but sometimes he just couldn't help himself.

"I'm sorry; I couldn't hear you over the sound of your entire plan crumbling to dust. Would you tell me all about it again, please?"

The doctor turned back to Adrian in a rage. He strode over to the wheeled chair, thrust his hands onto Adrian's shoulders, and said, "The famous Professor Grimmelore. When Fenris is done with you, you will not be so bold and impertinent. You will be nothing." He then pushed off Adrian's shoulders. Much to the doctor's surprise, the chair flipped onto its back. The professor had disabled the magnetic brake and all the restraints.

The doctor yelled in surprise, "NO!" as the entire lock mechanism of the armored door flew between the two of them, right through where Adrian's head had been a moment before, and went crashing through the forward window of the bridge.

The doctor, his assistants, and even Adrian looked on in shock as the door squeaked open and HEC walked onto the bridge while the wind whistled through the broken window.

The three assistants backed away from the door, and the children followed HEC onto the bridge. Isaac was rubbing the hand that was wearing the Magnetic Amplification Gauntlet.

Dr. Claremont yelled to his underlings as he dove for the airship's controls, "Seize them!"

When the assistants obediently stepped forward toward HEC and the children, Professor Grimmelore said, "HEC Code 1901AG. Protect the children!" as he jumped after the doctor. HEC's eyes went bright red and he put his arms out, keeping the children behind him and the assistants in front of them.

The assistants kept on going, right past the automaton and the children, and straight out the door.

Doctor Claremont yelled after them, "You cowardly fools! Come back here and defend the future of science!"

HEC and the children turned toward the sound of the doctor's voice. He seemed to have found a fire ax. He was using it to keep Professor Grimmelore at bay while also smashing some of the controls of the ship. The ship began to tilt, nose slightly upward, and accelerate westward away from the rising sun.

The professor stepped back a bit to give the doctor room to rant and said, "Is there even a name for what is wrong with you?"

"Oh? You think I am mad, do you? Well the joke is on you, sir! I have set the ship to head due west at top speed and have smashed the lift controls for the helium expander. You are trapped here on this ship. In about an hour we will race though the rendezvous point with Fenris."

Professor Grimmelore backed away a little more.

"It will be a simple matter for them to intercept this ship . . ."

Amelia, Isaac, and HEC now stood behind the professor and they all backed up.

"...and when they do, I will turn you all, along with the Icarus Device, over to the agents of Fenris."

Adrian looked at the table he was now standing next to and picked up the Icarus Device. "Do you mean this thing right here?"

"Do you see another Icarus Device around here?" replied the doctor.

"No, I think this is the only one on the ship; actually, the only one in the whole world." Adrian smiled.

The doctor frowned.

Adrian threw the device hard at the doctor, who easily ducked out of the way and said smugly, "Ah ha! You missed!" He then noticed it fly right out the broken window and head toward the ground over a mile below. "No! You idiot! What have you done?"

"Idiot? I thought that was rather clever of me, timing it just right to get the full dramatic effect and all that. It doesn't happen by accident, you know."

A look of rage came over the doctor's face as he raised the ax over his head and rushed toward Professor Grimmelore.

The Professor calmly said, "HEC, disarm him."

As the axe came down, HEC plucked it from the doctor's grasp with his left hand and with his right, grabbed the collar of Dr. Claremont's coat, and then lifted him about a foot off the deck. The doctor's face now looked shocked and surprised. Adrian looked him in the eye, smiled, and turned toward the children.

"All right, what on earth are you all doing here? Where are your parents? They are probably worried sick about you. How did you find me? HEC, I need to seriously go over your cards and programming."

"My apologies, sir."

Amelia said, "We came to rescue you. You said there was a spy in the department and Mum and Dad were always surrounded by people, so there was no other way."

"So, out of everyone there, you two got my message? And decoded it? Amelia, what's that you have there?" Adrian asked as he took the rivet gun from her. "Is that a projectile rivet gun? Where did you get something like that?"

"I made it in the maintenance closet for the helium expander. I also made a magnetic amplification gauntlet and power armor for HEC."

"You made all of that? And you both came here to rescue me?"

"It was her idea. I kept saying we should find a way to tell Mum and Dad."

"Let me guess: She was fearless about going forward with this adventure. Yes, well, all this will have to wait. As for now, we have to find a way off this ship. On the way into the bridge, I noticed two doors just outside of that door there. On these ships, they usually lead to escape hatches. There should be some escape balloons in there."

"Ha!" laughed Dr. Claremont, still dangling from HEC's hand. "There were only four and when those cowards ran away, they most likely took three of the balloons with them. You are doomed! Will you leave them behind to save your miserable life?"

"Let me think, how did you get onboard this ship?"

The children quickly explained how they came to be aboard the cruiser.

"Do you still have the wings?"

"They should still be in the maintenance closet."

Adrian smiled, "Excellent! There's no problem, then." He turned to HEC. "Place the good doctor here in this chair." He righted the wheeled chair. HEC placed the doctor in the chair, Adrian gestured toward the doctor with the rivet gun and said, "Don't move." He aimed and fired the rivet gun three times, the doctor screamed as the shots riveted the chair to the floor. Then, they strapped the doctor to the chair.

Adrian smiled, "My dear Dr. Claremont, the only one I'm going to leave behind is you. Then you can explain to Fenris how you managed to lose me, and the device, because of two children and my butler."

While the doctor ranted uselessly, the children's uncle explained his plan. "HEC, go fetch your wings; Isaac and Amelia, bring me the escape balloon rig with its hydrogen tanks. We are all going to get off this ship."

Build the Rocket Pack

You never know when you are going to need to make a quick getaway and a rocket pack is about as quick as it gets!

Materials

- 2 empty, matching two-liter soda bottles preferably green, with the caps
- 2 empty, matching one-liter bottles of any color, with caps
 Note: The bottles should all have interchangeable caps.
- 1 can of antique brass universal spray paint
- 1 can of hammered black universal spray paint
- 1 harness from Chapter 8
- 1 9 × 12-inch piece of 1/4-inch thick black craft foam
- 1 box of long split brads
- 2 9 × 12-inch sheet of black craft foam
- 1 box of 50 decorative split brads
- 1 roll of double-sided duct tape
- 1 6 × 18-inch piece of brown Fleather
- 1 1.5 × 8-inch strip of black Fleather tape
- Black duct tape

Tools

- Scissors
- Permanent marker
- 2 sticks, at least 24 inches long and small enough around to fit into the bottle openings
- 8 big books
- 1 nail, skewer, awl, or hole punch
- Straightedge or ruler
- Measuring device

Step 1: Prepare the Bottles for Painting

Make sure all four bottles are empty and rinsed, inside and out. Peel the labels from all of the bottles and be sure to get as much of the label removed as you can. Don't worry if you can't get every last bit, especially from the smaller bottles. Let them dry with the caps off. Replace the caps once they are dry; this makes them easier to find later. You may notice a bit of the glue line for the label will not come off. Do not worry about this. In fact it may be useful later. You know that little ring that is left when you remove the cap from a soda bottle? Use your scissors to remove them from all the bottles.

Set the two-liter bottles aside. They will be the tanks for your Rocket Pack.

Use your measuring tape as shown in the next illustration to mark around the top of the one-liter bottles approximately 2 inches down from the rim below the caps.

With your heavy craft scissors, cut the tops off these bottles. It will be easiest to squeeze the bottle in the middle to get your cut started.

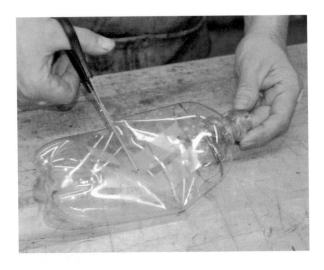

Then, cut toward the top and along the line.

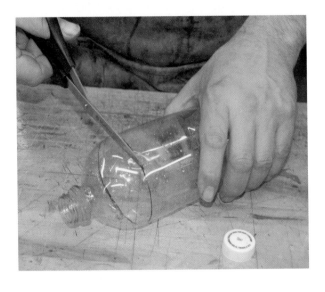

These will be the nozzles for your rockets.

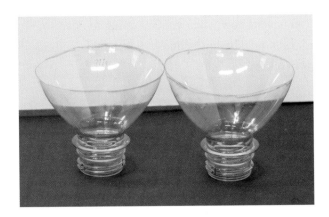

Step 2: Paint

I recommend one of the universal spray paints and primers in one. They are the easiest to use and the metallic paints give the best finish for many Steampunk devices. When you use the brass paint on a green bottle, it gives it a more interesting look. The hardest part about painting is being patient and not touching it until it's dry. I have loads of projects with fingerprints stuck in them forever.

Remove all four caps and place them on a piece of duct tape, sticky side up, about 1 inch apart. Just like in this picture.

This way, when you spray these small parts, they will not blow away and you can pick them up without touching the paint.

Now we'll do the same with the nozzles.

Hint

Please read the instructions on the paint, as different brands have different drying times and precautions, and instruction writers know what they are talking about, so please pay attention.

Spray the nozzles and the caps with the black paint and the tanks with antique brass. When spraying the tanks and nozzles, try not to get too much paint on the cap threads. Put each of the tanks on a stick so you can paint all the way around. Carefully place the sticks on a table with about four heavy books on them so the bottles are hanging off the table, kind of like this.

All these parts will have to dry overnight. Yes, really. Now, don't touch them. I know that you will be tempted to check them just before you go to bed. Don't do it. Once the tanks and nozzles are dry they should look like the next illustration.

Step 3: The Mounting Plate and Harness

While you are waiting for the paint to dry, you can make the harness to hold the tanks. It's easy; just go back to Chapter 8 and follow the instructions there. You can also make the additional Fleather components in the materials list.

Now you are going to add a mounting plate to the harness. With your scissors, cut your piece of 1/4-inch thick craft foam to 9 inches long and 7 1/2 inches wide by just cutting 4 1/2 inches off of one end of the 12-inch side.

To make it look a bit more professional, cut about 3/4 inch off each of the corners.

Draw a line down the center and additional lines 3/4 inch in from the top and bottom edge. Put a little arrow at the one end of your centerline to indicate the bottom of the mounting plate.

Along the top line, put a mark 1 1/2 inches out from either side of the centerline. Along the bottom line put a mark 2 1/2 inches out from either

side of the centerline. Using your awl or other poking tool, put a small hole at each of those four marks along the lines at the top and bottom and out from the centerline.

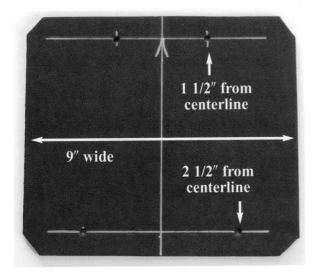

Lay your harness out on the table as in this picture. Place the loop that goes around the waist belt right in the place along the belt that hits the center of your back when you are wearing the harness.

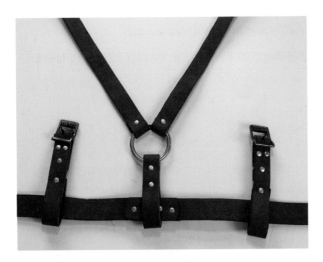

Place the mounting plate over the harness with the bottom edge of the plate even with the bottom edge of the waist belt of the harness.

Position the shoulder straps so you can see them through the holes near the top of the mounting plate.

Use a pen, nail, or something pointy to push through the holes and make a light mark on the straps behind the plate.

Remove the mounting plate and adjust your marks so they are in the middle of the straps, then punch holes in the straps at the marks.

Attach the mounting plate to the harness, using long split brads. It should look like this.

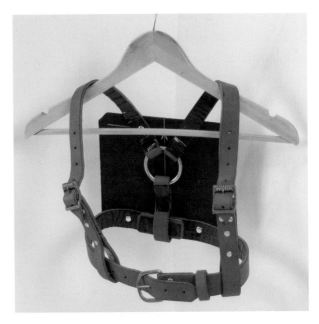

Stick a 1-inch square piece of black duct tape onto the bent-over tines of the split brads to make them more secure.

Step 4: Decorate the Tanks

From a 9 × 12-inch sheet of black Fleather, cut four 1 × 12-inch pieces. Mark each piece down the center at every inch. Skip the first mark and the last mark on every piece and put a decorative split brad at each mark. I found these ones that look like screws, but you can use whatever you can find or something you like better. You should be able to just push the brads right through the Fleather, but if it gives you any trouble, poke some holes first.

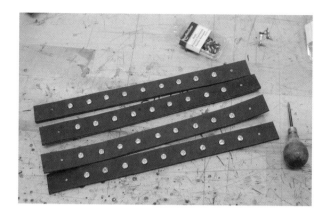

If you are a good person, you waited and now the tanks are dry and ready for you to work with them. If you were naughty, you now have fingerprints in the paint on the tanks and paint all over your finger, and I bet you made someone in your home pretty unhappy.

Examine one of the tanks. Make sure the cap is on tight. This will keep it from crushing much while handling it. Through the paint you will perhaps see the glue line for the label. Keep that side toward the mounting plate.

With the bottle standing on the table, make a mark from where the tank just starts to curve in at the top down to where it starts to curve at the bottom, and just to the right of the glue line.

Apply double-sided duct tape to the back of all four of the strips of Fleather you just embellished with the split brads and cut off any excess tape. They are now like extra-heavy rivet tape.

At the bottom, just above the part where the bottle starts to curve in, place one end of your extra-heavy rivet tape against the line you just drew and run it around the tank.

Do the same just below the part where the top of the bottle starts to curve inward. Then do the same thing to the other tank.

Note

Be careful when applying the heavy rivet tape as the tape on the back is very sticky and if you try to pull it up, you may pull the paint off of the tanks.

Step 5: Attach the Tanks to the Mounting Plate

On the back of the tanks, in the gap between the ends of the heavy rivet tape you just applied, put a piece of double-sided duct tape running from the top of the top piece of heavy rivet tape to the bottom of the bottom piece. Repeat this for the other tank.

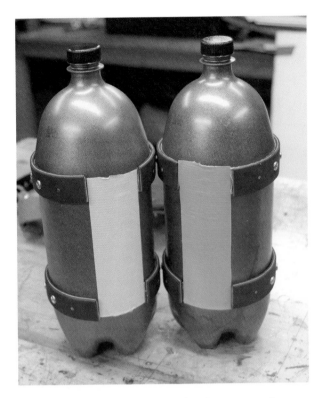

Poke a small hole about 1/4 inch from the end of each tank strap.

Then, poke two small holes in the plate about 1/2 inch in from the edge and about 1/2 inch toward the center from the black bands on the tanks. Do the same thing to the other side of the mounting plate. Attach the two tank straps to one side of the plate with two long split brads.

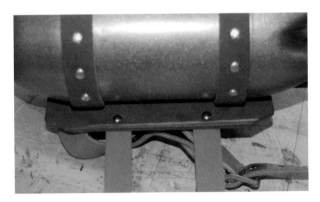

Cut four 3/4 × 3-inch pieces of double-sided duct tape, and place them on the tanks as shown here.

Place the tanks next to each other centered on the mounting plate with the caps facing down (below the belt of the harness) and the double-sided duct tape against the plate. Press them down firmly to make the tape stick.

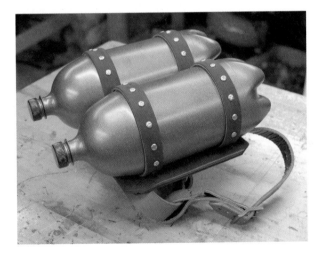

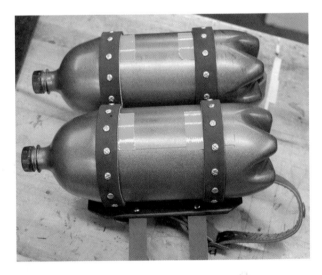

Cut two 1 × 18-inch pieces of brown Fleather tape, or make them long enough to wrap around both tanks and an inch on either side to attach them to the underside of the mounting plate. These will be the tank straps.

Peel the backing off that tape, then wrap the tank straps around the tanks so that they stick to the tape and onward, to be connected to the other side of the mounting plate with two long split brads. The tanks should now be secured to the mounting plate.

Step 6: Attach the Nozzles

Cut two 1 1/2 × 3 3/4-inch pieces of black Fleather tape. Place the tanks standing on the table with the caps up. Make sure the caps are on the nozzles. Apply a 1/2-inch square of double-sided duct tape to each nozzle cap and peel off the backing. Place a nozzle on top of each tank with the cap down so the nozzle cap and the tank cap are sticking together.

Wrap the Fleather tape around the caps, between the ridges, but make sure the ends of the tape meet on the back side where they will not be seen.

Now turn it over and look at it. You now have the basic Rocket Pack ready to go!

But why would you stop there? Basic? What type of Mad Scientist settles for "basic"?

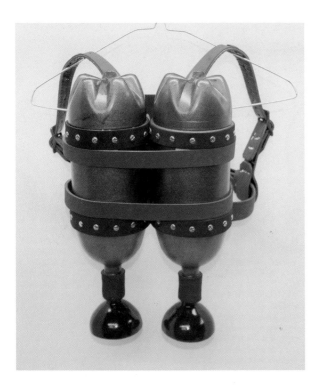

Step 7: Embellishments

I've used double-sided duct tape to place a mount patch with a valve handle on the side of each tank; a copper pipe connection across both tanks; and some rivet tape with a valve handle substituted for one of the rivets on both nozzle connections. Review the instructions in Chapter 2 for these embellishments that you can tape to your Rocket Pack to give it your own signature style.

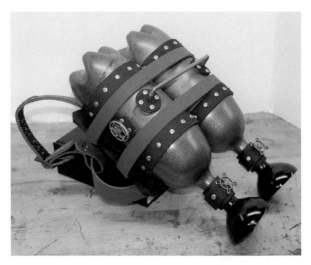

Now they can use the Rocket Pack to escape the ship before Fenris captures them. But how is Professor Grimmelore going to carry all of them with just the one rocket pack? Will he be forced to leave HEC behind?

Chapter 13

Epilogue
Wherein our heroes escape

"We have to time this just right," said the Professor over the rushing wind, by the open escape hatch.

"Just right? You want us to jump out of this hatch with HEC holding me, Amelia on HEC's back, and then HEC will deploy the wings—which could barely support our weight when it was just him and me—*and* as we hurtle toward the ground you are going to jump out with the rocket pack trailing a rope, which HEC will grab with the arm that is not holding me *and* you will tow us behind you. Did I miss anything?"

"No, that's pretty much it. Oh, wait, I forgot; a number of airships seem to be pursuing this one. I think they are Department interceptors but I can't be certain. It's best we avoid them, anyway," said Adrian as he pulled his goggles down over his smiling eyes.

"What?" asked Isaac as he looked out the hatch toward the rear of the ship and saw several shapes flying in formation and rapidly approaching. Before he could voice any more objections, his uncle informed them all that it was time to go by having HEC grab Isaac and jump from the hatch.

Isaac clenched his eyes while Amelia laughed nearly the entire way to Lakehurst. They came in low and landed just off the base.

Once they removed their goggles, Adrian announced, "Gather around, children, here is the plan. You are going to wait for three minutes, then sneak into the door on the north end of the base and right back into the lounge. I will be going right into the front gate and creating a distraction to cover your entrance."

"Why can't we all go through the front gate? We all saved the world from the Fenris," said Amelia, just a bit disgruntled.

"Yes, we did, and you all saved me. You are heroes and you indeed deserve a hero's welcome, but if we are lucky, your mother and father do not know you have been gone. If you walk through the front gate, yes, you will be heroes but your parents will never let you out of your rooms for the rest of your lives and if they found out that I dragged you through the air behind me on a rocket pack that I was pretty certain may explode at any moment—"

"What do you mean, *explode*?" interjected Isaac.

"Don't interrupt, it's not polite," said Amelia, seemingly completely unfazed by the prospect of having narrowly escaped becoming an unplanned fireworks display.

"Thank you. Anyway, if your parents knew, I would be doing research on the effects of vacuum on the human body onboard Her Majesty's Orbital Research Station before the day's end. Do you understand?"

The children nodded.

"Good. Now, I just need a few words with HEC and we can get started. HEC, would you come with me a moment?"

"Of course, sir."

There was much whispering, flashing of lights, and low tones. HEC and the Professor returned.

"As I said, three minutes. Remember, you are my heroes," Adrian said as hugged the children, then replaced his goggles and lifted off toward the front gate.

The children waited in silence until HEC announced that three minutes had passed. They cautiously ran to the north door of the base and were thankful to find it still unlocked. They made it to the lounge and found it just as they had left it. HEC found some blankets to replace the ones they had left in Trenton. They could hear a great commotion outside as HEC placed the blankets over them. Just as he resumed his place against the wall, the door was thrust open and Anna Griffith rushed in.

"Amelia, Isaac! Wake up! Your uncle has been rescued! I'm sorry; actually he seems to have rescued himself. Come along now!" She was too excited to notice the children were fully dressed after they pushed the blankets down and followed her from the lounge. DARC and aerobase personnel surrounded Adrian, all eagerly listening to the story of his incredible escape.

"… defeating Dr. Claremont, I used the hydrogen tanks from an escape balloon to fashion a crude rocket pack and made my escape. It was not too—Amelia! Isaac! Come here, you little monsters, I thought I might never see you again."

They both remembered to act surprised as they rushed forward and hugged their uncle.

"I was just telling these people about my narrow escape from the clutches of the fiendish Dr. Claremont. Oh, I noticed some ships pursuing the one I escaped. Any chance you know who they were?" he said to the Air Admiral.

"They were our interceptors," said Admiral Pike rather proudly. "One of the pilots said they saw an Unusual Flying Object; they described it as 'a flying man being chased by an eight-armed flying automaton.' I had put it down to flight fatigue, anyway. One of our signalmen found out Ensign Willoughby was sending unauthorized signals. Willoughby's in the brig, for now. Through that, we were able to find out where the exchange was to take place and we managed to intercept Claremont's ship. Regrettably Claremont seems to have escaped. All we found onboard were a bunch of wrecked automatons, and two technicians who kept going on about a 'monster automaton that was eating orphans' or some other hogwash. Anyway, we did not find the Icarus Device on the ship. Professor Grimmelore, did you bring it back with you or did Dr. Claremont escape with it?"

"No need to worry; the device was utterly destroyed during my miraculous escape. I will brief you all about it after breakfast," said the Professor.

"Oh my, breakfast! HEC, would you mind making some breakfast for the children? They are going to be late for school," said Alexander Griffith.

"School?" said both the children in utter astonishment.

"Yes, school. I know this is all terribly exciting, but that is no excuse. Now, run along."

HEC ushered the children back to the lounge to get them ready. The end of this day seemed a bit unfair to both Amelia and Isaac. They both came home with notes from their teacher complaining about them falling asleep in class. Anna and Alexander Griffith were not amused.

After a couple of weeks, everything was back to normal and Isaac and Amelia were greeted with a letter from their uncle, after they returned home from school. It was from London and was written on very lovely bordered paper. Amelia read it aloud.

Hello to my Favorite Niece and Nephew,

I am having a lovely time here in London. The weather here is abysmal, but that is to be expected. I will be staying here a bit longer than planned, but don't worry; I will be there soon. I hope all is well and Heathcliff is over his fever. You should keep him warm and dry, doctor's orders. I'm afraid I have to cut this short, as there is always so much to do here. I look so very much forward to seeing you both again soon.

Warmest Regards,
Professor Adrian Grimmelore
Your Uncle

"'Favorite niece and nephew'? I thought we were his *only* niece and nephew. Why would he think HEC had a fever? Is he joking?" Amelia asked Isaac as he sat across the kitchen table from her. He was staring at the back of the letter.

"No, with the light from the window behind you, I can see very small holes in the border." He took the letter from her. "It's a code." He took the decoder and a pencil and paper from his sack and began writing down the message.

"What does it say?" asked Amelia impatiently.

"Hold on." Isaac finished and began to frown a bit, and said, "Please, no."

"What? Come on, what does it say?" She took the paper from him and read it aloud, "HEC Code 1818AG." Amelia smiled delightedly as HEC sounded a low tone and his eyes began to blink.

Part the Third

Hastily Scribbled Laboratory Notes

Appendix A

This Way Lies Madness

I assume that if you have gotten this far into the book, you were either already quite interested in Steampunk or are hungry for more. Allow me to help broaden your gear-laden horizons by including here a list of recommended reading and/or viewing to help you get a better sense of this fantastical aesthetic.

I could, of course, write an entire new book and not cover half of what I might consider the essentials. I have decided to include, therefore, only a very, very select list of suggested readings and viewings. This is not to indicate in any way that these are the very best that the genre has to offer, but rather that these titles include design elements or inspirations that have been formative in my own development as an artist, designer, and mad scientist. I hope you find them all as useful and as enjoyable as I have. I've thrown in a few obscure references you are welcome to toss about to impress your friends and baffle your foes. The hardest part about writing this list was stopping. I could go on forever. I hope that you do, too.

Further Reading

Classic

I strongly recommend that you read some of the great Victorian and Edwardian science fiction tales that formed the inspiration for Steampunk. A handful of notables are listed here. You can find several editions of these issued by different publishers.

Appleton, Victor. 1910–1941, original series. *Tom Swift* series.

Doyle, Arthur Conan. 1912. *The Lost World.*

———. 1913. *The Poison Belt.*

Griffith, George Chetwynd. 1893. *The Angel of the Revolution: A Tale of the Coming Terror.*

Shelley, Mary. 1818. *Frankenstein.*

Twain, Mark. 1889. *A Connecticut Yankee in King Arthur's Court.*

Verne, Jules. 1870. *Twenty Thousand Leagues Under the Sea.*

———. 1864. *Journey to the Center of the Earth.*

Wells, H. G. 1901. *First Men in the Moon.*

———. 1898. *The War of the Worlds.*

Contemporary

To learn more about the modern Steampunk movement itself, I highly recommend the following reading list of fiction and nonfiction.

Carriger, Gail. 2012. The *Parasol Protectorate* series. New York: Orbit.

Foglio, Phil and Kaja. 2001–2011. *Girl Genius*, comic series. Seattle: Studio Foglio.

Gibson, William, and Bruce Sterling. 1991. *The Difference Engine*. New York: Bantam Spectra.

Guinan, Paul, and Anina Bennett. 2000. *Boilerplate: History's Mechanical Marvel*. New York: Abrams Image.

Marsocci, Joey and Allison DeBlasio. 2013. *1,000 Incredible Costume and Cosplay Ideas: A Showcase of Creative Characters from Anime, Manga, Video Games, Movies, Comics, and More* (1000 Series). Minneapolis, MN: Quarry Books.

Nevins, Jess. 2005. *The Encyclopedia of Fantastic Victoriana*. Austin, TX: MonkeyBrain Books.

Pullman, Philip. 1995. *The Golden Compass*. New York: Random House.

Robb, Brian J. 2012. *Steampunk: Victorian Visionaries, Scientific Romances and Fantastic Fictions*. London: Aurum Press. (This one is kind of hard to find in the U.S. but well worth the search.)

Ruhling, Nancy, and John Crosby Freeman. 1994. *The Illustrated Encyclopedia of Victoriana: A Comprehensive Guide to the Designs, Customs, and Inventions of the Victorian Era*. Philadelphia: Running Press.

Sears Roebuck & Co. 2007. *1897 Sears Roebuck & Co. Catalog*. New York: Skyhorse Publishing.

Stephenson, Neal. 1995. *The Diamond Age*. New York: Bantam Spectra.

Thomas, Brian D., and Raymond J. Witte. 2009. *Steam Powered Tales of Awesomeness*. Hatboro, PA: Epiphany Arts LLC.

Tinker, Major Thaddeus. 2012. *The Steampunk Gazette*. Hauppauge, NY: Barron's Educational Series.

VanderMeer, Jeff, and S. J. Chambers. 2011. *The Steampunk Bible: An Illustrated Guide to the World of Imaginary Airships, Corsets and Goggles, Mad Scientists, and Strange Literature*. New York: Abrams Image.

Victoriana, Lady Lisa. 2013. *International Steampunk Fashions*. Atglen, PA: Schiffer Publishing.

Willeford, Thomas D. 2012. *Steampunk Gear, Gadgets, and Gizmos: A Maker's Guide to Creating Modern Artifacts*. McGraw-Hill. (This is one of my personal favorites.)

In addition to those listed above, other contemporary writers and artists you should keep a sharp eye out for include (in alphabetical order):

- Pip Ballantine
- James Blaylock
- Greg Broadmore
- K.W. Jeter
- Jay Lake
- Tee Morris
- Tim Powers
- Cherie Priest

If you read nothing else at all, at least go online and read *Girl Genius* by Phil and Kaja Foglio. After all, it's free at www.girlgeniusonline.com!

Viewing

The Adventures of Brisco County, Jr. (TV series; Carlton Cuse, Jefrey Boam, 27 ep. 1993–1994)

Back to the Future, Part III (1990)

Chitty Chitty Bang Bang (1968)

City of Lost Children (1995)

Cowboys and Aliens (2011)

The Golden Compass (2007)

The Great Race (1965)

Hugo (2011)

John Carter (2012)

The League of Extraordinary Gentlemen (2003)

Legend (TV series; Richard Dean Anderson, John de Lancie, 12 ep. 1995)

Those Magnificent Men in Their Flying Machines (1965)

Oblivion and Oblivion 2: Backlash (1996)

Perfect Creature (2006)

Robot Carnival (animation, 1991)

Sherlock Holmes (2010)

SteamBoy (animation, 2004)

Time After Time (1979)

The Wild Wild West (TV series, 1965–1969)

Wild Wild West (feature movie, 1999)

Music

Abney Park

Steam Powered Giraffe

Professor Elemental

The Men That Will Not Be Blamed For Nothing

Emperor Norton's Stationary Marching Band

Frenchy and the Punk

Mr. B The Gentleman Rhymer

Vernian Process

Voltaire

Vaud and the Villains

Games

Role-Playing Games

Chadwick, Frank. 1988. *Space: 1889* RPG series. Heliograph Inc., Untreed Reads Publishing LLC.

Hensely, Shane Lacy. 1996. *Deadlands: The Weird West Roleplaying Game* series. Pinnacle Entertainment Group.

Pondsmith, Mike. 1994. *Castle Falkenstein* RPG series. R. Talsorian Games, Steve Jackson Games.

Stoddard, William. 2000. *GURPS Steampunk* RPG. Steve Jackson Games.

Witt, Sam. 1993. *Wooden Suits & Iron Men* RPG. Nightshift Games.

Videogames

Arcanum: Of Steamworks and Magick Obscura (2001)

Bioshock (2007–2013)

Machinarium (2009)

Thief (1998–2004)

Wild Arms (1996–2012)

Merchandise

Weta Rayguns: www.wetanz.com/rayguns

Clockwork Couture—Clothing, costumes, and accessories: www.clockworkcouture.com

Steampunk Emporium—Clothing, costumes, and accessories: www.steampunkemporium.com

The Blonde Swan—Very cool Steampunk hats: www.Blondeswan.com

Wolf Home Adventuring Outfitters—Loads of stuff, check out their gallery: wolfhomeadventuring.com

Airship Isabella—High end and incredible one of a kind pieces: www.airshipisabella.com

Damsel in this Dress—Lovely lady's wear: www.damseldress.com

Brute Force Studios—This is where you get the stuff for the "OMG!" effect. An absolutely incredible shop, if I do say so myself: www.bruteforcestudios.com

Appendix B

Dramatis Personae

Isaac Griffith

Isaac is our intrepid, but quite reluctant hero and aspiring Mad Scientist. Thirteen-year-old boy, nervous type. Four years previously, Isaac and his sister survived a deadly fever. Ever since they recovered, Isaac has been a mechanical genius. Likes his tea plain with lemon biscuits.

Amelia Griffith

Amelia is absolutely thrilled to be going on an adventure, any adventure will do, much to the horror of her family. Eleven-year-old girl, athletic and adventurous. Four years previously, Amelia and her brother survived a

deadly fever. Ever since they recovered, Amelia has been completely fearless, which is highly distressing to her parents. Prefers her toast with jam and no butter.

Anna Griffith

Anna is the children's doting, happy, and healthy mother. She is also an agent of DARC. She has no known military rank, yet seems to command everyone at the base where the story begins. Takes her tea very strong and with a bit of lemon.

Alexander Griffith

Alexander is the children's father with a long and happy life ahead of him. He is one of DARC's "No-Men." They decide if a technology is just too dangerous to exist. Tried coffee once; since then, nobody speaks of the "Yale Incident."

Heathcliff Ebenezer Chadwick

Everyone just calls him HEC. A Type V Grimmelore patent-pending experimental model general-purpose automaton, obedient and loyal. He is the near perfect butler and

he makes the best tea you will ever taste.

DARC

This is the Department of Advancement, Regulation, and Control. They are the gatekeepers of technology. This agency is attempting to keep the world safe from some of the worst effects of Mad Science. They are quite possibly the reason everyone thinks Nikola Tesla is crazy.

Air Admiral Pike

Admiral Pike is a veritable bear of a man and the Commander of the Lakehurst Aeroport. He has been ordered to be at Anna's disposal, very direct and to the point. No crust on his sandwiches.

Ensign Willoughby

Willoughby is the shifty, but terribly efficient aide to Air Admiral Pike. Does not like tea or toast. He is obviously the spy in DARC.

Professor Isadora Maelstromme

Professor Maelstromme is ingenious, beautiful, just a bit snobbish, and has an absolutely lovely British accent. Inventor and close friend of Professor Grimmelore. Drinks her tea straight up. Secretly obsessed with darker and darker forms of chocolate.

The Automaton Pilot

The Automaton Pilot has many arms and a one-track mind. It wants to get the ship to its destination always a little faster than last time. Exceptional pilot, surly and antisocial.

Technicians

Every mastermind needs "Technicians." Technician is generally the polite term for minion. Expendable and cowardly, they seem to faint easily. Nobody seems to care what they eat or how they like their tea.

Mark II Visbaun Patent Heavy Combat Automaton "Number Three"

"Mark II's," as they are called, are purpose made for airship combat. They are extremely tough and one out of four of this type of automaton seems to have at least minimal intelligence.

Professor Adrian Grimmelore

Adrian is children's beloved uncle and Anna's half-brother. He is probably a very bad influence on both of them. Daring, reckless, and an absolute genius. Known to associate with Professor Isadora Maelstromme. Unbeknownst to Amelia and Isaac, the professor had once suffered from the same fever that changed them. Drinks upward of twelve cups of tea a day all with too much sugar and milk.

Dr. Charles Claremont

Dr. Claremont is the Evil mastermind of this story, and what use is the story without one? He has captured Professor Grimmelore and plans to turn him over to the mysterious, anarchist group "Fenris." Megalomania: check. Monologuing: check. Chance of his plan succeeding: miniscule. Oddly, he also drinks upward of twelve cups of tea a day all with too much sugar and milk.

Easter Eggs

Did you get the little presents I left you? If not, then I will tell you what they are.

Lakehurst Aeroport This is where the famous Hindenburg disaster took place on Thursday, May 6, 1937, in our history. You have probably heard of that, but did you know that although it was a horrible fire and crash, more than half of the people survived?

The Griffith Family Name George Chetwynd Griffith (1857–1906) was a prolific British science fiction writer and noted explorer who wrote during the late Victorian and Edwardian ages.

Heathcliff Ebenezer Chadwick Frank Chadwick is an American game designer and *New York Times* bestselling author. He has designed hundreds of games. In 1988 he created *Space: 1889*, which was *my* gateway into the Steampunk world.

Air Admiral Pike Admiral Pike was once Captain Pike of the USS *Enterprise* in classic *Star Trek*. He was later replaced by Captain James T. Kirk. (Okay, I'm a *Star Trek* fan, too!)

"Are you orphans?" This is my own personal joke based on the fact that Young Adult writers like to get the parents out of the way, so loads of them make the children "orphans." (I like my parents!) So no, they are not orphans; they have healthy and loving parents. They are just very clever.

The Icarus Device In Greek mythology, Icarus is the son of the master craftsman Daedalus. The main story told about Icarus is his attempt to escape from Crete by means of wings that his father constructed from feathers and wax. He ignored instructions not to fly too close to the sun, and the melting wax caused him to fall into the sea.

Dr. Charles Claremont Christopher Claremont is a comic book writer and novelist, known for his 17-year (1975–1991) stint on *Uncanny X-Men*. Dr. Charles Xavier was the leader of the X-men.

"…and a huge crate of little dolls with big heads that wobble" This is an insider reference to the cargo in the episode titled "Our Mrs. Reynolds" of the science fiction television series *Firefly*, created by Joss Whedon.

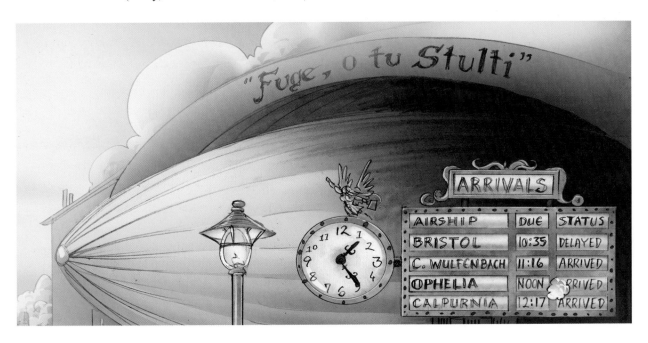

Appendix C

For the Brilliant but Mathematically Challenged Mad Scientist

Metric to U.S. Conversions (Length)

1 millimeter	=	0.03937 inch
1 centimeter	=	0.3937 inch
1 meter	=	39.37 inches
1 meter	=	3.281 feet
1 meter	=	1.0936 yards

U.S. to Metric Conversions (Length)

1 inch	=	25.4 millimeters
1 inch	=	2.54 centimeters
1 foot	=	304.8 millimeters
1 foot	=	30.48 centimeters
1 yard	=	914.4 millimeters
1 yard	=	91.44 centimeters

Conversion Chart: Fraction/Decimal/Millimeter

factor 1/25.4 – 4 places (1 inch = 25.4 mm exactly)

Fraction	Decimal	mm	Fraction	Decimal	mm	Fraction	Decimal	mm
1/64	0.0156	0.3969	1 1/64	1.0156	25.7969	2 1/64	2.0156	51.1969
1/32	0.0313	0.7938	1 1/32	1.0313	26.1938	2 1/32	2.0313	51.5938
3/64	0.0469	1.1906	1 3/64	1.0469	26.5906	2 3/64	2.0469	51.9906
1/16	0.0625	1.5875	1 1/16	1.0625	26.9875	2 1/16	2.0625	52.3875

(continued on next page)

Fraction	Decimal	mm	Fraction	Decimal	mm	Fraction	Decimal	mm
5/64	0.0781	1.9844	1 5/64	1.0781	27.3844	2 5/64	2.0781	52.7844
3/32	0.0938	2.3813	1 3/32	1.0938	27.7813	2 3/32	2.0938	53.1813
7/64	0.1094	2.7781	1 7/64	1.1094	28.1781	2 7/64	2.1094	53.5781
1/8	**0.1250**	**3.1750**	**1 1/8**	**1.1250**	**28.5750**	**2 1/8**	**2.1250**	**53.9750**
9/64	0.1406	3.5719	1 9/64	1.1406	28.9719	2 9/64	2.1406	54.3719
5/32	0.1563	3.9688	1 5/32	1.1563	29.3688	2 5/32	2.1563	54.7688
11/64	0.1719	4.3656	1 11/64	1.1719	29.7656	2 11/64	2.1719	55.1656
3/16	0.1875	4.7625	1 3/16	1.1875	30.1625	2 3/16	2.1875	55.5625
13/64	0.2031	5.1594	1 13/64	1.2031	30.5594	2 13/64	2.2031	55.9594
7/32	0.2188	5.5563	1 7/32	1.2188	30.9563	2 7/32	2.2188	56.3563
15/64	0.2344	5.9531	1 15/64	1.2344	31.3531	2 15/64	2.2344	56.7531
1/4	**0.2500**	**6.3500**	**1 1/4**	**1.2500**	**31.7500**	**2 1/4**	**2.2500**	**57.1500**
17/64	0.2656	6.7469	1 17/64	1.2656	32.1469	2 17/64	2.2656	57.5469
9/32	0.2813	7.1438	1 9/32	1.2813	32.5438	2 9/32	2.2813	57.9438
19/64	0.2969	7.5406	1 19/64	1.2969	32.9406	2 19/64	2.2969	58.3406
5/16	0.3125	7.9375	1 5/16	1.3125	33.3375	2 5/16	2.3125	58.7375
21/64	0.3281	8.3344	1 21/64	1.3281	33.7344	2 21/64	2.3281	59.1344
11/32	0.3438	8.7313	1 11/32	1.3438	34.1313	2 11/32	2.3438	59.5313
23/64	0.3594	9.1281	1 23/64	1.3594	34.5281	2 23/64	2.3594	59.9281
3/8	**0.3750**	**9.5250**	**1 3/8**	**1.3750**	**34.9250**	**2 3/8**	**2.3750**	**60.3250**
25/64	0.3906	9.9219	1 25/64	1.3906	35.3219	2 25/64	2.3906	60.7219
13/32	0.4063	10.3188	1 13/32	1.4063	35.7188	2 13/32	2.4063	61.1188
27/64	0.4219	10.7156	1 27/64	1.4219	36.1156	2 27/64	2.4219	61.5156
7/16	0.4375	11.1125	1 7/16	1.4375	36.5125	2 7/16	2.4375	61.9125
29/64	0.4531	11.5094	1 29/64	1.4531	36.9094	2 29/64	2.4531	62.3094
15/32	0.4688	11.9063	1 15/32	1.4688	37.3063	2 15/32	2.4688	62.7063
31/64	0.4844	12.3031	1 31/64	1.4844	37.7031	2 31/64	2.4844	63.1031
1/2	**0.5000**	**12.7000**	**1 1/2**	**1.5000**	**38.1000**	**2 1/2**	**2.5000**	**63.5000**
33/64	0.5156	13.0969	1 33/64	1.5156	38.4969	2 33/64	2.5156	63.8969
17/32	0.5313	13.4938	1 17/32	1.5313	38.8938	2 17/32	2.5313	64.2938

Fraction	Decimal	mm	Fraction	Decimal	mm	Fraction	Decimal	mm
35/64	0.5469	13.8906	1 35/64	1.5469	39.2906	2 35/64	2.5469	64.6906
9/16	0.5625	14.2875	1 9/16	1.5625	39.6875	2 9/16	2.5625	65.0875
37/64	0.5781	14.6844	1 37/64	1.5781	40.0844	2 37/64	2.5781	65.4844
19/32	0.5938	15.0813	1 19/32	1.5938	40.4813	2 19/32	2.5938	65.8813
39/64	0.6094	15.4781	1 39/64	1.6094	40.8781	2 39/64	2.6094	66.2781
5/8	**0.6250**	**15.8750**	**1 5/8**	**1.6250**	**41.2750**	**2 5/8**	**2.6250**	**66.6750**
41/64	0.6406	16.2719	1 41/64	1.6406	41.6719	2 41/64	2.6406	67.0719
21/32	0.6563	16.6688	1 21/32	1.6563	42.0688	2 21/32	2.6563	67.4688
43/64	0.6719	17.0656	1 43/64	1.6719	42.4656	2 43/64	2.6719	67.8656
11/16	0.6875	17.4625	1 11/16	1.6875	42.8625	2 11/16	2.6875	68.2625
45/64	0.7031	17.8594	1 45/64	1.7031	43.2594	2 45/64	2.7031	68.6594
23/32	0.7188	18.2563	1 23/32	1.7188	43.6563	2 23/32	2.7188	69.0563
47/64	0.7344	18.6531	1 47/64	1.7344	44.0531	2 47/64	2.7344	69.4531
3/4	**0.7500**	**19.0500**	**1 3/4**	**1.7500**	**44.4500**	**2 3/4**	**2.7500**	**69.8500**
49/64	0.7656	19.4469	1 49/64	1.7656	44.8469	2 49/64	2.7656	70.2469
25/32	0.7813	19.8438	1 25/32	1.7813	45.2438	2 25/32	2.7813	70.6438
51/64	0.7969	20.2406	1 51/64	1.7969	45.6406	2 51/64	2.7969	71.0406
13/16	0.8125	20.6375	1 13/16	1.8125	46.0375	2 13/16	2.8125	71.4375
53/64	0.8281	21.0344	1 53/64	1.8281	46.4344	2 53/64	2.8281	71.8344
27/32	0.8438	21.4313	1 27/32	1.8438	46.8313	2 27/32	2.8438	72.2313
55/64	0.8594	21.8281	1 55/64	1.8594	47.2281	2 55/64	2.8594	72.6281
7/8	**0.8750**	**22.2250**	**1 7/8**	**1.8750**	**47.6250**	**2 7/8**	**2.8750**	**73.0250**
57/64	0.8906	22.6219	1 57/64	1.8906	48.0219	2 57/64	2.8906	73.4219
29/32	0.9063	23.0188	1 29/32	1.9063	48.4188	2 29/32	2.9063	73.8188
59/64	0.9219	23.4156	1 59/64	1.9219	48.8156	2 59/64	2.9219	74.2156
15/16	0.9375	23.8125	1 15/16	1.9375	49.2125	2 15/16	2.9375	74.6125
61/64	0.9531	24.2094	1 61/64	1.9531	49.6094	2 61/64	2.9531	75.0094
31/32	0.9688	24.6063	1 31/32	1.9688	50.0063	2 31/32	2.9688	75.4063
63/64	0.9844	25.0031	1 63/64	1.9844	50.4031	2 63/64	2.9844	75.8031
1	**1.0000**	**25.4000**	**2**	**2.0000**	**50.8000**	**3**	**3.0000**	**76.2000**

Final Thoughts

I hope you enjoyed the story of Amelia, Isaac, HEC, and the incorrigible Professor Grimmelore. I had too much fun writing about them and can't wait to do so again! But even more, I hope you made some of the projects from this book.

When I was first discussing these projects with friends of mine, people told me, "These things might seem too hard for some people," "Don't you think that piece is a bit too intimidating?" and "Maybe you should dumb this down a little bit." I was actually shocked at that last statement. I can't imagine you would want something that's been "dumbed down" for you or for anyone for whom you might buy this book. Making Mad Science should be just as much of an adventure as rescuing a missing uncle! I apologize to any naysayers, but I can't seem to make myself oversimplify this, as I would feel as though I were insulting you, my readers. I like to think I have made these inventions challenging, yet fun. Maybe there's a book out there with some dumbed-down projects for those who can't handle the "good stuff," and when you show up with your incredible devices you've made from this book, try not to laugh too hard at those who are not nearly as gifted as you.

If you see me out and about at some event, convention, or gathering (assuming, of course, I manage to escape the demands of the workshop and laboratory), then please come up and talk to me. Ask me questions if you have them. Show me what you have made. Send me your pictures or tag me in online picture posts. I can always be reached at www.BruteForceStudios.com or catch me on Facebook at www.facebook.com/BruteForceStudios, if you have any question or if you just want to say, "What in the world were you thinking?" We are all forging future antiques, and I want to see where your imaginations lead.

Master Patterns

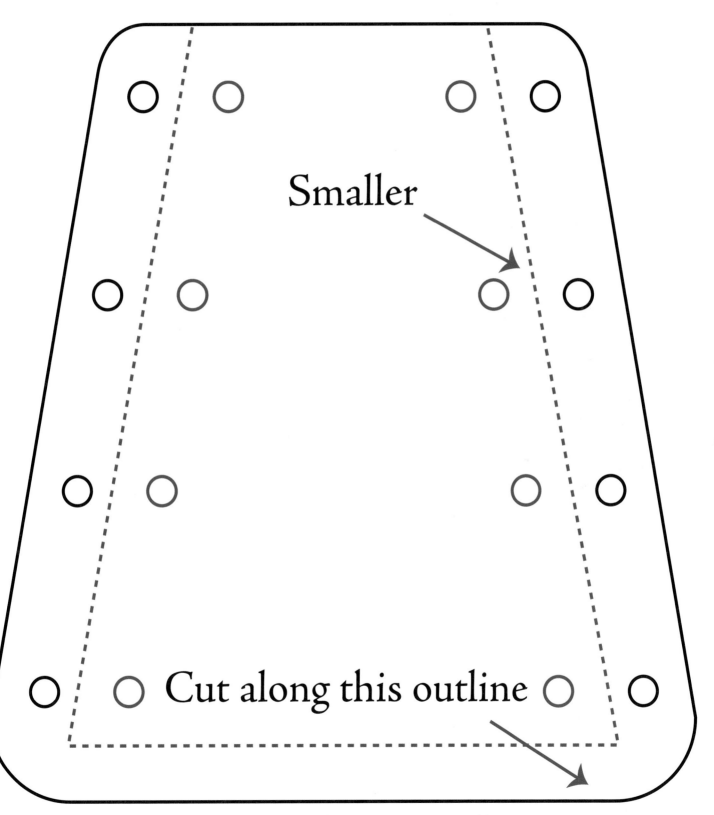

Smaller

Cut along this outline

FIGURE 4-1 Pattern for the Decoder Armguard base

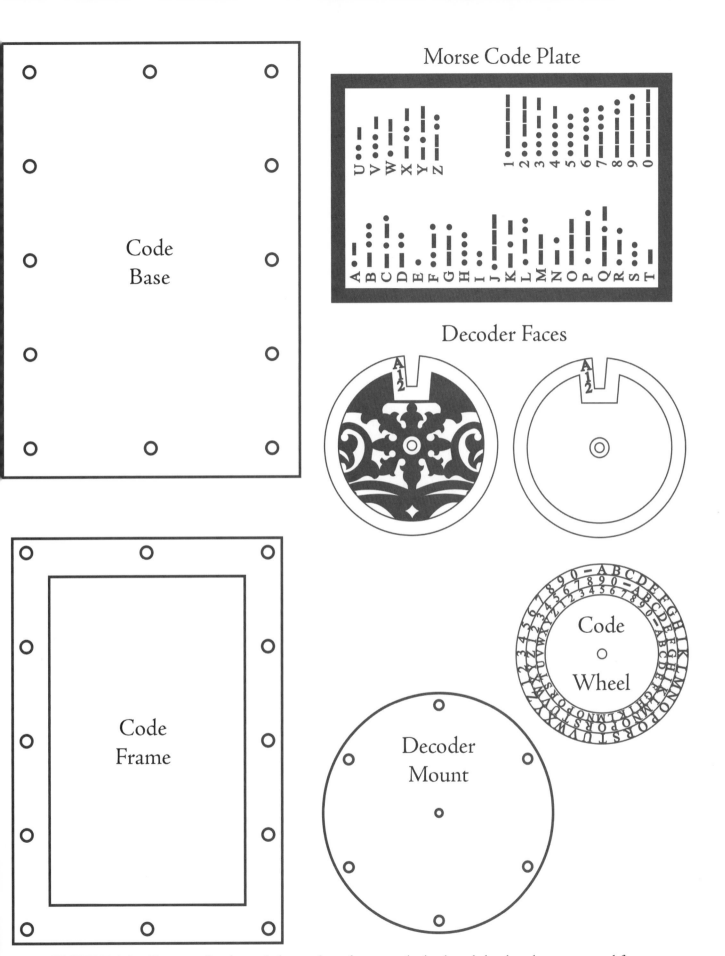

FIGURE 4-2 Patterns for the code base, plate, frame, and wheel, and the decoder mount and faces

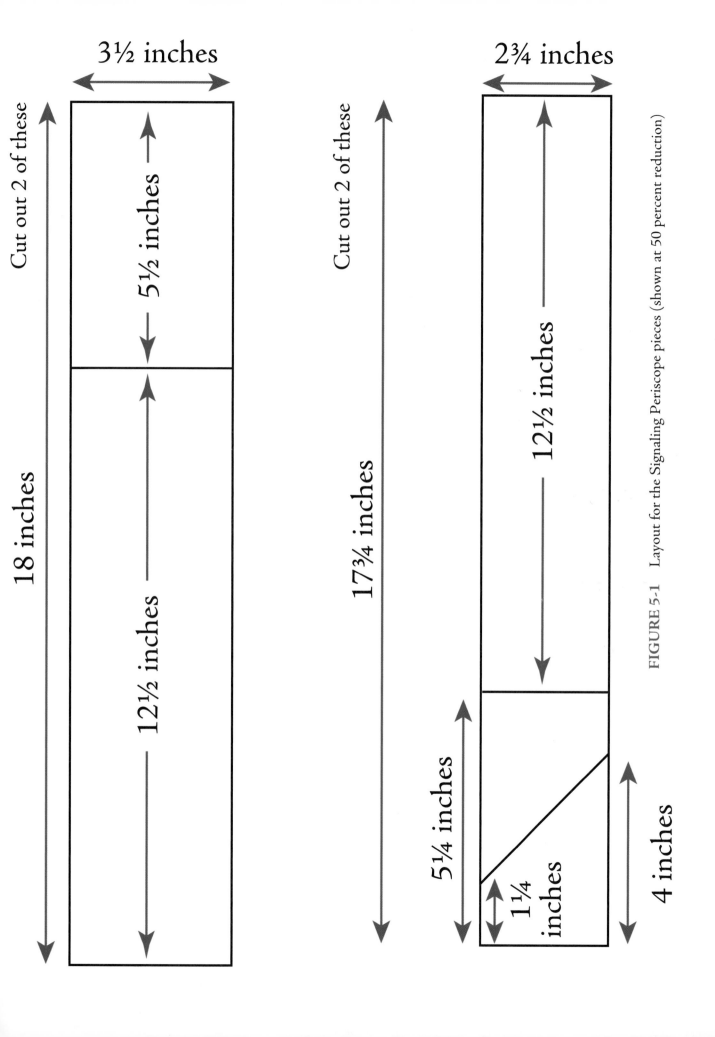

3½ inches

Cut out 2 of these

5½ inches

18 inches

12½ inches

2¾ inches

Cut out 2 of these

12½ inches

17¾ inches

5¼ inches

1¼ inches

4 inches

FIGURE 5-1 Layout for the Signaling Periscope pieces (shown at 50 percent reduction)

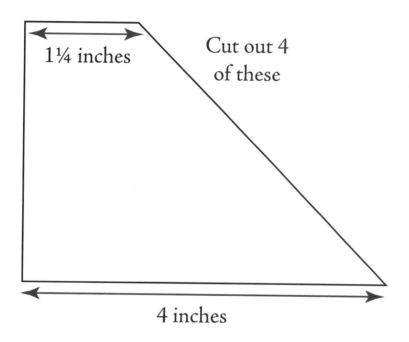

FIGURE 5-2 Pattern for the Signaling Periscope

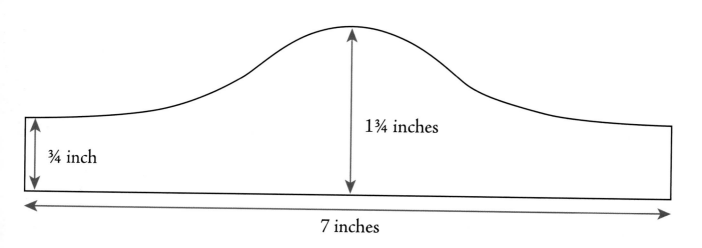

FIGURE 6-1 Pattern for goggles gasket

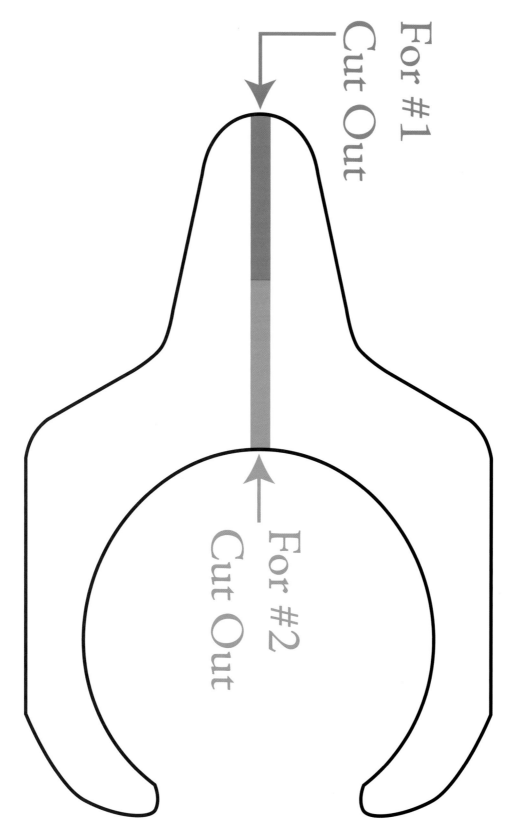

FIGURE 7-1 Pattern for grappling hook tines

FIGURE 9-1 Wing pattern (piece 1)

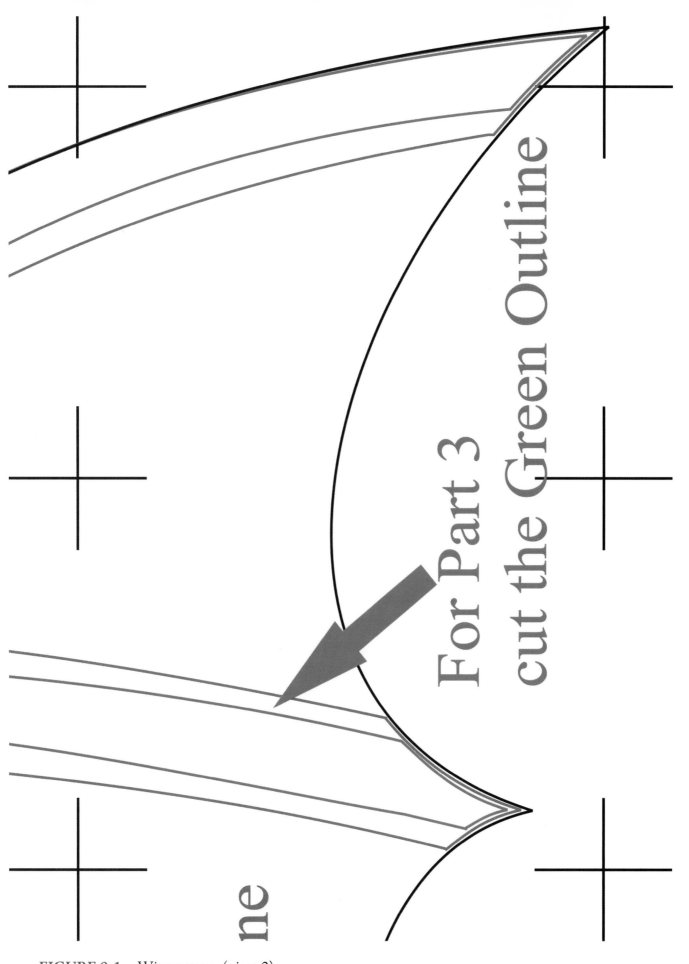

For Part 3
cut the Green Outline

FIGURE 9-1 Wing pattern (piece 2)

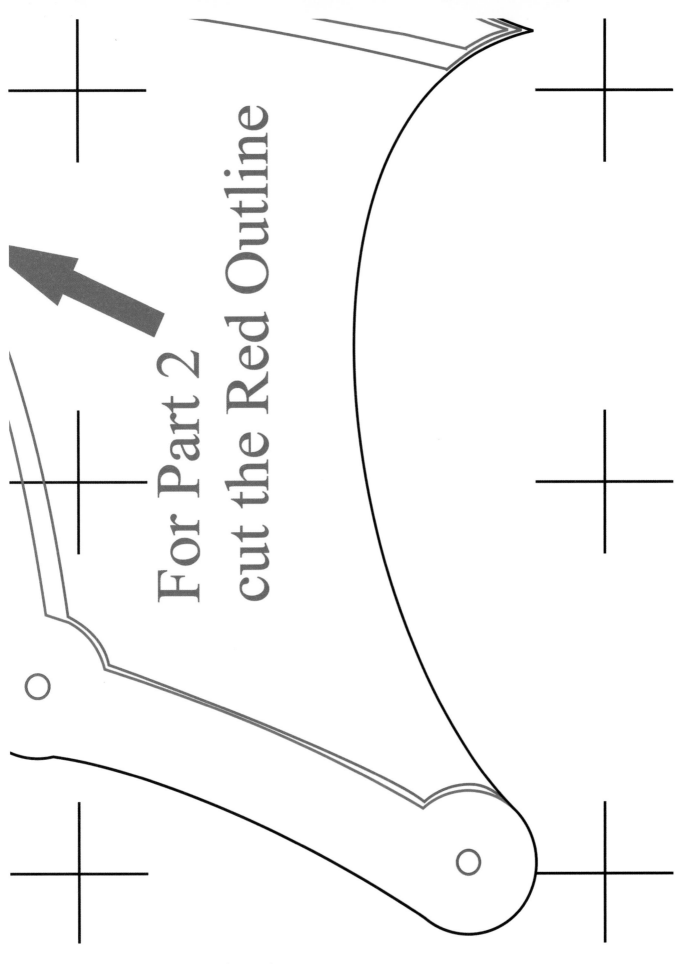

For Part 2
cut the Red Outline

FIGURE 9-1 Wing pattern (piece 3)

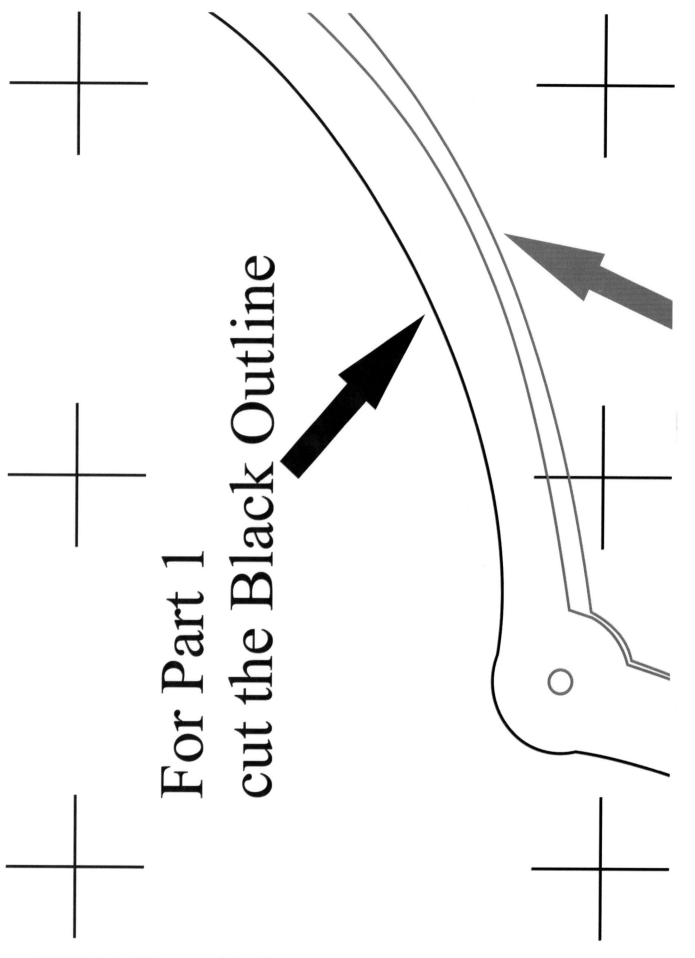

For Part 1
cut the Black Outline

FIGURE 9-1 Wing pattern (piece 4)

Pattern 1

Circle 3

3 inches

Circle 2

4 inches

Circle 1

4 1/2 inches

FIGURE 11-1 Patterns for the Power Armor

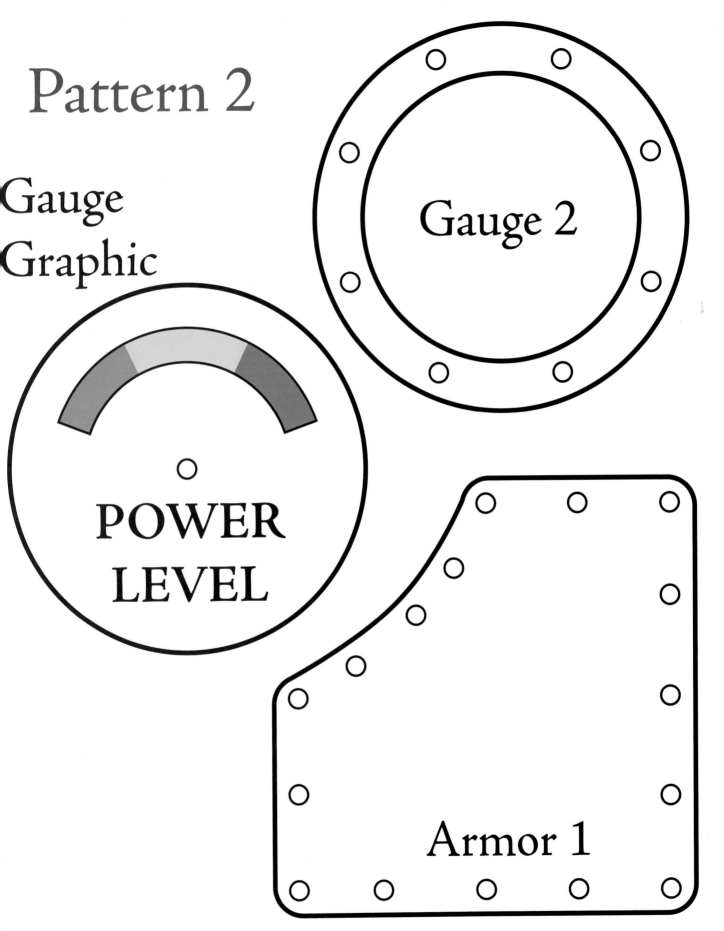

Pattern 2

Gauge Graphic

Gauge 2

POWER LEVEL

Armor 1

FIGURE 11-1 Patterns for the Power Armor

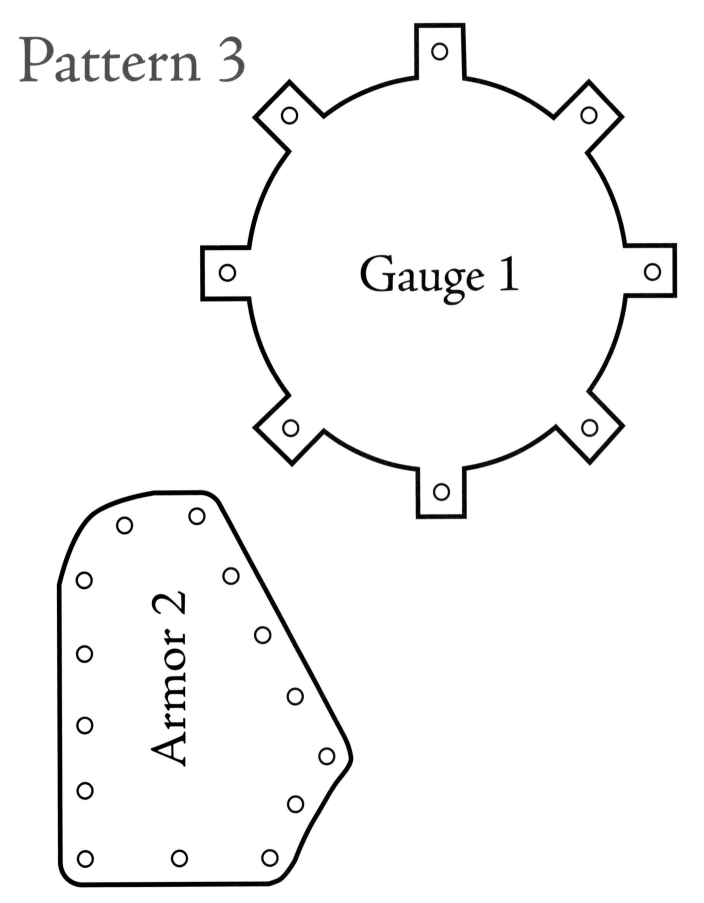

FIGURE 11-1 Patterns for the Power Armor

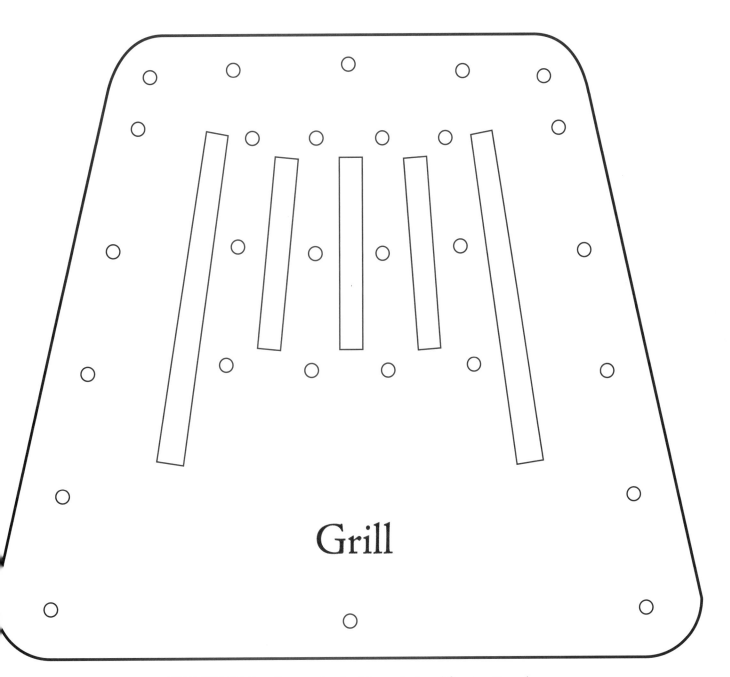

Grill

FIGURE 11-2 Pattern for the Magnetic Amplification Gauntlet

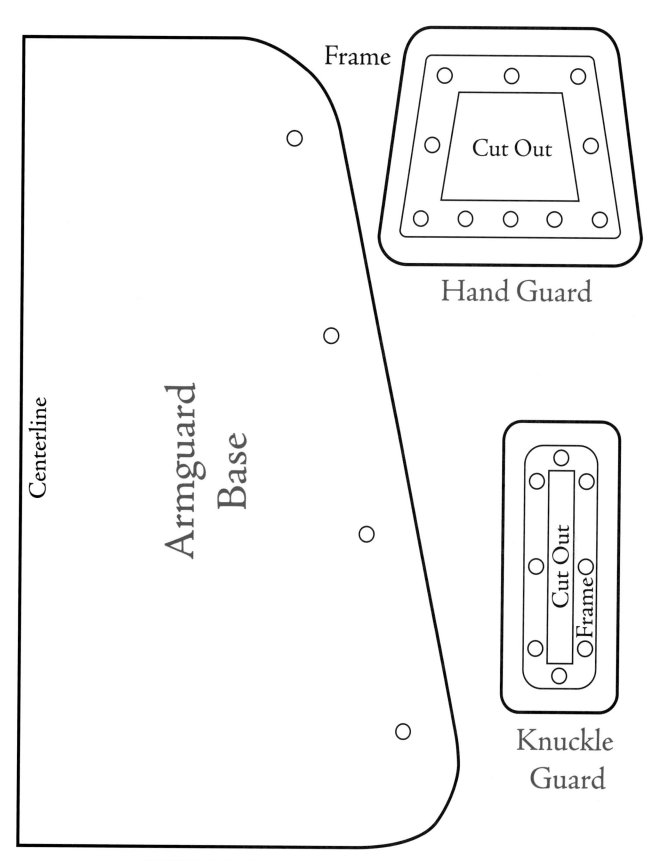

FIGURE 11-2 Patterns for the Magnetic Amplification Gauntlet

Index

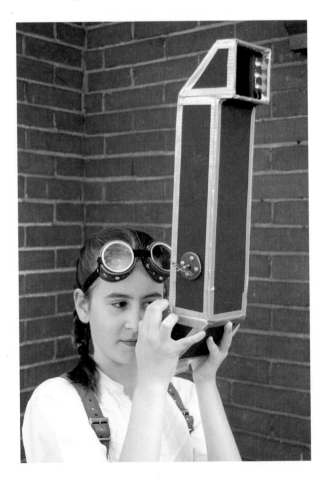

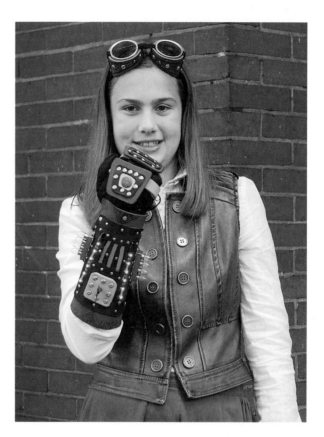

N

P

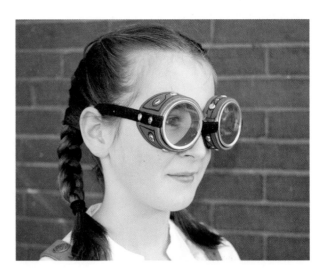

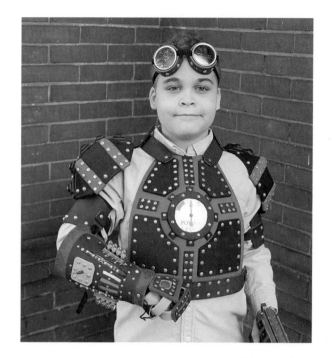

Unleash Your Inner Mechanical Mastermind

Filled with do-it-yourself Steampunk projects, this inventive volume shows you how to build exquisite, ingenious contraptions on a budget, including:

- Aetheric ray deflector solid brass goggles
- Altitude mask with integrated respiratory augmentation
- Armoured pith helmet
- Mark I superior replacement arm with integrated Gatling gun attachment
- And many more!

Steampunk Gear, Gadgets, and Gizmos:
A Maker's Guide to Creating Modern Artifacts

Thomas Willeford
ISBN 0-07-176236-1

Mc
Graw
Hill
Education

www.mhprofessional.com